THE
NATIONAL GALLERY
COLLECTION

THE
NATIONAL GALLERY
COLLECTION

SELECTED BY
MICHAEL LEVEY

National Gallery Publications
The National Gallery
London

National Gallery Publications
Published by order of the Trustees
© Michael Levey and The National Gallery 1987

British Library Cataloguing in Publication Data
National Gallery
The National Gallery collection.
1. National Gallery – – Catalogs
I. Title II. Levey, Michael
750'.74'02132 N1070

ISBN 0 – 947645 – 34 – 9
ISBN 0 – 947645 – 16 – 0 Pbk

Designed by Vassoula Vasiliou
National Gallery Design Studio
Colour origination by Essex Colour
Printed by W. S. Cowell Limited, Great Britain
Typeset by The Printed Word, London

Cover illustration: Raphael, *An Allegory* (detail)

Contents

Introduction

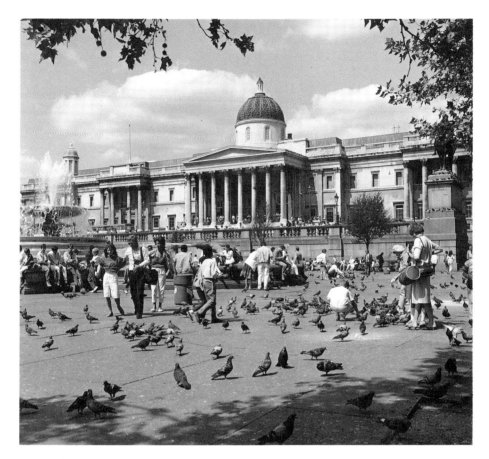

Lovers of painting require no explanation of why public art galleries exist – why, in particular, the National Gallery exists and should go on existing.

While literature and music are broadly available to everyone, paintings present the problems of being single, physical objects, not able to be disseminated or adequately duplicated. They need to be seen in the original to be fully enjoyed and understood, though a book such as this can offer a useful appetiser for that experience.

Paintings can, unfortunately, be treated as property. Access to them can be controlled, even prevented, by their owners in ways which happily do not apply to Shakespeare's plays and Mozart's music. It is the more necessary, therefore, to have some great paintings brought together, cared for and displayed permanently in a public building – one to which we all have access freely – if Western painting is ever to be appreciated, as it deserves to be, on equal terms with Western music and literature. In Britain appreciation of all the visual arts, not solely painting, has tended to be neglected in traditional education, and this makes the role of museums and galleries the more vital.

The public museum was very much a child of nineteenth-century thinking and doing, though some of the thinking had begun in the previous century. Education and culture were then seen as desirable twin social goals, deserving support by governments (whose members were often cultured and knowledgeable about the visual arts). When England eventually got round to considering seriously the need for a national picture gallery, the Prime Minister of the day took an active part. Not private sources but public funds were called on, and the National Gallery came into existence by the will of Parliament.

That event took place in 1824. The infant institution was certainly humble in comparison with the great Continental galleries already in existence – like the Louvre in Paris and the Prado in Madrid – built often on the riches of royal collections. At first it was also humbly housed. It lacked a constitution, and for thirty years or so it lacked a director and any firm sense of direction. Yet, however haphazardly, it grew. The very absence of a great inheritance meant it had positively to strive to acquire paintings, especially if it was ever to become an art gallery of international standing.

By the time the National Gallery celebrated its centenary in 1924 that position was achieved. It had a prominent building, with a façade that was familiar, in Trafalgar Square (p.7). And behind the façade was a collection of paintings not large numerically but in quality of the greatest choiceness, with a spread of representation across the chief national schools that gave it admirable character as one of the most balanced of all Galleries.

How it achieved its position is a story often told, at least in outline. Brilliant buying by the first Director, Sir Charles Eastlake; wonderfully generous gifts and bequests (beginning with the gift of Sir George Beaumont and the bequest of the Reverend William Holwell Carr); sustained efforts by the Trustees to gain sufficient space; and increasing struggles to obtain sufficient funds and to 'save' paintings from export: such are the main threads in a story that could pardonably seem in 1924 happy, glorious and concluded. Well might some thrifty-minded MP have risen in the House of Commons to propose that by way of celebration the National Gallery should keep its doors open but close its Collection, seeking no more public funds for purchases.

In fact, that did not precisely occur, though the Gallery suffered – as it has always been made to suffer – at times of financial crisis. It never assumed that its days of actively acquiring paintings were done, though perhaps in the 1920s and 1930s it had no very coherent policy in making acquisitions or in stimulating wider appreciation of painting as such. The Collection continued to grow, partly in response to growing awareness that there were periods and schools of painting, and painters, to which it failed to do justice. Most glaring was the failure to represent the later nineteenth century, and there the nation is indebted to the generosity of Samuel Courtauld. A pioneering collector in Britain of superb Impressionists and other French paintings of the period, he created a fund for public acquisition of such pictures.

Today the Collection is still not large – numbering around 2,200 paintings – and it continues to evolve. Even in the last twenty-five years taste and knowledge have broadened our views about the scope of European painting in the centuries up to 1900. Some of the new awareness has been reflected in the Gallery's more recent acquisitions. What is important is that the Collection should be permitted – should possess the financial sinew – to go on growing. Growth in itself signals vitality.

With its occasional quirks and its admitted 'gaps' (some now probably never to be filled), the Collection as it stands provides a marvellously coherent and assimilable overview of Western European painting: from the beginnings in medieval Italy to the earliest years of the present century. Greatly enhanced as it has been in the decades since 1924, the Collection is unchanged in basic character. It has never sought to be a collection of merely historical specimens, embracing every painter, regardless of quality.

The future of museums and galleries in Britain today is by no means clear or assured. Even the public ownership of paintings is liable to arouse hostility in some quarters, quite apart from the traditional tendency to be indifferent to the value of museums. Such institutions cost money to run and money to repair. They perform a public function, but one scarcely quantifiable in financial terms. Ultimately, they are justified only as long as they find an audience eager to enjoy what they offer.

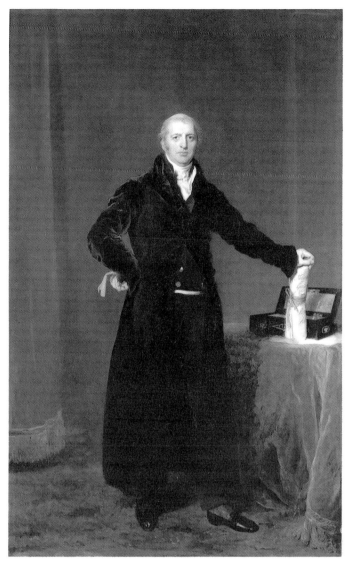

Sir Thomas Lawrence: *The 2nd Earl of Liverpool* (1770-1828), painted in 1827.
The sitter holds papers inscribed 'National Gallery'.

The words of Sir George Beaumont, uttered in the year before the Gallery was founded, but when its founding was being mooted, were admirable and bravely optimistic, though even now they have not been entirely realised: 'I think the public already begin to feel works of art are not merely toys for connoisseurs, but solid objects of concern to the nation...'

Instigation for the founding of the Gallery came from a variety of sources. To start with, it was founded in the reign of a monarch more often ridiculed than respected: George IV. The King happened to be unusually cultivated and deeply responsive to painting, a great patron and collector, who many years before had spoken of the need for some national holding of paintings. It was his favourite living painter, Sir Thomas Lawrence, President of the Royal Academy, who strongly urged that a private collection of pictures coming up for sale in London in 1823 should not be sold abroad, as seemed possible, but offered first, 'for a less sum', to the government.

The collection had been made very much with Lawrence's guidance. It had belonged to a new style of collector, a rich, middle-class, mercantile figure, John Julius Angerstein, the

effective founder of Lloyds. He died in 1823, apparently leaving instructions that his small yet fine collection of old master paintings should be sold. Angerstein's son took Lawrence's advice and offered the paintings, hung in his father's London house at 100 Pall Mall, to the government. The then Prime Minister was Lord Liverpool, a politician usually regarded – in so far as he is regarded at all – as a total mediocrity. To the National Gallery, however, he is something of a hero. His response was sufficiently positive to bring the Gallery into existence; and when Lawrence painted his portrait, a few years later, he showed Liverpool holding a roll of papers referring to the Gallery's creation (p.9).

In April 1824 the House of Commons voted to purchase Mr Angerstein's pictures for the nation, and to take the lease of his town house as the place to display them (p.11). The thirty-eight paintings acquired were of all the main national schools, including the British, represented by a Reynolds and by Hogarth's *Marriage à la mode* series (p.196). Among the Italian pictures was Sebastiano del Piombo's huge *Raising of Lazarus* (p.62), which is still inventoried as Number 1 in the Gallery.

Sir George Beaumont was on the Gallery's supervising body, which soon became the Board of Trustees. He deserved his place, for not only had he been advocating the founding of such an institution but, with rare self-sacrificing generosity, he had offered to give his own collection in his lifetime were his hopes accomplished. His offer became public knowledge and must have coloured the government's decision. Although Beaumont's collection was not large, it contained some major paintings, among them Rubens' superb *Autumn Landscape with a View of Het Steen* (p.134) and an early masterpiece by Canaletto (p.96).

Haphazard as purchases appear to have been in the early times, before the appointment in 1855 of Eastlake as the first Director, the Trustees made some inspired acquisitions, beginning in 1826 with Titian's *Bacchus and Ariadne* (p.75). They also benefited from some splendid gifts and bequests. In 1828 the future Duke of Sutherland presented Rubens' *Peace and War* (p.132), which had been the artist's own gift to Charles I. With the Holwell Carr Bequest of 1831 came Rembrandt's *Woman bathing in a Stream* (p.176) and a very rare item, *Saint George and the Dragon* by Tintoretto (p.80), thus giving the Gallery a fine and characteristic example of a painter Ruskin would, many years later, claim to have 'discovered' in Venice. Nor were the works of earlier Renaissance artists entirely neglected: Bellini's *Doge Loredan* (p.51) was bought in 1844, and more remarkable still was the purchase the previous year of the unique Arnolfini portrait by Jan van Eyck (p.104).

These paintings joined the Collection in its newly built permanent home in the Gallery designed by William Wilkins on the north side of Trafalgar Square. It had been opened in 1838, and one of its first visitors was the recently crowned Queen Victoria. Imposing though it might look, the building was only one-room deep, and until 1869 it had to be shared with the Royal Academy.

Problems of space existed therefore at Trafalgar Square from the start. They have continued to bedevil the Gallery's future, right up to the present day. A bold solution, made possible by extreme generosity, came in 1985, with the announcement that an extension on the adjoining 'Hampton site', long designated for the Gallery's expansion, would be funded by Sir John Sainsbury and his brothers, Mr Simon Sainsbury and Mr Timothy Sainsbury MP.

Before becoming Director in 1855, Eastlake had been first Keeper and then a Trustee of the Gallery. However, it was only when he took up the new post – which he held in addition to being President of the Royal Academy – that he showed the full effect of his combined expertise, pertinacity and flair. The decade of his directorship, ending with his death in office, has always been looked on, rightly, as the significant period for the establishment of the character and status of the Collection. Under Eastlake many of

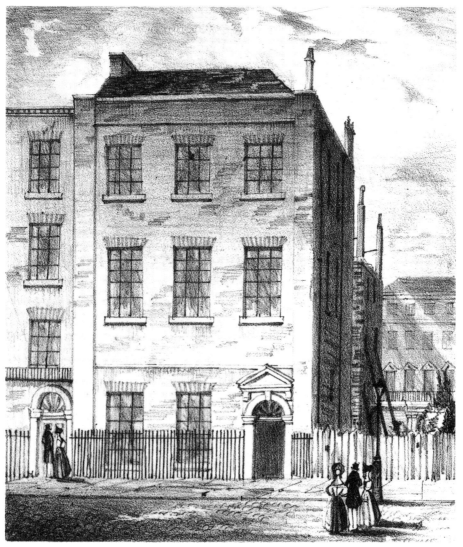

N.º 100, PALL MALL,
or the National Gallery of England.

A contemporary print of the town house of John Julius Angerstein, which housed the National Gallery
in its earliest years.

the great figures of the early Italian Renaissance were introduced into the Gallery, represented by masterpieces of a kind no longer available and bought at a time when their merits were not fully recognised. By going to Italy and purchasing there, Eastlake was able to acquire such now famous masterpieces as Uccello's *Battle of San Romano* (p.27) and Piero della Francesca's *Baptism of Christ* (p.38). Eastlake's taste was impressively wide. He bought the Gallery's first Rogier van der Weyden (p.107) and also its first full-length Reynolds (p.200). More daringly, he added the beautiful Bronzino *Allegory* (p.65), which might well have caused a scandal in mid-Victorian England.

Eastlake's purchasing was so brilliant that it has possibly tended to throw into the shade the acquisitions of his immediate successor, Sir William Boxall. Yet it was in Boxall's directorship that a major purchase was made, of Sir Robert Peel's collection, bringing the Gallery a range of remarkable Dutch seventeenth-century pictures, including Hobbema's *Avenue, Middelharnis* (p.151), and some fine seventeenth-century Flemish

works, among them *Susanna Lunden*, better known as '*Le Chapeau de Paille*', by Rubens (p.133). Boxall was succeeded by Sir Frederick Burton, Director for twenty years up to 1894 and the last holder of the post to have sole responsibility for making purchases. He it was who bought Botticelli's *Venus and Mars* (p.31), the only mythological painting by the artist outside Florence. He bought widely and well, and introduced some new, then generally unfamiliar painters into the Collection, such as Vermeer (p.171).

By 1900 the outlines of the Collection were becoming set – rather dangerously so. French painting after the age of Claude and Poussin had never been much collected in England, and the Gallery went on reflecting that neglect, ignoring the eighteenth century and uneasy, if not antagonistic, about the nineteenth century, all the way from David to Post-Impressionism. Italian seventeenth-century painting, esteemed when the Gallery was founded, had dropped from favour, while Italian eighteenth-century painting – apart from Canaletto and Guardi – never interested English collectors.

Little sustained effort was made to remedy the resulting deficiencies in the Collection. Yet very great acquisitions continued to be made, sometimes through the gift, or with the help, of the National Art-Collections Fund, a private body which was created in 1903, with the aim of assisting the national collections: Velázquez's '*Rokeby Venus*' (p.186), in 1906, Holbein's *Duchess of Milan* (p.127), in 1909, Masaccio's *Virgin and Child* (p.24), in 1916, Bruegel's *Adoration of the Kings* (p.130), in 1920, Titian's *Vendramin Family* (p.76) and the '*Wilton Diptych*' (p.210) both in 1929.

In 1917 the Gallery had benefited – more perhaps than it deserved – from the bequest of Sir Hugh Lane, which included such major nineteenth-century French paintings as Manet's *Music in the Tuileries Gardens* (p.236) and Renoir's *Umbrellas* (p.242). Dissatisfied with the Trustees' lack of enthusiasm about his intentions, Lane added a codicil to his will, bequeathing his pictures to Dublin – but the codicil was unwitnessed.

Among the few major acquisitions of the 1930s, perhaps the most significant was purchase of a late masterpiece by Ingres, his portrait of Madame Moitessier (p.231). In that decade also a rare and exquisite early Italian painter, Sassetta, entered the Collection, represented by no less than seven of the panels from his life of Saint Francis (p.21).

In the early post-war years, and given impetus by arrangements with Dublin to share the Lane paintings on a regular loan basis, considerable effort went to strengthening the nineteenth-century French school. Important large-scale examples were purchased of the work of Cézanne (p.249) and Monet (p.240). Numerous other acquisitions were made. After a public appeal, and with financial support from the government, the National Art-Collections Fund presented the Leonardo Cartoon (p.56). Two masterpieces by Gainsborough, from early and from late in his career (pp.197 and 199), were bought. And the later Italian schools received some welcome attention; among other items a series of frescoes by Domenichino was acquired (p.90). Subsequent unforeseen opportunities to extend effectively representation of the nineteenth century in France and the eighteenth century in Italy came with the purchase of an example of the 'Douanier' Rousseau's work (p.246) and a ceiling painting by Tiepolo (p.101). In 1972, after a public appeal and through the generosity of a single major benefactor, the Gallery managed to retain in the country Titian's late mythology, *The Death of Actaeon* (p.77).

More recently, the Gallery's range of acquisitions has consciously been extended. Some of the more major – by no means all – are reproduced in this book, which attempts to illustrate, in a fairly small compass, the richness, the variety, the balance and the sheer quality of the Collection built up at Trafalgar Square over the years. Here are just some of the paintings to be found there, of the kind Sir George Beaumont had in mind: works of art which can truly be claimed as 'solid objects of concern to the nation'.

Early Italian Painting

Although today the early Italian Renaissance paintings form one of the greatest glories of the Collection, there was no impetus to acquire them in the first years of the Gallery's existence. At that date paintings of the period before Raphael tended to be looked on by most British connoisseurs as 'curiosities'. It was not until the appointment of Sir Charles Eastlake as the first Director in 1855 that a policy of collecting earlier Italian paintings positively began.

Paintings of the highest quality were then still available in Italy, and Eastlake was a constant traveller there. What he purchased as a result remains astonishing. He negotiated for a complete collection which included Uccello's *Battle of San Romano* (p.27). By one of the rarest of all early Italian painters, and now among the most esteemed, Piero della Francesca, he bought a major altarpiece, the *Baptism of Christ* (p.38) and the *Saint Michael* panel (p.40), which he kept in his own collection. He missed few of the great names and was not afraid to range widely, going back in time to acquire, for example, Margarito's *Virgin and Child Enthroned* (p.14).

Eastlake's successors fully shared his concern for the early Italian Renaissance, though well before the end of the nineteenth century taste had drastically revolved, bringing the painters back into repute and creating fierce competition for their work. Nevertheless, by 1900 the Collection illustrated with fine examples the development of Italian painting from Duccio onwards, including the Venetians as well as the Florentines and Sienese, taking in the less familiar Schools like that of Ferrara, and culminating in a group of paintings by Botticelli unrivalled outside Florence.

The early twentieth century saw some significant additions, among them Masaccio's *Virgin and Child* (p.24). Even now not every great Italian painter of the period is included, and a figure like Ghirlandaio, so popular with the Victorians, is surprisingly under-represented. Yet the quality and the range – from portraits to altarpieces via mythological pictures – are superb; and there can be few, if any, other public collections in the world that give such effective visual force to the words 'early Italian Renaissance painting'.

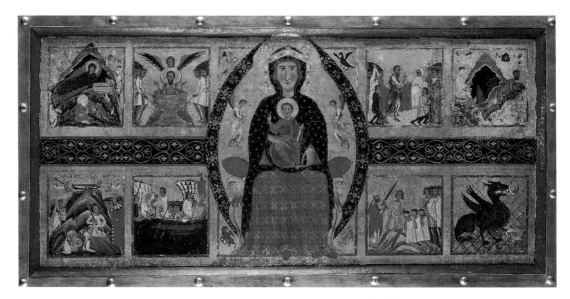

MARGARITO of Arezzo (active 1262[?])
The Virgin and Child Enthroned

'Margarito made me', this painting proudly declares, being signed thus at the
Virgin's feet. In his period the painter was a famous figure, much employed not only in
and around his native Arezzo, but also in Rome. He is one of the earliest Italian painters
to sign his work, as well as being one of the earliest painters represented in the Gallery.
This panel must have been painted for an altar and it surrounds the large-scale, majestic
figures of the Virgin and Child with smaller, vivid scenes, chiefly of saints' lives. They
include Saint Benedict rolling in brambles to conquer his lustful thoughts, and a
decorative, heraldic-like dragon disgorging quite safely Saint Margaret whom
it had previously swallowed.

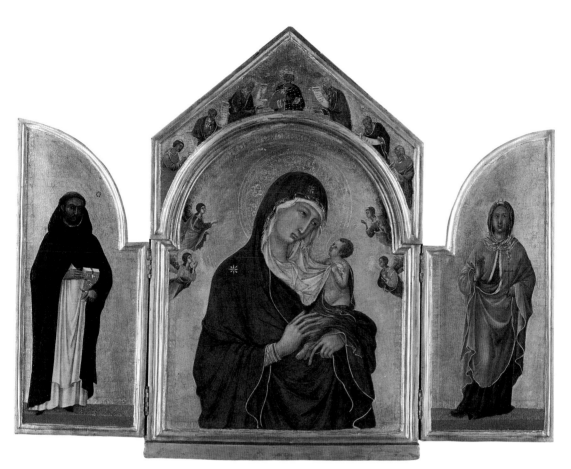

DUCCIO (active 1278, died 1319)
The Virgin and Child with Saints

This beautifully preserved small triptych can be closely associated with the first great Sienese painter, Duccio, a master of both line and colour. It was probably painted for private devotion and breathes a tender intimacy as well as sophistication. Untroubled by any urge to depict 'reality' in the sense of the normal, visible world, the painter makes of his central panel a heaven of gleaming gold, from which angels peer out to adore the deliberately far bigger image of the Virgin gazing intently at the Child she clasps. Much less solemn than Margarito's Child, this baby returns the Virgin's gaze as He plays with folds of her delicately fringed veil, and the painting seems to quiver with a double sense of movement and piety.

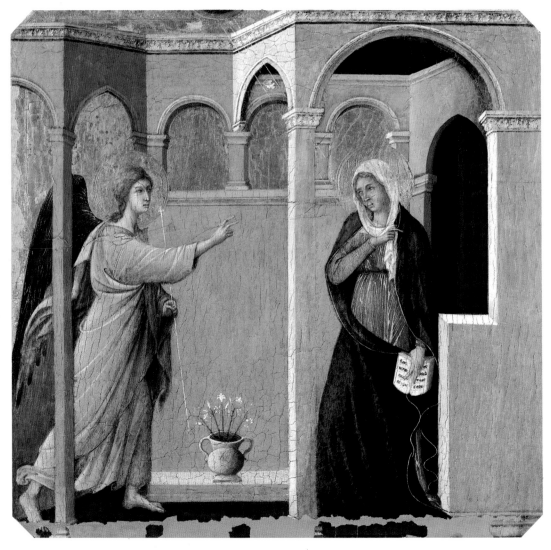

DUCCIO (active 1278, died 1319)
The Annunciation

Duccio's most famous work was the *Maestà* altarpiece, consisting of many panels on both sides, set up on the high altar of the cathedral in Siena in 1311. A few of the small panels were detached from the main group at some much later date and dispersed. The Gallery owns three of these, of which the *Annunciation* comes from the front of the altarpiece. All Duccio's gifts are concentrated in this narrative composition which shows the Angel Gabriel entering the Virgin's house at Nazareth to announce that she will give birth to the Son of God. Duccio creates a marvellous, mildly three-dimensional house of pink and grey that opens out, almost as if cut in cardboard, in a series of crisp archways, through one of which the angel enters commandingly, clad in robes of aerial tones, mauve and bright blue. For clarity of colour and line, and for sheer lucidity of narrative, this jewel of a painting challenges the greatest of later interpretations of the subject, like those by Lippo Lippi and Crivelli (pp. 29 and 54).

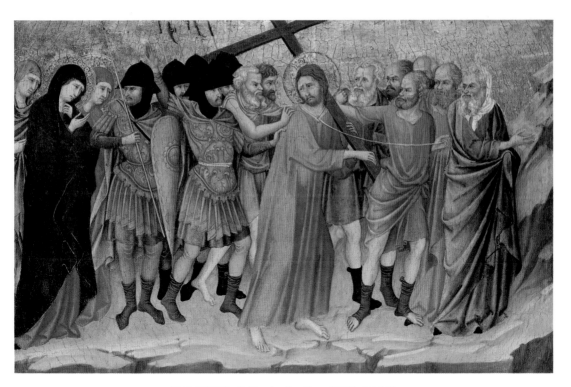

UGOLINO di Nerio (active 1317–1327)
The Way to Calvary

What Duccio had achieved was to mean much to several generations of Sienese
painters and most strongly affected the immediate one, of which Ugolino is an
outstanding representative. He worked for the church of S. Croce in Florence, painting a
typical, many-panelled altarpiece, most of it surviving though dispersed. Among the
several portions owned by the Gallery are four panels from the predella at the base of
the altarpiece, dealing with Christ's Passion and Resurrection. Ugolino tells the story
with instinctive compositional sureness, making Christ the central sad figure of an
emotional drama, pushed and tugged on towards the right by the press of soldiers,
but turning back to the group of women at the extreme left,
who include His grieving Mother.

Ascribed to GIOTTO (1266[?] –1337)
Pentecost

The great founder-figure of Florentine painting was Giotto, offering an alternative vision to that of Duccio, one far more concerned with settings of three-dimensional 'realism', occupied by figures of sculptural solidity. In this panel, one of a scattered series illustrating the Life of Christ, the painter creates a room of strong, four-square geometrical effect and firm symmetry, enclosing the Apostles but allowing us to see also the amazement of the people outside the room, as the Holy Ghost descends in tongues of fire and the Apostles begin to speak in other languages. Whether or not the painting is by Giotto himself, it is an impressively coherent, carefully thought-out visualisation of a subject quite difficult for art.

Style of ORCAGNA (Andrea di Cione) (active *c*.1343, died 1368/9)
The Adoration of the Kings

Not blazingly original but highly agreeable and easily assimilable, this *Adoration*
is in a popular Florentine style, that of the leading painter of the day, Orcagna. He
himself was apparently dead when the work began on the elaborate altarpiece from
which it comes, for the church of S. Pier Maggiore in Florence. The major portions of the
altarpiece are in the Gallery, including its large central panel of the *Coronation of the
Virgin*. The style is less rigorous than Giotto's, more decorative than 'realistic', though
this composition has lively unexpected touches – like the rather rodent-looking dog
trotting off from the central incident of homage to seek a drink from the pipe oddly
inserted amid the foreground rocks.

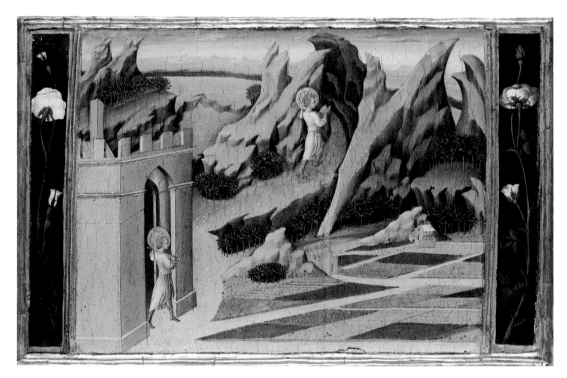

GIOVANNI di Paolo (active 1420, died 1482)
Saint John the Baptist retiring to the Desert

It is no surprise to learn that Giovanni di Paolo was a Sienese artist, living on into
the active lifetime of Leonardo da Vinci but still speaking in effect the language Duccio
had formulated so many years before. Yet 'old-fashioned' is not a word to apply to this
fresh and exquisite work of art, with its almost electric vitality of line. Saint John
positively springs up into the mountain wilderness where the jagged peaks seem to bend
and curve at his approach. With no less vitality does the painter add those natural grace-
notes of a white rose and a red, on curving, springing stems, at either side of the
composition, enhancing the wild charm and unforced sweetness of the scene.

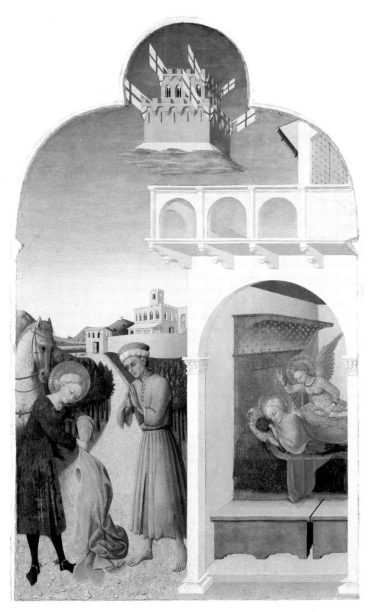

SASSETTA (Stefano di Giovanni) (1392 [?] –1450)
The Dream of Saint Francis

The composition smoothly combines two incidents from the early life of Saint Francis of Assisi and is the first in a series of eight panels dealing with the saint (seven of them in the Gallery). Prosperous and chivalrous, the youthful future saint slips off his cloak for a poor, barefoot knight whose destitution is contrasted with, for example, Saint Francis's spurred, well-shod feet. Subsequently, Saint Francis sleeps – in a heavenly bed, with its canopy of gold stars on a blue ground – while an angel shows him a vision of a floating palace, hung with banners bearing the Cross, which symbolises the Franciscan Order he will found. Sassetta is the Fra Angelico of Siena, touched artistically with awareness of Renaissance concerns about perspective and atmosphere (no longer is the sky shown as gold) and able also to call on a faith which is wonderfully untroubled and impressively sure.

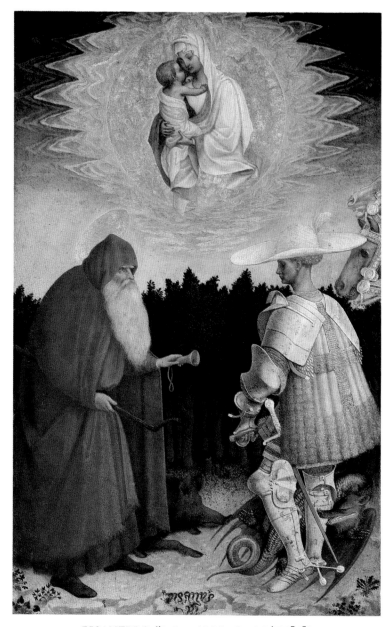

PISANELLO (living 1395, died 1455[?])
The Virgin and Child with Saints

There were great, highly individual painters all over fifteenth-century Northern
Italy, and it is one of the glories of the Gallery Collection that so many of them — some,
like Pisanello, very rare — are to be found in it. A master of line and author of sensitive
drawings, often of animals and birds, Pisanello brings all his gifts to this haunting
composition. The Virgin and Child are suspended in a medallion-like halo in the sky,
scarcely sensed by the two contrasted saints below, encountering each other on the edge
of a dark wood. The hermit saint, Saint Anthony Abbot, comes with his pig, while Saint
George, the dapper young soldier in smart armour and broad-brimmed straw hat, is
accompanied by his familiar dragon, here shown snarlingly alive and provoking Saint
Anthony's pet. As a final touch of fantasy, Pisanello has twisted the foreground
grasses into a form of signature: *pisanus/pi*(nxit).

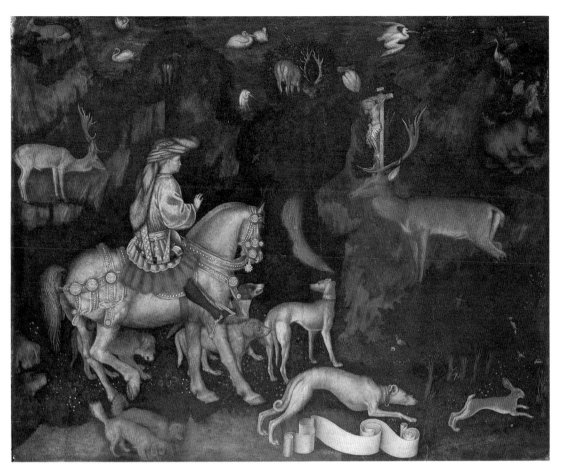

PISANELLO (living 1395, died 1455[?])
The Vision of Saint Eustace (?)

Pisanello was much employed at courts, and a courtly-religious subject, like this one, is admirably suited to his style. Out hunting, in a landscape alive with the shapes of rabbits and birds, as well as deer and hounds, the young saint (either Saint Eustace or Saint Hubert) is abruptly confronted and converted by a stag bearing between its horns the image of the Crucified Christ. The effect is very similar to that of a tapestry. Pisanello totally excludes the sky and lets the rocky woodland setting form a screen against which shine out the profiles of the saint and his richly caparisoned horse. And in this enchanted world the miracle takes place quite naturally.

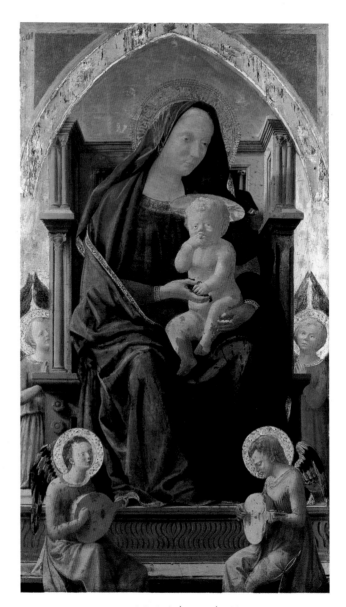

MASACCIO (1401–1427/9)
The Virgin and Child

Masaccio was almost Giotto re-born, though with a shorter lifespan. He was the Florentine painter who best understood and could best develop the achievements of Giotto – and he was not alone in Florence in his concern for visual logic, space and mass. He was part of the inspired triumvirate made up of the sculptor Donatello and the architect Brunelleschi. The Virgin's throne here, with its carefully varied columns and its classical feel, may owe something to Brunelleschi, and the monumental, bulky figure of the Virgin has a strongly sculptural quality. Masaccio's art is severe and grave. In no playful way does the solidly modelled Child on the Virgin's knee suck grapes, as literal foretaste of the Passion. This painting is the central panel of an altarpiece painted by Masaccio in 1426 for the church of S. Maria del Carmine in Pisa. It is at once youthful and mature: a manifesto of 'new' aims in art which Masaccio did not live to see develop further.

Fra ANGELICO (active 1417, died 1455)
Christ Glorified in the Court of Heaven

Fra Angelico's output consists entirely of religious paintings, and there is a certain rightness in this for he seems the embodiment of total faith, as a Dominican friar and as an artist. It was for his own friary church of S. Domenico near Fiesole, just outside Florence, that he painted the altarpiece from which comes this central predella panel. To the sounds of a massed angelic orchestra, the risen Christ is saluted as He appears glorified in heaven. Fra Angelico (in secular life Guido di Pietro) is himself perfectly at home there. He fondly delineates the variety of musical instruments – organ, cymbals, harps and violins, as well as long trumpets – played by about a hundred spangled-winged angels who joyously greet the Redeemer. And in paying tribute to Fra Angelico's piety, it should be stressed that he was no naïve amateur but a wonderfully gifted, highly sophisticated artist.

Follower of Fra ANGELICO (active 1417, died 1455)
The Rape of Helen by Paris

The author of this marvellous mid-fifteenth-century Florentine painting is not known, though it has been associated with Benozzo Gozzoli, sometime assistant to Fra Angelico and painter of the famous frescoes in the Medici chapel. The shape of the painting suggests that it was planned to decorate a piece of furniture, possibly a chest, and its classical antique subject-matter is typical of such decoration. The painter puts the story into the costume and setting of his own period. The abduction by Paris of Helen, the wife of the Greek king Menelaus, caused the outbreak of the Trojan war, but here it is conducted in the spirit of party-games played by well-dressed, well-bred people. What is so marvellous about the picture is the vivacity and sureness of the artist's vision. From the pink temple to the milky green sea, on which floats a castle-like ship, everything has a new-minted freshness and clarity, very different from normal 'reality' yet utterly convincing.

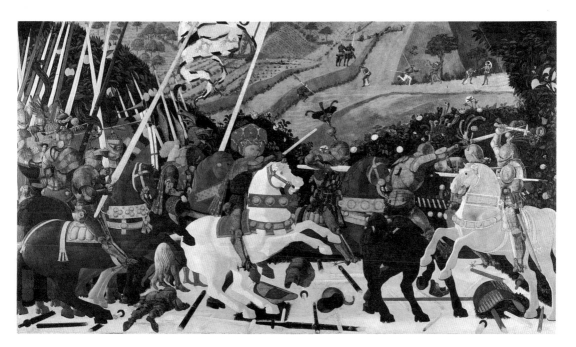

Paolo UCCELLO (*c*.1397–1475)
The Battle of San Romano

This is one of three scenes of the Battle of San Romano painted by Uccello and which hung together in the Palazzo Medici in Florence. The battle had been fought in 1432, between the Florentines and Sienese, and here the victorious Florentine commander, Niccolò Mauruzi da Tolentino, rides forward on a white horse, brandishing a baton which might almost be that of a music conductor or tournament-organiser. On a platform-stage hedged by rose-bushes and orange-trees, the battle becomes a pageant of banners, armour, prancing horses, and visored knights, exchanging blows but spilling no blood. Niccolò's own page quite safely rides into the affray bare-headed, holding a helmet like a lacquered waste-paper basket. Uccello delights in delineating its contours – and indeed all the contours, so that the floor, with its crisscross of vertical and horizontal lines (made up of lances), takes on all the abstract quality of a Mondrian.

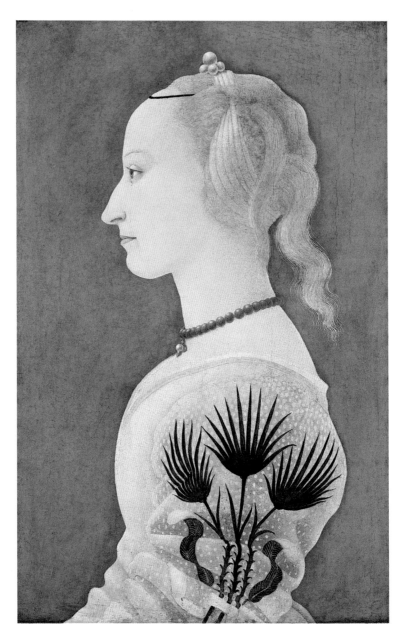

Alesso BALDOVINETTI (*c*.1426–1499)
A Lady in Yellow

Renaissance interest in humanity fostered the development of portrait painting –
and not solely of famous or important people. The portrait in profile was a type
particularly developed in Florence, influenced no doubt by classical coins and medals
but also offering opportunities for incisive draughtsmanship which remained
characteristic of Florentine art. The female portrait was something of a novelty before
the fifteenth century, and it too was fostered in Florence. Baldovinetti tends to be
overshadowed by his great contemporaries like Uccello, but here he displays a strong
sense of design. Complementing the sitter's blond hair with a dress of yellow – an
unusual colour for costume – he gives her a refined, palely delicate air and adds a
further stamp of individuality in the device of the three spiky black palms that writhe
like wrought-iron rather than lie along her embroidered sleeve.

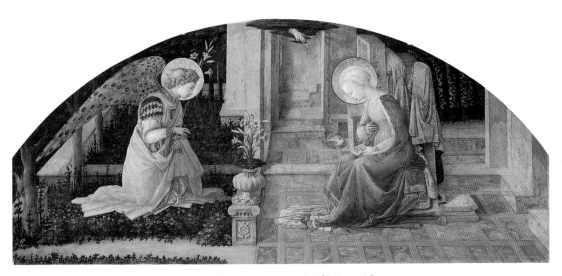

Fra Filippo LIPPI (*c.*1406[?]–1469)
The Annunciation

The Medici family must have commissioned this painting, perhaps in connection with the hoped-for birth of an heir, because on the low balustrade between the Virgin's courtyard and her garden, under the pot of lilies, the painter depicts a favourite Medici emblem, of three feathers in a diamond ring. The painting's later provenance is also of interest to the Gallery, since it entered the Collection as the gift of the first Director, Sir Charles Eastlake – a nice gesture to have been able to make. The Victorians probably esteemed the painter more highly than do many scholars today but this is a deservedly popular and beautiful work. Lippi divides the composition between the tiled interior of the Virgin's house (with a glimpse of her bed) and the tree-lined garden outside, and makes charming the encounter of two worlds. The haloed profile heads of the Virgin and the Angel Gabriel complement each other as they slightly bow at meeting, she humbly from within her domestic environment and he – an exotic, almost hovering presence borne on peacock wings – half-shyly, arrived from heaven to hail the future mother of the Saviour.

Sandro BOTTICELLI (*c*.1445 – 1510)
Portrait of a Young Man

After Baldovinetti's typical profile portrait (p.28), there is a distinct shock in the impact of Botticelli's full-face portrayal of a young man, gazing directly if impassively at the spectator. Supreme master of line though he is, Botticelli seems equally concerned here with modelling the planes of the face out of light and shadow, so that the head juts convincingly forward, increasing the three-dimensional effect. Line is re-asserted in the drawing of the eyelids, while the hair is made into a rippling pattern all the artist's own. The result is partly real and partly ideal, the portrait of an actual Florentine, one feels, but merging under Botticelli's touch with the angel faces the painter likes to depict in religious pictures pressing about the Madonna.

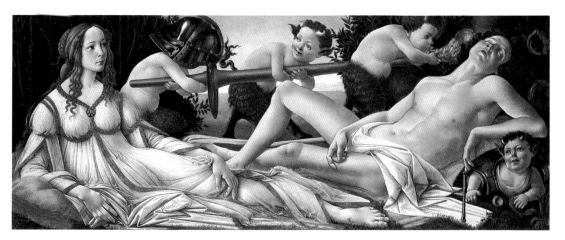

Sandro BOTTICELLI (*c*.1445–1510)
Venus and Mars

This is the sole mythological painting by Botticelli to be found outside Italy. Its presence in the Collection, along with other rare paintings by him, indicates the pronounced English taste in the nineteenth century for the artist, which contributed to a revival of interest in him and his work. With Botticelli, pagan subject-matter is treated with a seriousness previously reserved for Christian themes. His goddess Venus is not only beautiful but felt to be a great power, as she reclines elegantly beside the sea from which she once rose, wrapped in a white dress that ripples and eddies in countless fluid folds. Perhaps at her bidding the baby satyrs, frolicking with the naked god's armour, will wake him from his deep slumber, and love will again conquer war.

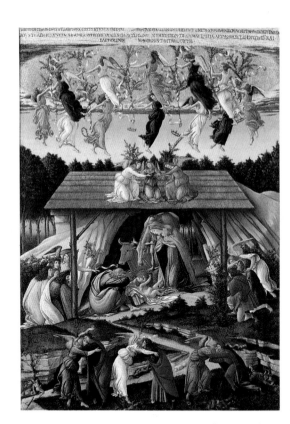
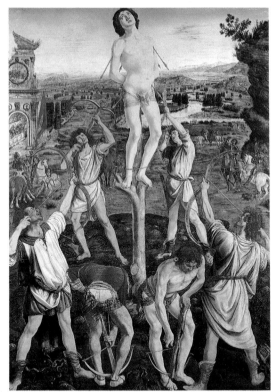

Sandro BOTTICELLI (*c*.1445–1510)
Mystic Nativity

Botticelli imprints on his paintings a sense of personality so marked that it can verge on the disturbing. His thought is always original – never more so than in this unique interpretation of a familiar subject. What did it really mean, he seems to ask, when God was born in human form, and angels rejoiced in heaven, singing of peace on earth to men of good will? He asks the question with special urgency, for he was painting his picture around 1500 'in the troubles of Italy', as his inscription in Greek states at the top of the painting. Christ's Birth is seen as it were cosmically. In a heaven of molten gold, interlinked angels dance amid laurel sprays and crowns. On earth, three angels embrace three mortals, and others guide the groups of shepherds and kings, all laurel-crowned and depicted in a very similar way, to worship the Child, Himself the Prince of Peace.

Antonio and Piero del POLLAIUOLO (*c*.1432–1498, *c*.1441–*c*.1496)
The Martyrdom of Saint Sebastian

Even in fifteenth-century Renaissance Florence, the size of this altarpiece – over nine feet high – was imposing. The Pollaiuolo brothers may have collaborated on it. It was painted for the Oratory of Saint Sebastian attached to the church of the SS. Annunziata and commissioned by a member of the Pucci family. An old tradition records that a member of another leading Florentine family was the model for the saint. The landscape is certainly modelled on that of the Arno valley around Florence, and the bodies of the archers are obviously studied from life. The painting asserts a standard of almost scientific naturalism and realism quite alien to Botticelli, anticipating the approach of Leonardo da Vinci, in his early twenties when the altarpiece was painted.

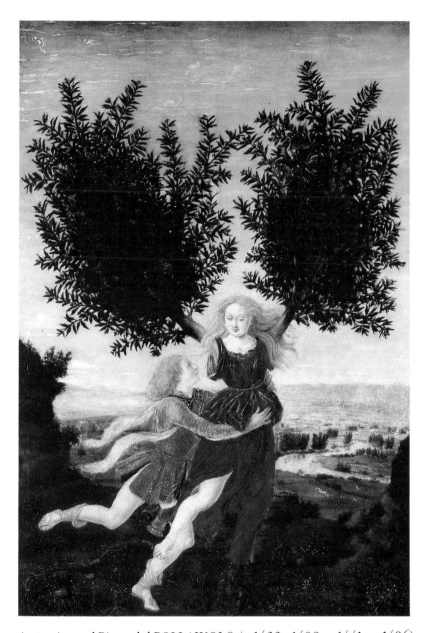

Antonio and Piero del POLLAIUOLO (*c*.1432–1498, *c*.1441–*c*.1496)
Apollo and Daphne

The scale of this painting – just over a foot high – abruptly contrasts with that of the *Martyrdom of Saint Sebastian*. And despite the attribution above, it is hard to believe that the two artists – brothers though they were – could have worked on it together. Quality and commonsense suggest it is likely to be by Antonio, the more gifted of the two, a sculptor and goldsmith, who could give to figures nervous energy of the kind embodied here in the athletic Apollo and the rapidly metamorphosing Daphne, turning into a laurel-tree even as the god tries to grasp her body. The vivid poetry of the scene is enhanced by its being set in the landscape of the painter's native Tuscany, and Apollo himself lives again in fifteenth-century Florentine dress.

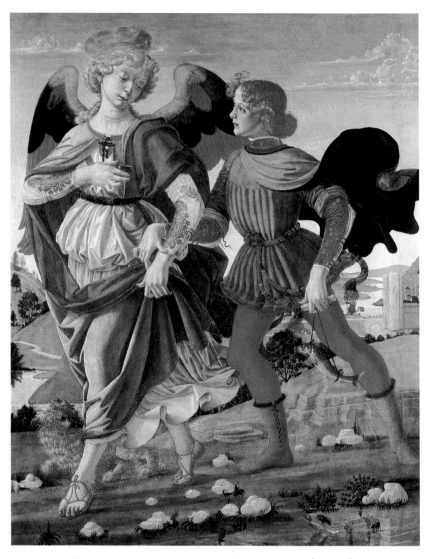

Follower of Andrea del VERROCCHIO (*c.* 1435–1488)
Tobias and the Angel

For many people this rightly popular painting virtually *is* the National Gallery, where it has hung for well over a century. The fact that its author is unknown matters not in the least and certainly does not hinder enjoyment of its mastery. It is loosely associated with the great Florentine artist Verrocchio, best known as a sculptor. The painting speaks of an artistic climate of absolute certitude and optimism. The young Tobias takes the angel's arm with trusting faith – and both the boy and the not-to-be overlooked woolly dog have to step out to keep pace with the angelic velocity so well conveyed. The story is a happy one. Tobias is returning home with the fish whose gall will cure the blindness of his father, Tobit. And beyond the story are wider implications: that on life's journey men should have faith, put their trust in angel guardians and they too will reach their heavenly home.

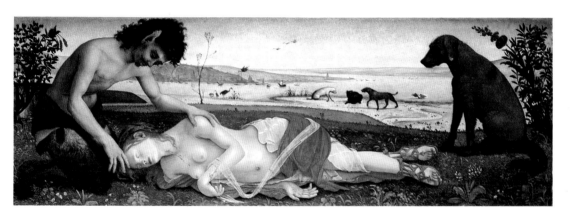

PIERO di Cosimo (*c.*1462–after 1515)
A Mythological Subject

By the salty-looking shore of a chill estuary a woman lies dying, or perhaps
already dead, wounded in the throat. At her feet and head crouch a dog and a shaggy
faun; the dog looks on mournfully as the faun tends the woman yet seems powerless to
do more than grieve. Exactly what classical story is illustrated remains unclear. What is
clear is Piero di Cosimo's profound empathy with wild creatures and lonely places. He
gives poignancy to death in this Arcadia of dogs and birds, where grassy earth forms the
woman's bier. It is not surprising that the painter of this picture once devised for the
carnival in Florence a fantastic Car of Death, and that he himself was considered an
eccentric, with his fears about dying, his fondness for animals and his
indifference to worldly success.

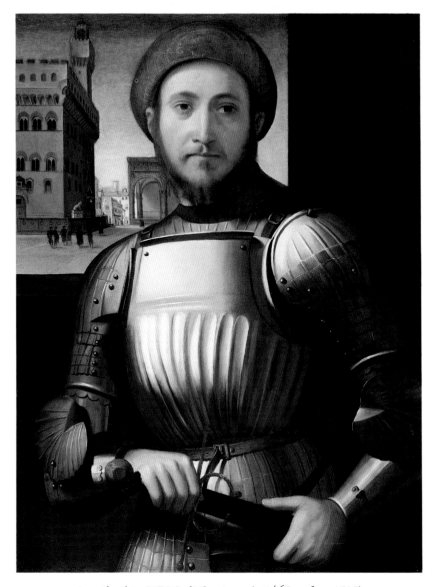

Ascribed to PIERO di Cosimo (*c*.1462–after 1515)
A Man in Armour

Both the sitter and the painter of this fascinating portrait are unknown, and
perhaps it is through the wistful, doggy look of the sitter that the painting became
associated with Piero di Cosimo. The view in the background identifies the setting as
Florence and shows the seat of government, the Palazzo della Signoria, with
Michelangelo's famous statue of David, set up in 1504. The sitter broods almost Hamlet-
like, one hand on his sword-hilt as though hesitant to draw it. Yet possibly
he stands guard over Florence at the period – when the ruling Medici family
was banished – incarnating steadfastness of purpose and a determination
to defend the republic.

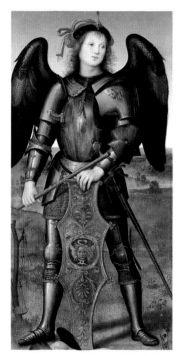

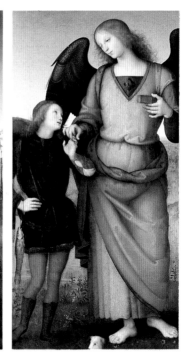

Pietro PERUGINO (living 1469, died 1523)
The Virgin and Child with Saints Michael and Raphael

These three panels are part of an altarpiece commissioned for the Certosa at Pavia from a painter more usually associated with the city from which he gets his name, Perugia. Prolific and competent, Perugino was a success in his lifetime and with posterity, at least up to the nineteenth century. He was one of the first early Italian Renaissance painters to be represented in the Gallery (these panels being bought in 1856). Today, his calm, typically Umbrian style, a little bland perhaps for all its accomplishment, is less in favour. In these gently luminous compositions, especially that of Saint Michael, he achieves a sense of balance which seems to echo his own position as an artist, the pupil of Piero della Francesca and traditionally the master of Raphael.

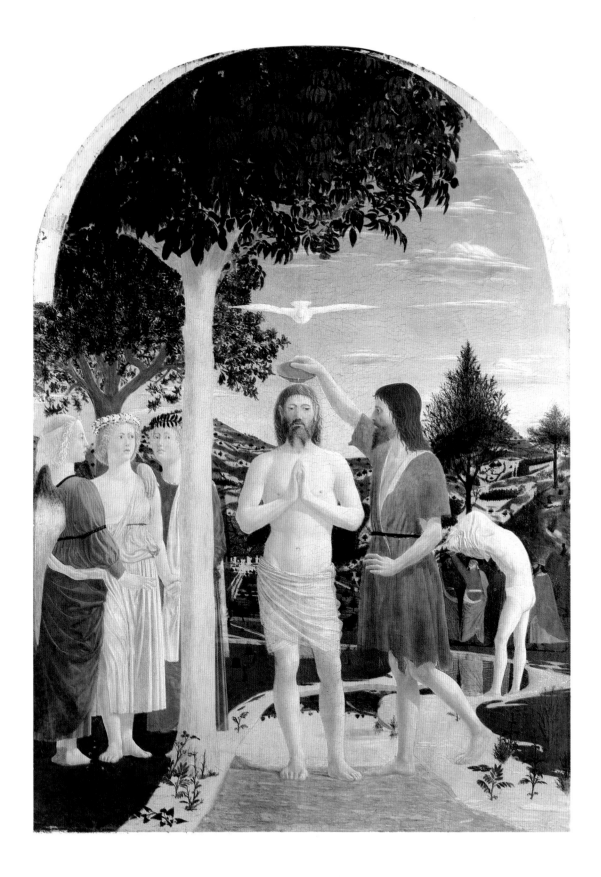

PIERO della Francesca (active 1439, died 1492)
The Baptism of Christ

Piero della Francesca painted this altarpiece for the priory of Saint John the Baptist in his native town of Sansepolcro in Umbria, and the town can be seen in the background. Although the painting is not dated, it is usually assumed to be an early work by him. Early or not, it reveals Piero's originality as a painter, in concept and in execution. Its pale tonality is almost that of fresco. The figures have an ideal, statuesque quality; their flesh is compacted, it seems, of thousands of tiny particles, like motes of atmosphere compressed and made visible. And everything in the painting is felt to be the product of profound, meditated thought.

At once buried in the composition — and yet immediately apparent — is the geometry of triangles, horizontals and verticals, and nicely calculated intervals, which gives the composition its structure and invests the scene with intense timelessness. The man in the middle distance seems fixed in the action — scrupulously observed — of removing his shirt. The angels take root like the tree beside which they stand, and over Christ's head water forever pours from the pure oval of the bowl held by the Baptist, while in the ether above, hardly more embodied than the cloud-shapes that float parallel, the Dove hovers whitely with outstretched wings.

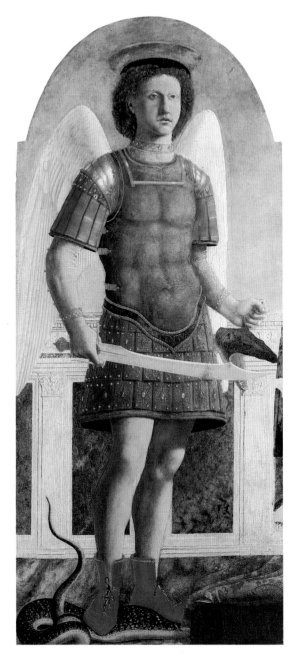

PIERO della Francesca (active 1439, died 1492)
Saint Michael

It was, again, for his own town of Sansepolcro that Piero painted a now dispersed, partly destroyed altarpiece from which this panel comes. Today so much emphasis is laid on the painter's intellect and his mathematical interest that it is easy to underplay his vivid response to textures and his sensitive technique, in which paint thins and thickens as if responding to the play of light over surfaces. Here it embraces with sensuous effect all the Archangel's various accoutrements: from his bristling laurel crown to his soft red leather boots, taking in the jewelled skirt of his cuirass and not failing to record the coral buttons that stud like minute pebbles the rippling current of his near-transparent shirt sleeves.

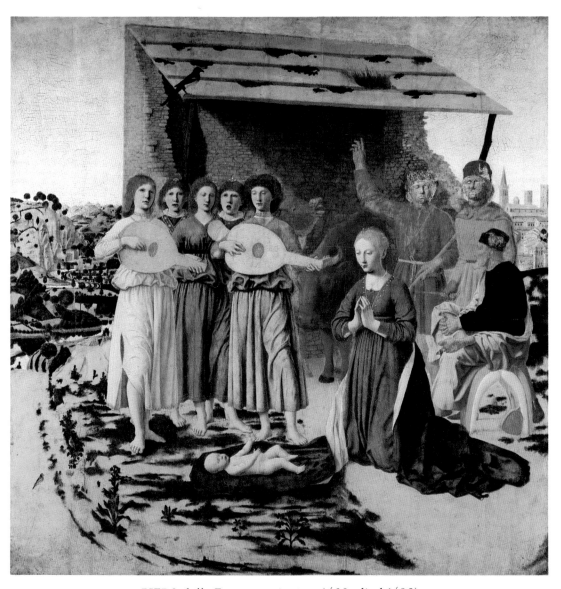

PIERO della Francesca (active 1439, died 1492)
The Nativity

Damaged though this painting is in places, it is one of the painter's most impressive and ambitious works, assumed on stylistic grounds to be done late in his career. That the scene is set on the morning of Christ's Nativity seems central to Piero's concept, infusing it with cool, clear tones. In one way, everything looks matter-of-fact, stripped of ostensible 'religious' trappings — no haloes, for example, and no wings for the angels. Each person and indeed each shape — even the saddle on which Saint Joseph sits — has, however, more than natural gravity. Nowhere is that more impressive than in the still figure of the Virgin herself, richly if discreetly clad for such humble surroundings, her blue robes and blond head modelled with a subtlety and feeling for light at its coolest that hardly enter painting again until Vermeer.

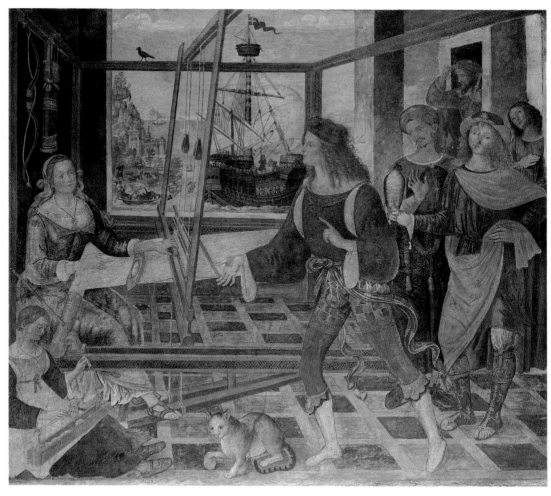

PINTORICCHIO (active 1482, died 1513)
Scenes from the Odyssey

Somewhat underestimated as an artist nowadays, Pintoricchio was a leading
decorative painter of his day, summoned to work for the Borgia Pope in Rome and
famous for the frescoes in the Piccolomini Library of the cathedral in Siena. It was for a
palace there that he frescoed this scene, the chief portion of which shows Penelope at
her loom and her son Telemachus hastening in, returned from seeking his father
Odysseus. Pintoricchio makes effective use of the lines of the loom, helping to frame the
ship in the background, and supplies plenty of delightful details – like the cat playing
with a ball of yarn. The result is less Homer's *Odyssey* than an appealing, slightly
enhanced view of domestic life in an upper-class household in Renaissance Italy.

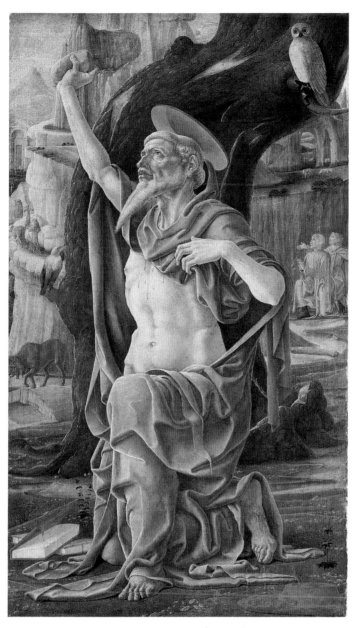

Cosimo TURA (*c.*1431–1495)
Saint Jerome

By the fifteenth century there flourished in Italy numerous small centres of
painting marked by very distinct styles and fostering painters of highly original talent.
Ferrara was one of the most individual of these centres, a city ruled by the Este family,
enlightened artistic patrons. Tura was the outstanding painter there, and the *Saint
Jerome* is typical of his fervid, restless, almost hallucinatory and partly non-naturalistic
art. Other painters might depict Saint Jerome in a green and pleasant wilderness, but
Tura loves the challenge and the opportunity of depicting a truly arid desert of stone and
stony forms, with a semi-petrified tree-trunk bent into a strange shape and made
stranger by the staring owl perched on its sole branch. Draperies like tinfoil encase the
saint, writhing about him in folds with a life of their own. Tura's vision is intensely
personal, and it is hard not to feel that in Ferrara he had the ideal environment.

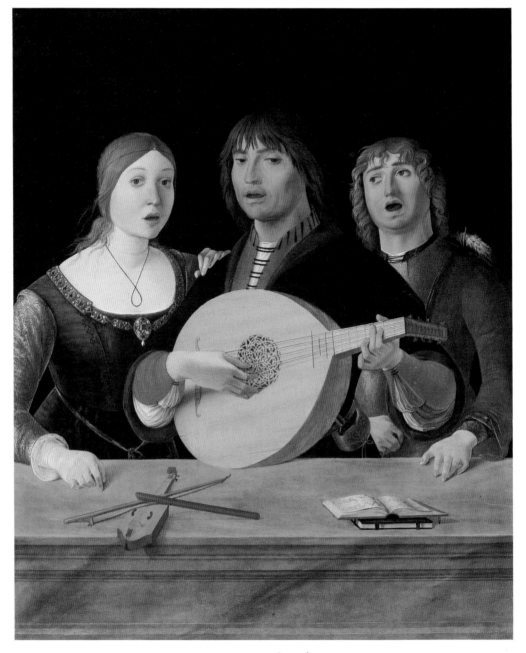

Lorenzo COSTA (1459/60–1535)
A Concert

Subjects for painting diversified during the fifteenth century, and virtually a new
one is introduced by the 'concert' – not of angels at Christ's Birth but performed by
ordinary men and women shown assembled, as in real life, for private music-making.
The Ferrarese painter Costa paints what is probably one of the earliest secular concert-
scenes in Italian art. A trio of people is grouped together and observed with typical
Ferrarese precision – down to the exquisitely fretted rose of the lute played by the
central man and the extent to which each performer's mouth opens in singing his
or her part. Music easily becomes a metaphor for general harmony, and from
this concert exudes an air of civilised concord.

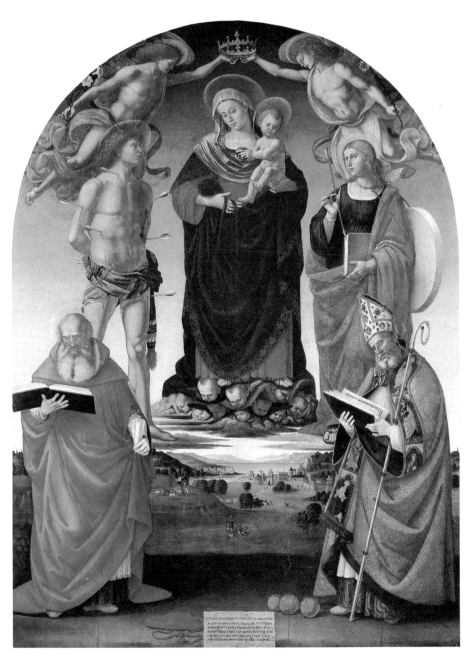

Luca SIGNORELLI (1441[?] −1523)
The Virgin and Child with Saints

Signorelli is yet another example of a painter famous in his lifetime but now
somewhat underestimated, despite his Last Judgement frescoes in the cathedral in
Orvieto. This is one of several large altarpieces by him bought by the Gallery around the
end of the nineteenth century, and it has the additional interest of having been painted
for a French physician, Lodovicus de Rutenis (Rodez), who was Signorelli's family
doctor. Signorelli's studies of the nude were to be admired by Michelangelo, and here the
painter takes the opportunity of Saint Sebastian and the angels flying overhead to depict
the male body. The female saint is Saint Christina, to whom de Rutenis had a special
devotion, having built a chapel dedicated to her, where this painting originally hung.

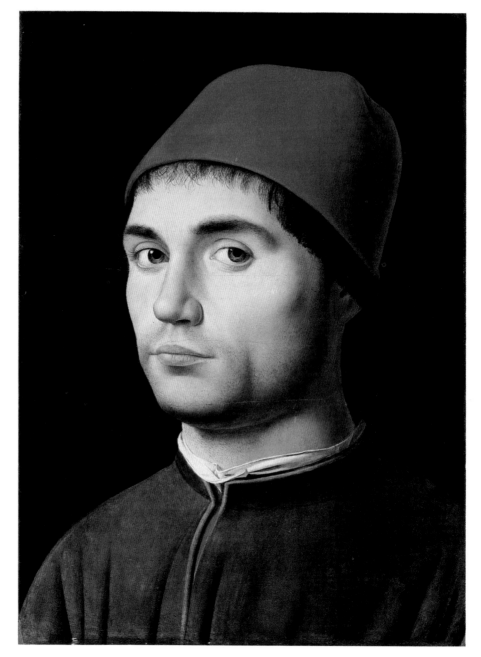

ANTONELLO da Messina (active 1456, died 1479)
Portrait of a Man

In its quiet way, this is one of the most compelling and memorable of all the
portraits in the Gallery, partly because of its flawless technique, which records the sitter
in such close-up, minute detail, down to the stubble covering his cheeks and throat. No
less precisely rendered are the few folds of white linen at his neck and the satisfying bulk
of his berry-red cap. Antonello was certainly aware of Netherlandish achievements, and
to some extent this portrait is like an Italian reworking of van Eyck's *Man in a Turban*
(p.106). Above all, the unflinching scrutiny conveyed in the glassy, large-pupilled eyes
has about it something so probing as to encourage, however misguidedly,
thoughts that this is the painter's self portrait.

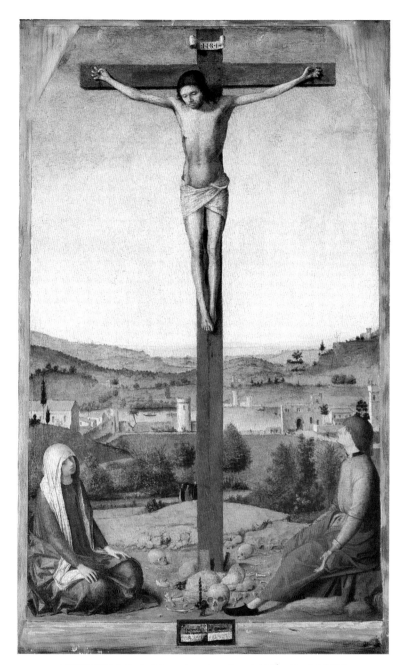

ANTONELLO da Messina (active 1456, died 1479)
Christ Crucified

Antonello is a slightly mysterious artist, though one of great originality and power. Out of a native Southern temperament and an artistic response to Northern, chiefly Netherlandish painting (including Jan van Eyck's), he created a style that is rigorous yet far from inhuman. He invests the scene of Christ Crucified with deep poignancy and a sense of desolation extending beyond the eloquently grieving Saint John and the Virgin huddled on the ground, until the whole world seems to be in mourning. Golgotha as the 'place of the skulls' is rendered starkly, and the wood of the tall Cross on which the thin, exhausted Christ has been nailed is drenched with His blood.

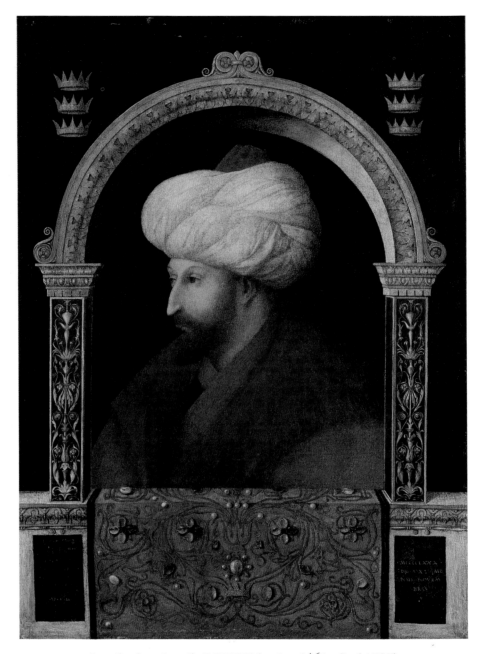

Ascribed to Gentile BELLINI (active 1460, died 1507)
The Sultan Mehmet II

In 1453 Constantinople fell to the forces of the Ottoman Sultan Mehmet II and a new era began for the city. Renamed Istanbul, it became the centre of the expanding Ottoman empire. Mehmet II is the first of the Sultans of whom authentic likenesses exist, and it is not unreasonable to associate this sadly repainted yet impressive image with the Venetian painter Gentile Bellini (the brother of Giovanni) who certainly worked in Istanbul. With Western technique and attitude, the painter manages to convey the sense of an exotic, shrewd and powerful ruler – and the sole Sultan ever honoured with the title 'the Conqueror'.

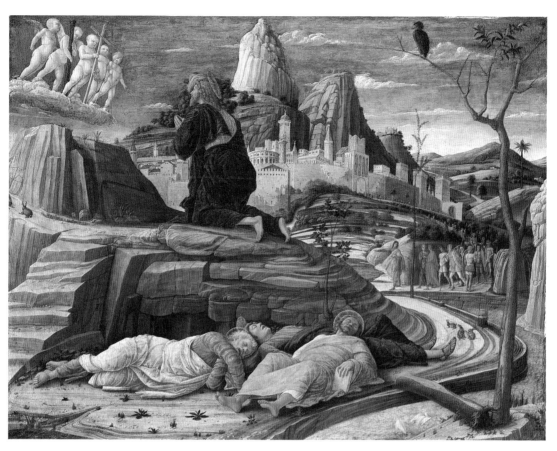

Andrea MANTEGNA (*c.*1430/1–1506)
The Agony in the Garden

Mantegna seems to work not so much in paint as in metal, and this richly inventive composition, where every rift is loaded with artistic ore, might have been executed not with a brush but with an engraver's tool. An essentially linear precision carves out the tall, sugar-loaf peaks of the distant mountains as much as the fissures of rock and foreground blades of grass that make up a very dry garden of Gethsemane for Christ and His sleeping Disciples. Even the clouds might be chips of stone or steel. Mantegna's vision is all-embracing. He conjures up a magnificent prospect of Jerusalem as an antique city, records the inexorable line of Christ's advancing captors, and makes visually inexorable also Christ's forthcoming Passion, seen in an angelic vision in which the foremost angel displays the Cross.

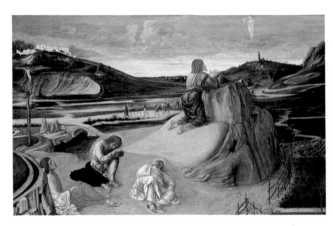

Giovanni BELLINI (active *c*.1459, died 1516)
The Agony in the Garden

Bellini was the brother-in-law of Mantegna, and it is hardly possible to avoid comparing the two painters' treatment of this subject, since both paintings belong to the Collection. Mantegna seems anyway to have influenced Bellini, and here Bellini's composition suggests distinct awareness of Mantegna's (p.49). Yet Mantegna's steady illumination has been replaced by a subtle, half-shadowy atmosphere, marvellously affecting the tone of the whole incident. Light is slowly seeping back into the green landscape as morning comes and Christ sees floating before Him a single, barely substantial child, holding the cup of His Passion which will not pass from Him.

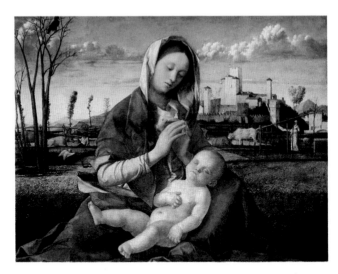

Giovanni BELLINI (active *c*.1459, died 1516)
The Madonna of the Meadow

Although the present title is probably of no great age or art-historical authenticity, it aptly penetrates to the heart of this painting. The Madonna is shown seated on the soil, a true Madonna of Humility, praying over her sleeping, naked Son, while around them goes on the life of the fields. The indications are that this is a day of early spring, and the atmosphere is at once keen and sensuous, with light washing around each object. The sleeping Child's pose may anticipate that of the dead Christ but the painting seems no less to hint at renewal, natural and divine, with a reminder that Christ's Death was followed by His Resurrection.

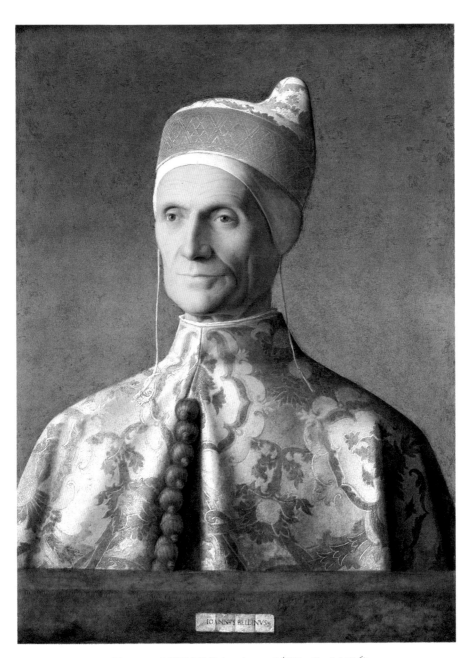

Giovanni BELLINI (active *c*.1459, died 1516)
Doge Leonardo Loredan

'Fearless, faithful, patient, impenetrable, implacable', wrote Ruskin in praise of
the Venetian senate in its great Renaissance days, and he might almost have been
describing this portrait of Leonardo Loredan as Doge, titular head of the Venetian state.
Figurehead the Doge might be, but no figurehead was ever more proudly modelled to
convey the essence of wise, firm and benevolent government. The man is virtually
mummified, swathed in stiff, embroidered robes, the swelling nut-like buttons of which
help to reinforce the message of dignity and undeviating purpose. Yet the portrait,
official commission though it doubtless was, is no dead or routine piece of recording. It
comes alive artistically through the painter's magic manipulation of light. Even while
deifying the Doge, Bellini subtly subordinates him to his own painterly ends.

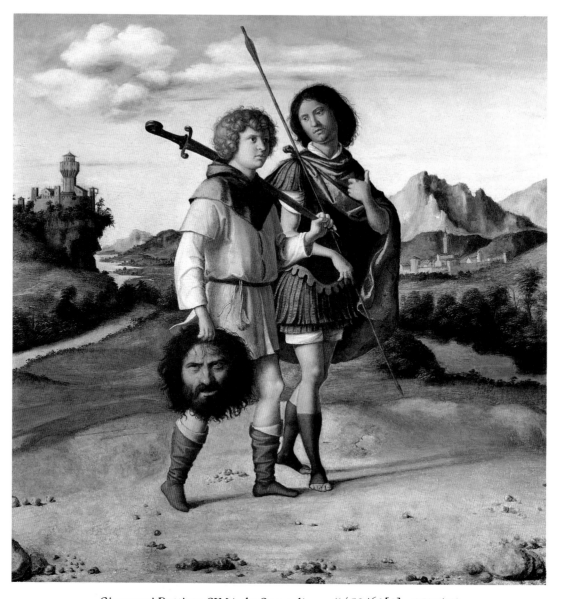

Giovanni Battista CIMA da Conegliano (1459/60[?] –1517/18)
David and Jonathan

While David, as shepherd boy, slayer of the giant Goliath and King of Israel, is a common subject in painting at all periods, he is rarely depicted as here, in the company of his friend Jonathan, son of King Saul. Cima seems to enjoy contrasting the slightly pudgy, rustic David, matter-of-factly toting Goliath's head, like a surreal carrier-bag, with the taller, thinner and more soldierly Jonathan, whose glance is both affectionate and admiring. Cima, active in Venice but born in the small hill-town of Conegliano, rarely fails to introduce some landscape touches into his paintings, and here the two friends trudge contentedly through a typical North Italian countryside.

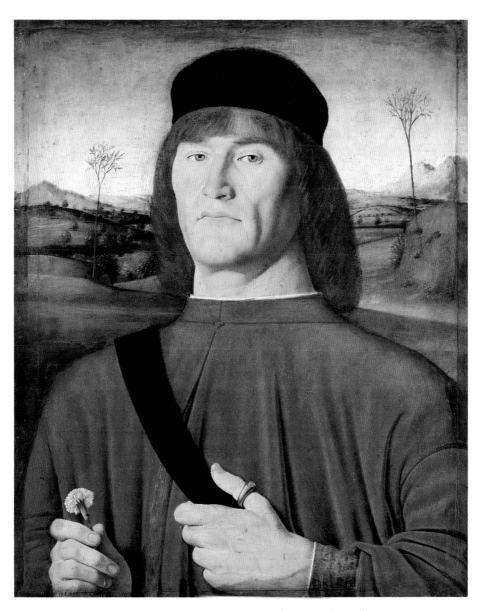

Andrea SOLARI (active by 1495, died 1524)
A Man with a Pink

The occasional outstanding success by a rather minor painter is probably a more disconcerting phenomenon than the occasional failure by a great artist. Solari is not among the great artists, though perfectly competent if rarely very individual. He seems to have fallen under a variety of influences, above all that of Leonardo da Vinci. Earlier, Venetian painting had influenced him, and the result here – thanks partly to the features of the sitter – is a pungent piece of characterisation and a fine painting. The sitter's physiognomy, not least the line of his mouth and his pale blue eyes, matching the blue gem set in his ring, suggests someone likely to brandish an object more threatening than a flower – but that may malign him. What Solari has seized is the strong physical impact of a personality.

Carlo CRIVELLI (active 1457–1493)
The Annunciation

For many painters living in the region around Venice, the city was an obvious attraction as the place to go and work in. It seems only one of Crivelli's idiosyncracies that he, Venetian by birth, should have chosen to work away from Venice. Yet he would not have received the commission for this particular painting had he not been living in the town of Ascoli Piceno, in the Marches of Italy. It was on the Feast of the Annunciation in 1482 that Ascoli learnt that Pope Sixtus IV had granted certain rights of self-government to its citizens. To commemorate the occasion, this *Annunciation* was painted four years later. The bishop-saint who, unusually, accompanies the angel, is Saint Emidius, patron of Ascoli, itself depicted in the model he holds. Hardly less remarkable is the full urban realisation of the scene, with its sumptuous architecture and accessories (including scattered fruit, pots of flowers and a peacock). It all runs the risk of excess, but Crivelli's taut line controls each object and figure, and by fierce concentration he manages to retain – amid such diversity – total coherence.

Italian Painting 1500–1600

Supreme sixteenth-century Italian painters like Titian and Raphael never lost their fame, and from its earliest years the Gallery had or rapidly acquired fine examples of their work. Titian's superbly confident, colourful *Bacchus and Ariadne* (p.75) was bought as early as 1826. In the same year Veronese's *Consecration of Saint Nicholas* (p.84) and Parmigianino's altarpiece (p.67), a rare item, were presented to the Collection. Correggio was another esteemed name, and his art was soon represented by paintings of very different scale and theme, from a small religious work, the *Madonna of the Basket*, to alluring mythology, the *'School of Love'* (p.66). A more difficult painter to represent was Tintoretto, but it was not necessary to wait for Ruskin to 'discover' him; already, with the Holwell Carr Bequest of 1831, came the small yet typically energetic and brilliantly original *Saint George and the Dragon* (p.80).

Yet the sixteenth century in Italy was not solely a period of the established, traditionally great artistic figures. Later painters of the century had suffered from being overshadowed or treated as inevitably lesser. And it is remarkable that the Gallery was able by the 1860s to demonstrate some of these painters' achievements. A painting by Lotto was first bought in 1862, as was *'The Tailor'* (p.82), the most famous painting by Moroni outside Italy. Moretto's highly wrought *Portrait of a Young Man* (p.82), like a soulful Holbein, had been acquired even earlier. With the additions of later purchases and gifts, the School of Brescia is now strongly represented in the Collection.

Two very great artists presented great problems, not least through sheer rarity: Leonardo da Vinci and Michelangelo. In 1868 the opportunity was wisely taken to buy the *Entombment* (p.58), a panel of masterly authority which can reasonably be ascribed to Michelangelo. The School of Milan was popular in Victorian times, and works by pupils of Leonardo entered the Collection well before our version of the *'Virgin of the Rocks'* (p.57). Yet for many people the heart of Leonardo's art is summed up by the large cartoon of the *Virgin and Child with Saints Anne and John the Baptist* (p.56), presented by the National Art-Collections Fund in 1962.

In more recent times the Gallery has strengthened its representation of this period, notably of Parmigianino and Pontormo. And over the years since Titian's *Bacchus and Ariadne* was first bought, the range of his art, ever-evolving in a long career, has been illustrated by major acquisitions. In 1929 the unique group portrait of the *Vendramin Family* (p.76), a masterpiece of the artist's maturity, entered the Collection. In 1972, after much striving under threat of export, and a public appeal, Titian's very late mythology, the *Death of Actaeon* (p.77), was purchased. Perhaps no sixteenth-century Italian painter is shown better at the Gallery than Titian. He is the master oil-painter of all time, so the distinction is deserved.

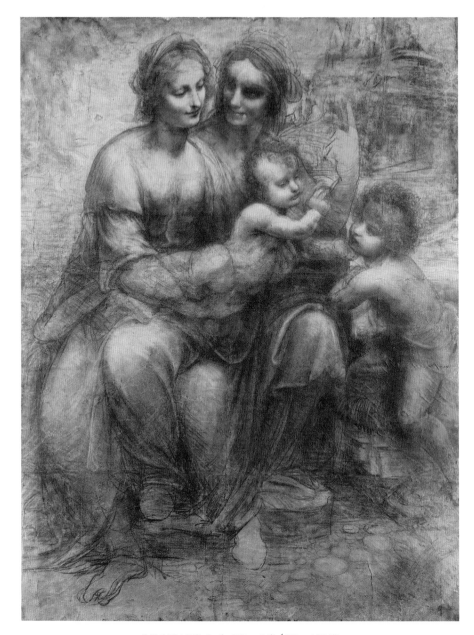

LEONARDO da Vinci (1452–1519)
The Virgin and Child with Saints Anne and John the Baptist

This large-scale drawing, made up of several sheets of paper, is presumably the preparatory drawing or 'cartoon' for a painting never executed by Leonardo. It is not pricked for transfer, as such cartoons normally were. Older than Michelangelo and Raphael, Leonardo takes chronological priority in the formation of a new 'High Renaissance' style of tremendous accomplishment, exciting contemporaries to recognise the artist as no mere craftsman but a creative genius. Leonardo's art is intensely mysterious and bewitching. The two smiling maternal women, almost merging into a single figure, seem moulded out of more than human clay, lifelike yet stranger than people in ordinary life, uncanny in their grace and their apartness. Something divine, it seems, is here, and the upraised, pointing finger of Saint Anne testifies to the solemnity of the scene.

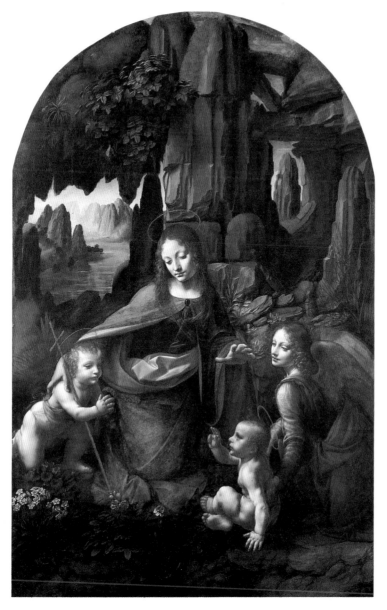

LEONARDO da Vinci (1452–1519)
'The Virgin of the Rocks'

With his myriad gifts, as musician, mathematician and scientist as well as painter, it is not surprising that Leonardo tended to leave his paintings unfinished. What is surprising is that he should have been responsible for two paintings as similar in composition as this one and the version in the Louvre. The Louvre version is entirely by him, which is more than can be said with certainty about the London painting, where pupils may have assisted him. Yet it remains a haunting work. In a grotto more fantastic than any devised by Tura (compare p.43), and yet made to look naturalistic, the Virgin and the other figures are pale but fitting inhabitants, hidden in some secret place of the earth and isolated by the sunken river that winds among the jagged cones of rocks. The whole universe seems to have been re-ordered by Leonardo, made more wonderful but also more alien, and it is easy to forget that this composition is intended as a Christian religious one.

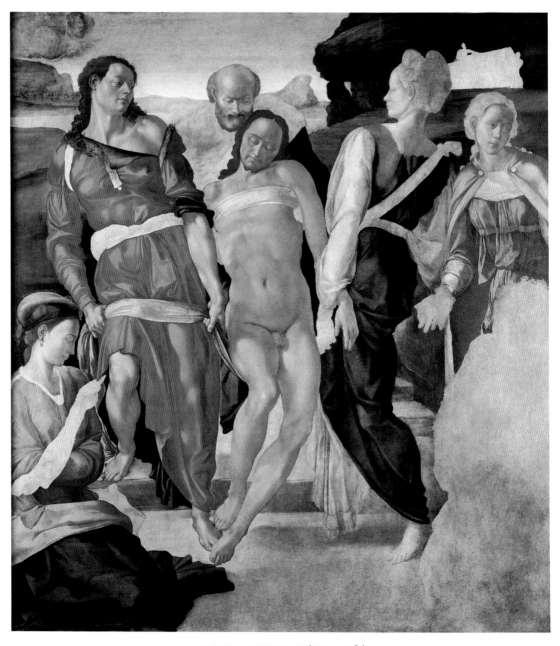

MICHELANGELO (1475–1564)
The Entombment

Few easel paintings exist by, or convincingly attributed to, Michelangelo.
Although unfinished and not documented, this panel has long been attributed to him,
and it is easy to see why. The concept of Christ, like a naked, defeated athlete, being
borne backwards – deep into the picture area – and up steps to a tomb, barely blocked
in at the top right, has great originality. The sculptural feel of the figures is strong,
notably in the pose and muscular energy of the red-clad man at the left of Christ. The
painter evinces little concern for landscape or for the setting; his interest is patently in
the form of bodies in action and in repose. The result is powerful, even in its unfinished
state, and certainly breathes the ethos of Michelangelo.

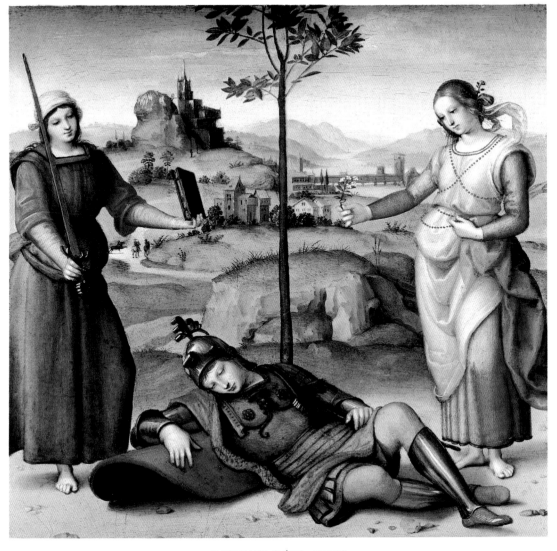

RAPHAEL (1483–1520)
An Allegory

Youngest of the traditional trio of creators of the High Renaissance style, Raphael was for long the most esteemed, as he was also the most directly influential. His accomplishment is so suave that it verges at times on the bland, but his invention was tremendous and his art has a surprising variety of mood. This *Allegory* is an early work, already highly accomplished, and with distinct freshness and charm. The sleeping knight will presumably have to choose between the two ladies, one soberly clothed, with covered head, bearing a book and sword, and the other more lightly and frivolously dressed, holding out a flower. Duty and Pleasure, it may be, are each offering their attractions, but Raphael balances the choice, like the composition, and leaves the hero – and the spectator – undecided.

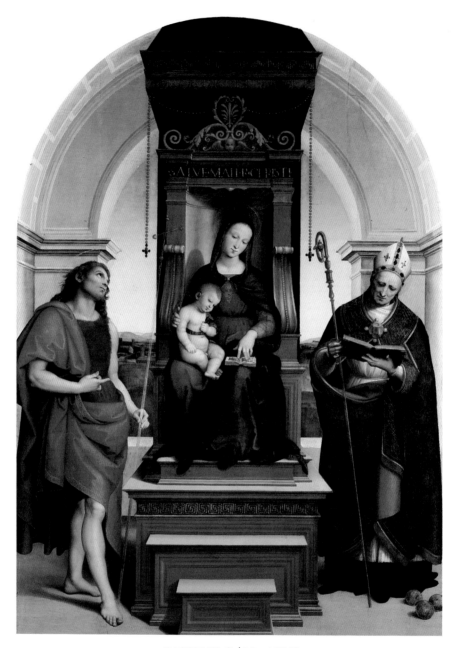

RAPHAEL (1483–1520)
'The Ansidei Madonna'

Some five years perhaps – at most – separate Raphael's *Allegory* from this large-scale altarpiece, painted for the chapel of the Ansidei family in a church in Perugia. On the Madonna's robe is a date, probably to be read as 1505. Anything that was slightly tentative in the earlier composition has here been rounded out, smoothed out and become mature. Raphael retains a fondness for balance and now develops his gift for simplified though strongly realised forms – like the solid geometry of the steps of the Madonna's throne. The visual clarity seems a reflection of intellectual clarity, well symbolised in the slim glass tube of the tall cross lightly clasped by the Baptist. All is serene and daylit, in an atmosphere very different from Leonardo's *'Virgin of the Rocks'* (p. 57). Here no doubts or problems exist – only solutions.

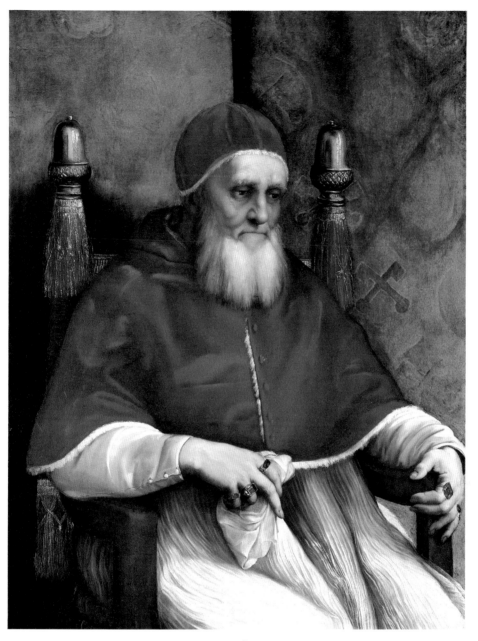

RAPHAEL (1483–1520)
Pope Julius II

The rising tide of Raphael's successful career carried him to Rome and papal patronage. For Pope Julius II he frescoed a series of rooms in the Vatican, including, in the Stanza della Segnatura, the *School of Athens*, the quintessence of High Renaissance ideals. The Pope was a thoroughly Renaissance figure, a successor to Saint Peter whose kingdom appeared surprisingly much of this world. Julius II was old but still masterful, still ambitious if temporarily rather subdued, when Raphael painted him, wearing a beard in mourning for losing control of the city of Bologna. With all his other gifts, Raphael was a great portraitist, able to present his sitters in ways both dignified and intimate. The type of portrait he created here of Julius II was long to serve as the pattern for all papal portraiture.

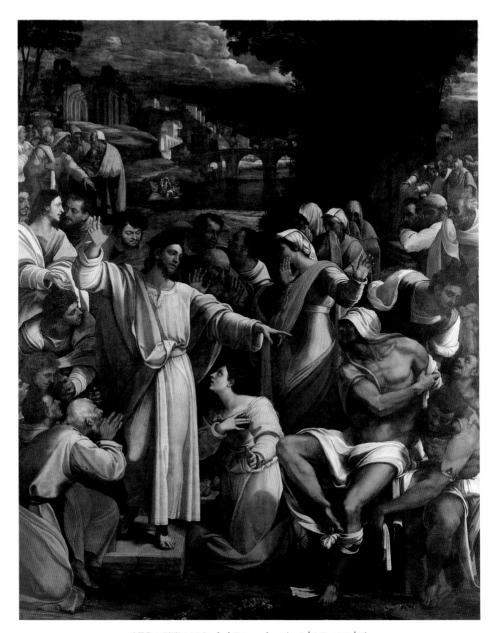

SEBASTIANO del Piombo (*c*.1485–1547)
The Raising of Lazarus

Sebastiano was a Venetian painter who settled in Rome. He painted this huge picture in virtual competition with Raphael, who was painting for the same commissioner, the future Pope Clement VII, the *Transfiguration* now in the Vatican Gallery. Michelangelo – no lover of Raphael – is traditionally said to have helped Sebastiano with drawings for some of the figures, probably those involved in the central incident. Whatever its genesis, the painting is a tour de force of massed, gesticulating bodies and glittering colour, full of obvious portrait heads and with a poetic landscape background that recalls Sebastiano's Venetian origins. Perhaps all the elements have not been quite successfully fused, but the grand manner of the composition is impressive, and in its conscious rhetoric the painting looks forward to the Baroque.

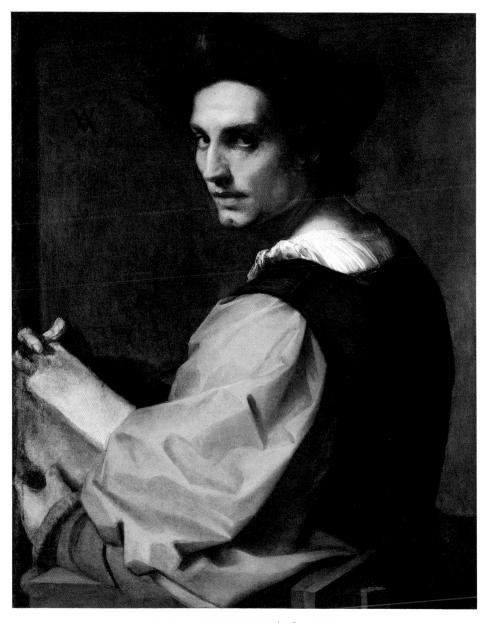

Andrea del SARTO (1486–1530)
Portrait of a Young Man

'A common greyness silvers everything', observes Andrea del Sarto in Browning's
monologic poem about the painter. A common blue-greyness gives harmony to this
portrait which seems to be painted in a dusky twilight from which the sitter emerges,
turning in his chair to gaze out with a moody, pensive air. The concept is typical of a
style of portrait in sixteenth-century Florence, very different in aspiration from the
Early Renaissance certainty conveyed in, for example, Botticelli's male portrait (p.30). At
his best Sarto is a subtle and highly sensitive artist. Here he seems in strongest *rapport*
with his sitter, probing behind the face to express something of the mind, and no less
delicately exploring the contours and texture of the choice costume, especially the
voluminous sleeve that partly projects towards the spectator.

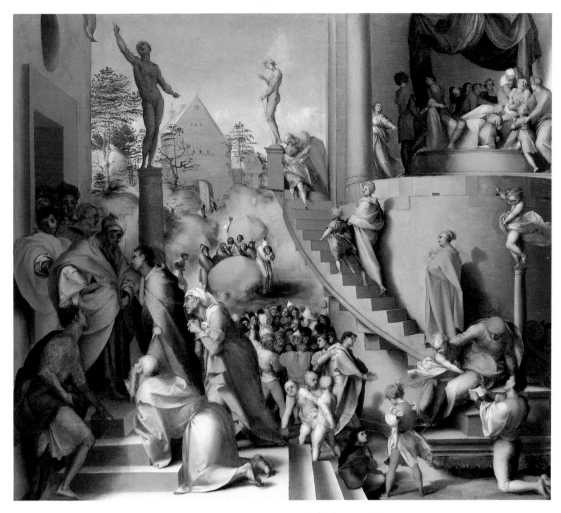

Jacopo PONTORMO (1494–1557)
Joseph in Egypt

Pontormo was the pupil of Sarto and the master of Bronzino, and this trio of
painters, each with his own distinct individuality, by themselves rebut any old-
fashioned ideas about a 'decline' of painting in mid-sixteenth-century Italy, least of all
in Florence. More openly eccentric than Sarto, artistically and personally, Pontormo
fashioned a style of extreme refinement, with recherché colour and exuberant fantasy
elements, all well displayed in this painting. It is one of a series, to which various
Florentine painters contributed, executed as decoration for the marriage-chamber of
Pierfrancesco Borgherini. Pontormo's inventiveness hardly needs stressing. From the
extraordinary triumphal car in the foreground to the dizzily curving flight of stairs, he
creates a world totally and proudly his own. And in a final personal touch, he has seated
on the steps at the front of the composition his own youthful pupil, Bronzino.

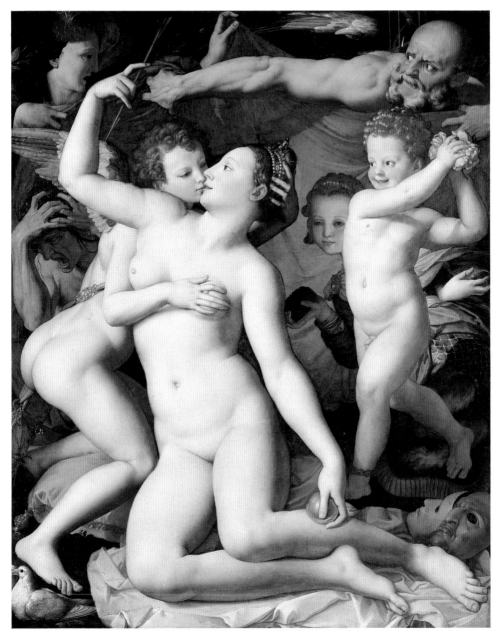

BRONZINO (1503–1572)
An Allegory with Venus and Cupid

However abstruse and puzzling this allegory may seem to be, much about it is
clear, beginning with the main figures of Venus and her son Cupid kissing. As he
embraces her with rather more than innocent affection, she removes from his quiver an
arrow – symbol of love's power. Apart from Time at the upper right, most of the other
figures predictably symbolise the pleasures and pains of love, and the allegory may well
illustrate the conquest of Love by Beauty, enshrined in Venus. In any event, Bronzino
puts all his art into celebrating visual beauty as he works like a jeweller on a large scale,
entwining bodies pale as pearls, with gilt wire for hair, and setting the completed
artefact against brilliant blue hangings, themselves as cold and hard as though
carved from some rare mineral.

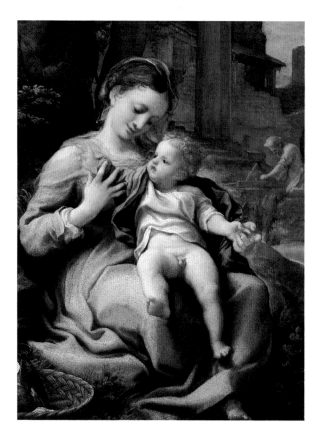

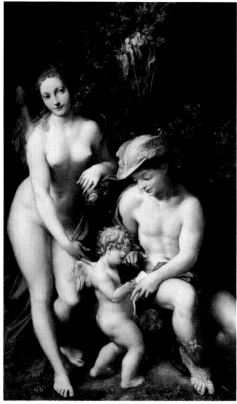

Antonio Allegri da CORREGGIO (active 1514, died 1534)
The Madonna of the Basket

Correggio had a gift of instinctive charm in painting equivalent to Tchaikovsky's gift of melody. Both men were careful not to rely solely on such gifts. Charming as is this small religious picture, it is more than a playful, domestic interpretation of Christ's infancy. The Child whose arms are outstretched will one day be stretched out and nailed to the Cross, having been stripped of His garments. And even in Saint Joseph's absorption in carpentry may lie a hint of that Cross composed of wood.

Antonio Allegri da CORREGGIO (active 1514, died 1534)
Mercury instructing Cupid before Venus

Art history has some difficulty in explaining Correggio, so unforeseen is he in his own century and so thoroughly *dix-huitième* can he be, as in this mythology. It is no wonder that the eighteenth century loved his work. The surface of this painting is like that of porcelain, soft-paste porcelain, *pâte tendre*, and the flesh of all three figures has been caressed into existence, cell by cell, under Correggio's brush. The vision is that of some secular Garden of Eden, with no lurking serpent, and the very foliage has a rustling allure. An old title for the picture was *'The School of Love'*, but in such a deliciously hedonistic climate any attempt to instruct Cupid must inevitably fail.

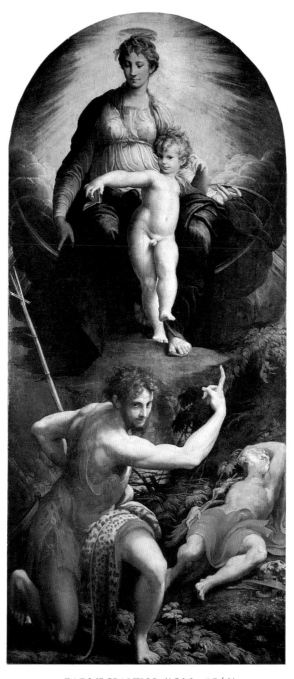

PARMIGIANINO (1503–1540)
The Madonna and Child with Saints John the Baptist and Jerome

Parmigianino, so called after his birthplace of Parma, was only twenty-four when
he painted this altarpiece in Rome, at the time of the Sack of the city in 1527. Inevitably,
it includes detectable influences from other, older artists, like Raphael, but what is most
striking is its originality and its elegance. Parmigianino's natural stylishness declares
itself even in the unusually slim format, which emphasises the proportions of the tall
Virgin and those of the Child who seems to dance at her knee. The long, pointing finger
of the Baptist is almost dislocated in its fluid expressiveness as he indicates the vision
above, bathed in shimmering radiance.

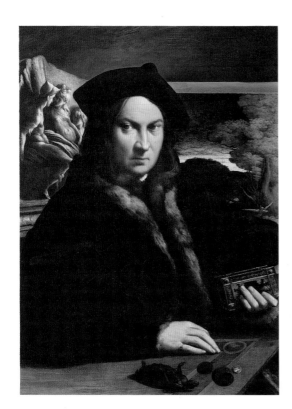 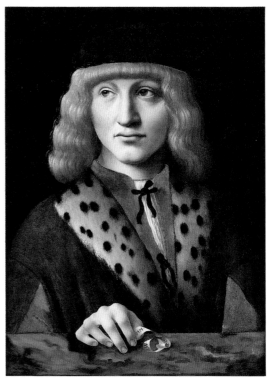

PARMIGIANINO (1503–1540)
Portrait of a Man

Portraiture is an important aspect of Parmigianino's art – in contrast to that of Correggio. And each portrait seems to have stimulated him to fresh ideas for presentation. In this one there is a strange, slightly oppressive air to both sitter and setting. The sitter, prosperously though not ostentatiously dressed, is unsmiling and elusive in terms of personality, almost suspicious, his gaze turned from the spectator. Choice though the setting is, suggesting the tastes of a connoisseur, there is something ominous in the segment of landscape revealed at the right. Even the enchanting fragment of bas-relief, surely chiselled out of Parmigianino's imagination, seems glimpsed by stormy light.

Giovanni Ambrogio PREDA (*c.*1455– after 1508)
Francesco d'Archinto

On the scroll d'Archinto holds is the date 1494, and by that year Leonardo da Vinci had been living for some time in Milan. Preda and his brother Evangelista were associated with Leonardo in the contract for the London *'Virgin of the Rocks'* (p. 57), and Leonardo's influence is at work here, with rather peculiar results. Less suave than Luini, Preda has grafted on to what seems a competent, thoroughly fifteenth-century talent some of Leonardo's novel and near-surreal effects. Slight suggestions of waxwork hover about the sitter's pallid face and glassy eyes, while the determined effort to render the texture of his hair, down to its last blond filament, has given it something of the artificial vitality of a nylon wig.

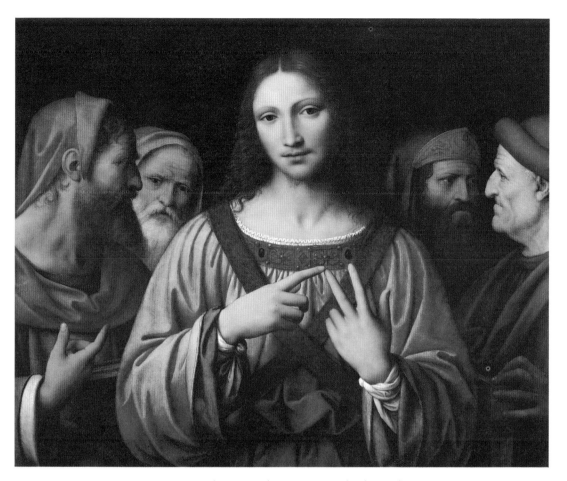

Bernardo LUINI (active 1512, died 1532)
Christ among the Doctors

This once very famous painting was for long thought to be by Leonardo da Vinci. Leonardo's influence on Luini and other painters in Milan was almost too potent, in some instances robbing them of individuality. Luini did not entirely succumb – though he came close – being sweeter and softer in both sentiment and handling than Leonardo. In this painting he shares Leonardo's interest in expressive, almost caricatured physiognomy, contrasting the wrinkled faces of the mature and supposedly wise Doctors with the youthful countenance of Christ, Himself perfect wisdom. Luini is also indebted to Leonardo for the type of Christ, faintly androgynous, faintly smiling, with hair that curls and ripples in countless tendrils.

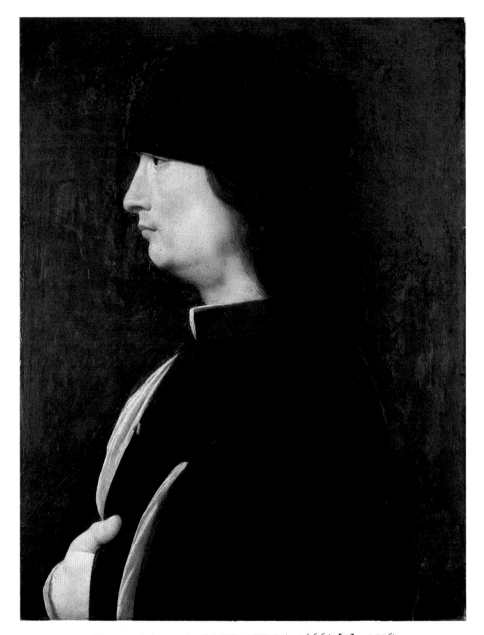

Giovanni Antonio BOLTRAFFIO (*c*.1466/7[?] –1516)
A Man in Profile

Boltraffio seems to have been Leonardo's principal pupil in Milan. There the profile portrait enjoyed some popularity at the turn of the fifteenth century, and Boltraffio's sober, sombre and tonally restricted use of it here is extremely effective as a piece of painting. Admittedly, there appears some danger of the sitter being extinguished as a living person between the darkness of the cap he wears pulled low over his eyebrows and the severe line of his stiff collar. Yet the image works very well. Preda's *Francesco d'Archinto* (p.68) looks showy in comparison with this austerely clad figure, and Boltraffio's is the more subtle work of art.

NICCOLÒ dell'Abate (*c.*1509/12–1571)
The Story of Aristaeus

The story is more properly, more familiarly, that of Orpheus and Eurydice. What
is depicted is Eurydice's flight from the shepherd Aristaeus, when she trod on a snake
and subsequently died from its bite. Her corpse is seen right of centre of the
composition, but the narrative is somewhat dwarfed by the painter's interest in showing
a vast landscape panorama, of woods and hills and buildings, fretted by an exciting
coastline. Fantasy elements mingle with natural observation to make a deliberately
inventive and decorative painting. Niccolò dell'Abate probably executed it in France,
where he spent approximately the last twenty years of his life, working for the French
crown and decorating the royal palace at Fontainebleau.

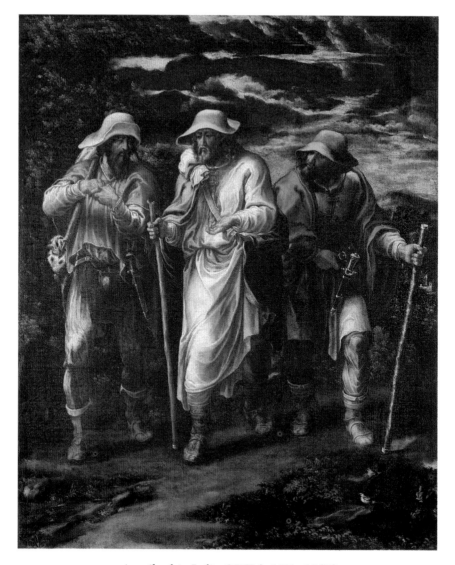

Ascribed to Lelio ORSI (*c*.1511–1587)
The Walk to Emmaus

According to Saint Luke's gospel, two of Christ's Disciples set off to walk, after His death, 'to a village called Emmaus'. On the road they were joined by a stranger, later revealed to them as Christ (see Caravaggio, p.88). It is traditional for the three figures to be shown in paintings as pilgrims, much as they appear here. Orsi is by no means a famous painter and is chiefly known as a draughtsman. One of his drawings treats the subject very similarly to this distinctive painting, reasonably associated therefore with him. Against a hectic sky, the three tall, apparent pilgrims stride forward in almost hallucinatory manner, and Orsi subtly conveys the dominance of Christ as the central figure and His uneasy effect on His companions, still unaware of His identity.

GIORGIONE (active 1506, died 1510)
The Adoration of the Magi

The brevity of Giorgione's career is implied by the dates above. Part of the myth which still surrounds him and his work comes from that brief career, his early death and the paucity of authentic paintings by him. Yet it is clear that he was extraordinarily gifted and exercised a significant influence in Venice beyond his lifetime. This *Adoration* is not certainly by Giorgione but seems convincingly attributed to him. While the group of the Holy Family recalls Giovanni Bellini's art, the Magi and their retinue bring, suitably enough, a new talent with them: one of fresh colour effects and graceful, half-negligent forms. All the novelty seems summed up by the attendant at the extreme right, costumed fashionably and painted with delicate precision, somewhat detached from the main scene and wrapped in a private dream.

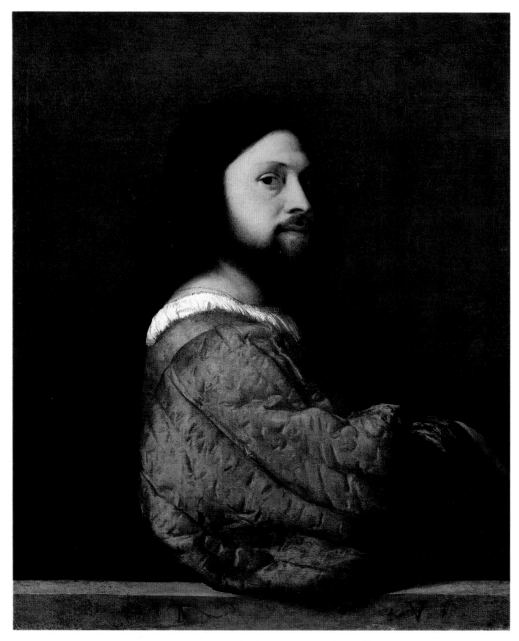

TITIAN (active before 1511, died 1576)
Portrait of a Man

When Giorgione died Titian had another sixty-six years of artistic activity before him, during which time his style would constantly evolve, in a way not previously seen in Western painting. And no previous artist had shown such an appetite – such gusto – for conveying in strongly physical terms perceived physical reality. This portrait is an early work but in it Titian displays his confident mastery of oil-paint, making it convey not merely the sitter's features but – almost eclipsing the head as focus – also the sweep of silken quilted costume, ballooning out so convincingly along the parapet. The eye passes over this expanse of paint as if negotiating a fully three-dimensional object. Only when one looks closely does the illusion dissolve into flecks and touches of blue pigment, each laid on to play its part in this 'portrait of a sleeve'.

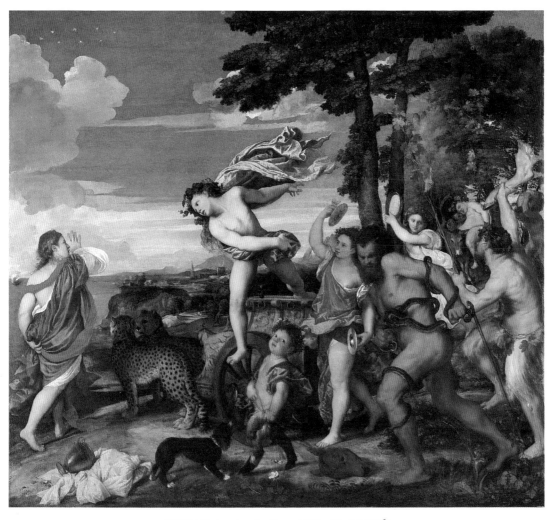

TITIAN (active before 1511, died 1576)
Bacchus and Ariadne

It was for a great Renaissance prince and patron, Alfonso d'Este, Duke of Ferrara, that Titian painted this thrilling mythology, with its forever leaping wine-god Bacchus encountering and startling the abandoned mortal Ariadne on the island of Naxos. The painting was the last of three great bacchanalian pictures Titian painted for a room of the Duke's castle in Ferrara, and few subjects could better have suited the painter. It is the force of uninhibited love that sends Bacchus leaping. And exuberant, uninhibited love of life infuses every particle of the painting, from the reeling intoxicated rout of the god's followers to the magically lush landscape of Naxos, where deep, green, wooded cliffs, set against mountains blue and sharp as copper-sulphate crystals, plunge steeply towards the turquoise sea. Behind, and barely covering the excited god, there streams his wine-red mantle, like a banner proclaiming the arrival not so much of Bacchus on the island as of Titian in Venice.

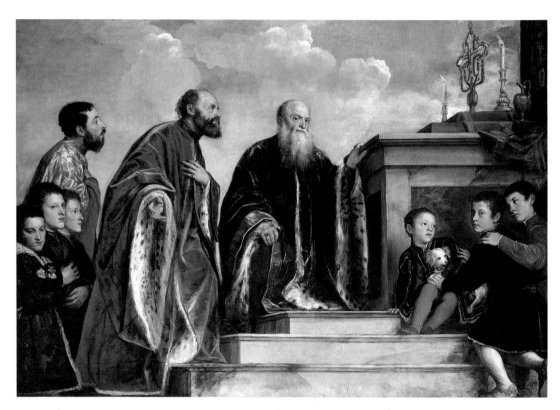

TITIAN (active before 1511, died 1576)
The Vendramin Family

Titian's fierce attachment to physical reality made him a great portrait-painter. By the time he painted this unique group portrait, in the 1540s, he was acknowledged far beyond Venice. His style had altered and evolved from the period of the half-length male portrait (p.74). He now handles the paint with far greater freedom, almost roughly it seems, brushing in the spotted fur-lining of the heavy robes with such tactile vivacity that it vibrates against their smoother, velvety textures. He depicts his sitters full length, presenting here a gamut of the ages, running from the venerable, white-bearded Gabriele Vendramin to the little boy, nursing his dog, propped on the steps of the altar where more adult members of the family worship a relic of the True Cross. There is something oriental in this exclusively male view of the family, especially as there happened to be alive at the time six Vendramin daughters.

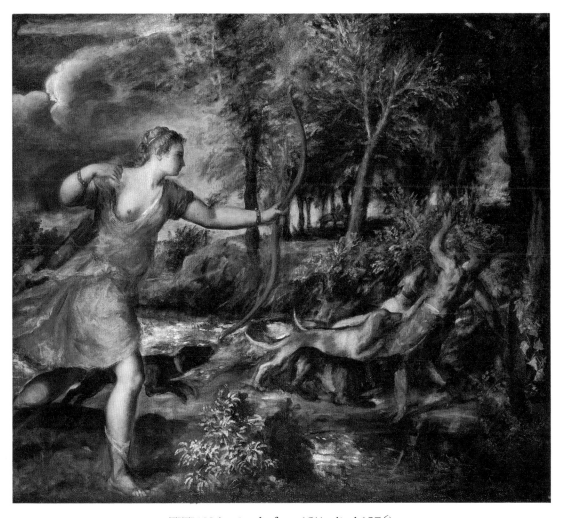

TITIAN (active before 1511, died 1576)
The Death of Actaeon

Twenty years or so separate this painting from the *Vendramin Family*. Titian's handling of paint has entered its final and perhaps most masterly phase, with a freedom that seizes the essence of forms and then moves rapidly on. At the same time, he has restricted his palette. His vision too has deepened, exuberance giving way – at least here – to a more thoughtful and poignant response, suitable to the horrific story depicted. Punished by Diana for stumbling accidentally on her while bathing, the hunter Actaeon was transformed by her into a stag and devoured by his own hounds. Here the towering, baleful goddess urges on the dreadful deed, under a lowering sky, in an autumnal woodland where the trees seem almost shaken by the ferocity of what is happening in their midst.

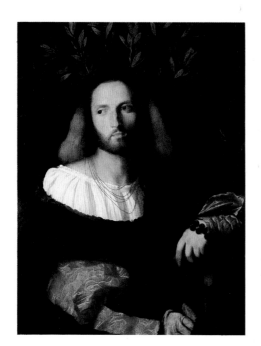 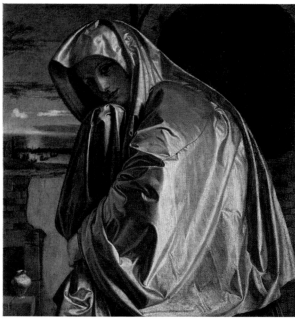

PALMA Vecchio (active 1510, died 1528)
Portrait of a Poet

Palma is a Venetian painter whose pictures seem to celebrate the importance of doing nothing. Their mood is always verging on that of siesta, of a pleasantly luxurious kind. The 'poet' here – assuming that he *is* a poet and not some other category of literary figure – is resting almost literally on his laurels, a fan of leaves of which provides the background for his contemplative pose, with a book under his hand and a sumptuous costume to clothe him. That the great Italian poet Ariosto is the sitter has often been suggested. If so, Palma certainly seems to agree with the poet's brother, who celebrated him posthumously as amiable in character and noble in appearance.

Gian Girolamo SAVOLDO (active 1508, still living 1548)
Saint Mary Magdalen approaching the Sepulchre

Savoldo came from Brescia but settled in Venice. And it is in Venice that he boldly places this scene of Mary Magdalen approaching the sepulchre where Christ is laid. Savoldo was fond of subtle light effects and beautifully captures the first glimmer of dawn over the water-girt city. He had great feeling too for textures and materials. He muffles the saint in thin silvery fabric, of suitably nocturnal associations, and carefully records the seam along her shoulder where two widths of it are sewn together.

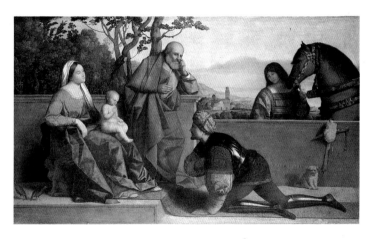

Vincenzo CATENA (active 1506, died 1531)
A Warrior adoring the Infant Christ and the Virgin

This painting has such an unusual subject that it seeems odd no facts have been
discovered to explain it. Catena was a Venetian, and the large size and shape of the
picture suggest it is a typical votive-piece of the period. A Doge kneeling before the
Virgin and Child would be no novelty, but the warrior who prostrates himself in this
composition seems to be Eastern, or Middle Eastern. The church in the background
would certainly seem to have some relevance, while the slightly overawed dog is
probably more than a charming genre detail and symbolises faith.

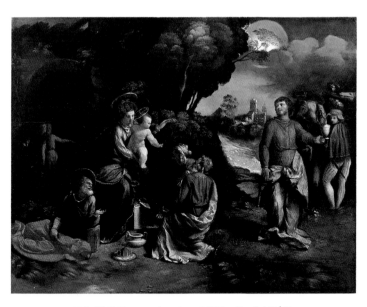

DOSSO Dossi (active 1512, died 1542)
The Adoration of the Kings

Dosso Dossi is himself proof that Ferrara in the sixteenth century continued to
produce fascinating and idiosyncratic painters. Dispensing with any conventional ideas
of the stable at Bethlehem, Dosso takes the scene here deep into the wilds of a wooded
countryside. The magus-like, dignified Kings discover the Holy Family in a grove of
trees, close to a rushing torrent, while a vast moon, like a portent, glows
softly amid the clouds.

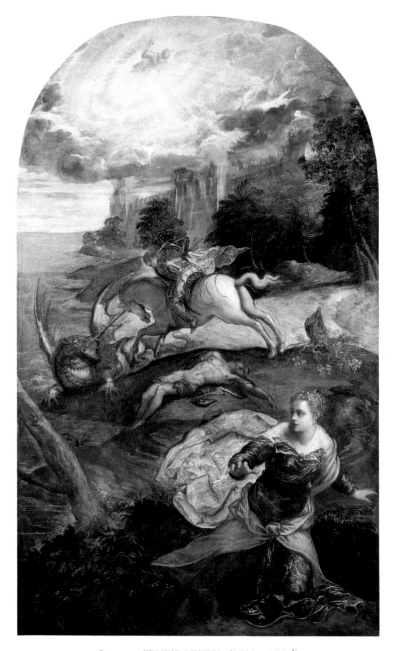

Jacopo TINTORETTO (1518–1594)
Saint George and the Dragon

Where Palma celebrates indolence, Tintoretto constantly celebrates action. In his paintings something is always and very definitely happening. The subject of Saint George fighting the dragon was in itself suitably energetic, and Tintoretto adds happenings in heaven to accompany those on earth. So daring and dynamic is his style, and his approach, that the Princess in the foreground, who is actually depicted on her knees, appears to be flying out of the picture as her cloak swirls around her. The sea foams and trees toss. Saint George charges at the dragon, forcing it towards the waves. The final excitement – very typical of Tintoretto in its thought as well as in its execution – comes from the sky overhead where the clouds are riven in a blaze of light, at whose centre is manifested God.

Lorenzo LOTTO (born *c*.1480, still living 1556)
A Lady as Lucretia

The confusing title misses the point: it seems that a lady called Lucrezia is here portrayed by Lotto, with allusion to the Roman heroine Lucretia who, after being raped by Sextus Tarquinius, stabbed herself (as shown in the drawing the sitter holds). Lotto is known to have painted a certain Lucrezia Valier, and this portrait may well be of her.

Lotto has a keen feel for personality and costume and enjoys designing unusual compositions. He creates a formidable, arresting air about this sitter, who seems in little danger of suffering her namesake's ordeal and more likely to prove a future matriarch.

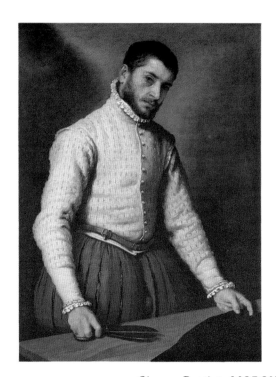 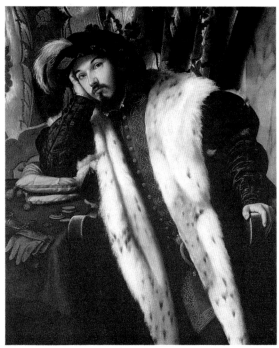

Giovan Battista MORONI (active 1546/7, died 1578)
Portrait of a Man ('The Tailor')

Moroni trained under Moretto, as might be surmised, and concentrated even more exclusively on portraiture. His ethos tends to be a bourgeois one, with lawyers and clerics among his sitters, and his people are often painted with head tilted, as though in direct conversation with the spectator. The present painting is among his masterpieces, typical in its restrained realism yet unusual in apparently showing, if not a tailor, a merchant in cloth, at work professionally. In more ways than one does the sitter seem to take the spectator's measure.

MORETTO da Brescia (c.1498–1554)
Portrait of a Young Man

Today Brescia is one of the least charming of North Italian cities but in the sixteenth century it became the home of a number of talented painters and fostered a style of solid, sober realism, especially in portraiture. Moretto is among the most gifted of Brescian painters, a very close contemporary of Holbein, who might not have disdained responsibility for Moretto's virtuoso array of materials – marble, velvet, brocade and leather, as well as fur, fur cascading down from the sitter's shoulders like lightly paw-marked snow. In the sitter's cap is a badge inscribed in Greek, 'Alas, I desire too much'. Perhaps it refers to some emotional need, for in terms of worldly goods there seems little more for the man to desire.

Jacopo BASSANO (active 1535, died 1592)
The Good Samaritan

He lived, an early biographer writes of Bassano, 'away from the noise of courts
and royal palaces', beside the bridge in his small native town of Bassano, north of Venice.
Rusticity is a strong element in his art, though that does not mean there is anything
naïve or clumsy about it. Almost effortlessly, it seems, Bassano re-thought traditional
religious subjects. His *Adoration of the Shepherds*, for example, is full of convincing,
countrified people. In this depiction of a familiar parable he suggests not only caring
humanity but all the actual circumstances of the incident as it might have occurred in a
countryside setting, giving visual force to Saint Luke's words about the compassionate
Samaritan placing the robbed and wounded man 'on his own beast'.

Paolo VERONESE (1528[?] –1588)
The Consecration of Saint Nicholas

So precociously pious was Saint Nicholas, according to legend, that on the day of his birth he stood up to pray while being bathed. After that, consecration as bishop of Myra might well come as something of an anti-climax, though an angel drops from heaven here with the future saint's mitre and crozier. Veronese lavishes on the subject all the resources of his rich imagination. Too often praised and treated as merely a great 'decorator', Veronese is indeed a decorator – and designer – of genius, as this composition shows. Yet he never neglects significance for ostentation. Splendid as he makes the scene, he puts at its centre Saint Nicholas, a crouched and humble figure, whose unexpected singling out is emphasised by the surrounding pageantry.

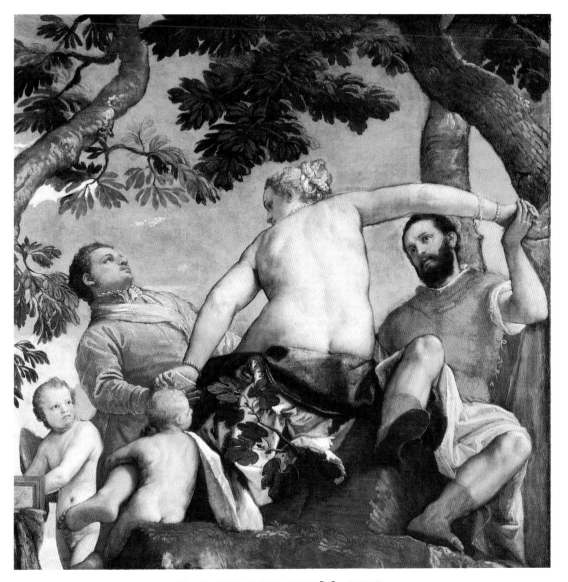

Paolo VERONESE (1528[?] –1588)
Allegory of Love

This is one of a set of four canvases by Veronese, all in the Gallery, that deals with aspects of love, and was intended probably as a ceiling decoration. Though the precise significance is not established, it is at least apparent that here a woman finds herself between two men, contrasted in costume — perhaps as courtier and soldier. More absorbing than the 'story' is the skilful composition Veronese has created, with the woman's outstretched arms arching across the centre of the painting, lightly echoed by the tree-trunks arching above the figures. No painter has ever understood better than Veronese how to construct a perfectly serious, coherent world, alternative to ours and at every point more harmoniously beautiful.

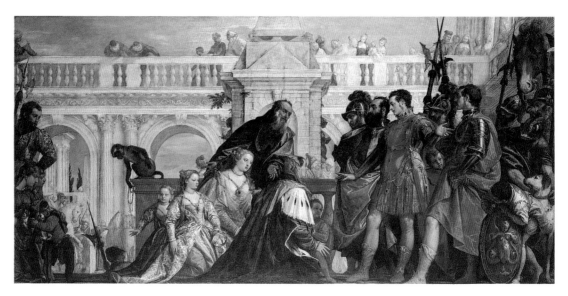

Paolo VERONESE (1528[?] –1588)
The Family of Darius before Alexander

Venetian by adoption, Veronese seems at times to sum up Venice more
quintessentially even than Titian. For the great Venetian patrician family of Pisani, he
painted this tremendous pageant-picture, long famous and influential. Its theme is the
courtesy and magnanimity shown by Alexander the Great (in red) to the family of his
defeated foe, Darius of Persia, who mistook Alexander's friend Hephaestion (in gold) for
the conqueror. A moment of high drama and fine behaviour is played out by great
personages on a public stage, as East meets West. Veronese sets it largely in the Venice of
his own day, implying that it is thus – with noble hearts under noble costumes –
that the best people always act.

Italian Painting after 1600

As one surveys the Gallery's representation of the Italian Schools from 1600 onwards up to the end of the eighteenth century, there is a sense of some faltering in the sweep and depth of the Collection. Yet from Caravaggio to Canaletto, many of the greatest painters are included, and represented by outstanding works.

When the Gallery was founded, British taste for the Seicento was strong in certain areas, while apart from Canaletto the Settecento was little collected or esteemed. During the nineteenth century the Seicento was virtually eclipsed and the Settecento remained little regarded. Those facts for long – surprisingly long – coloured the Gallery's own Collection. The seventeenth-century Bolognese School, especially the Carracci, Domenichino and Reni, were included from early days, though large-scale religious works, like altarpieces, had little appeal in a Protestant country. Not until 1913, with the gift of Annibale Carracci's *Dead Christ Mourned* (p.89), was there anything on a larger scale to hint at the vein of Baroque piety running through much Italian painting of the period. Guercino, for some reason, was not sought after by the Gallery when taste for the Seicento was still pronounced, and he remains strikingly under-represented. The decorative Baroque of Pietro da Cortona is entirely absent. On the other hand, Salvator Rosa was firmly established in British private collections, and a very fine landscape by him (p.92) was an early purchase.

Sir George Beaumont's gift to the nation, which stimulated the founding of the Gallery, had included an early masterpiece by Canaletto, the so-called *'Stonemason's Yard'* (p.96), and other fine paintings by the artist were added over the years. Guardi was less popular, and it was only at the beginning of the twentieth century that a group of works came, with the Salting Bequest, to convey the nature of his very different talent. The history and decorative painters of the eighteenth century were largely ignored by the Gallery, though two small sketches by Tiepolo were purchased late in the nineteenth century, as were also some paintings by Pietro Longhi, among them his popular *Exhibition of a Rhinoceros in Venice* (p.98).

Only in comparatively recent years has the Gallery responded to the revaluation of both Seicento and Settecento painting. An important series of frescoes by Domenichino (p.90) was purchased in 1958. A splendidly vigorous work by Luca Giordano, on an impressive scale (p.94), was bought as recently as 1983. More difficult in some ways to represent adequately today is the Settecento, especially beyond Venice. Batoni, so popular as a portraitist of the British in Rome during the eighteenth century, did not enter the Collection until 1960. And still only feebly represented is the famous view-painter of the period in Rome, Panini.

Yet shrewd buying brought the Gallery in 1958 its first eighteenth-century altarpiece, Pittoni's *Nativity* (p.99), and a combination of unexpected circumstances, not least generous Government assistance, resulted in 1969 in the purchase of a great rarity, a ceiling-painting by Tiepolo (p.101), which in itself compensates for many years of English indifference to the last great Venetian decorative artist.

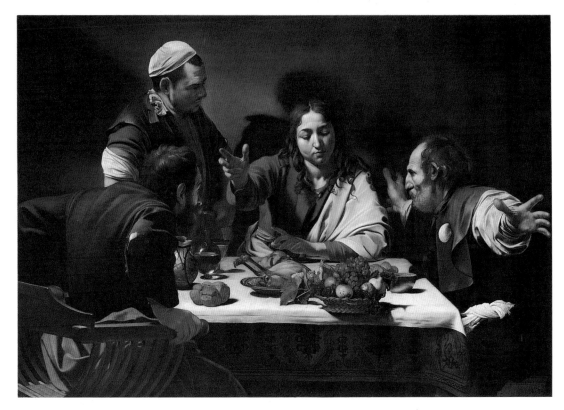

Michelangelo Merisi da CARAVAGGIO (1573–1610)
The Supper at Emmaus

Painted in Rome probably around 1600, this composition dramatically declares
new aims in art, with a fresh emphasis on 'realism', well conveyed by the still life on the
table and the strong play of light and shade. Caravaggio's technique, in which every
object seems flawlessly realised, with more than ordinary clarity, creates an illusion
which has its own excitement – suitably enough for the miraculous moment depicted.
The spectator is virtually commanded to share the experience of the Disciples, and join
them at table, as Christ manifests Himself after the Resurrection. 'Their eyes were
opened', Saint Luke's gospel says, and the words might be extended to cover
the effect generally of Caravaggio's art on his contemporaries.

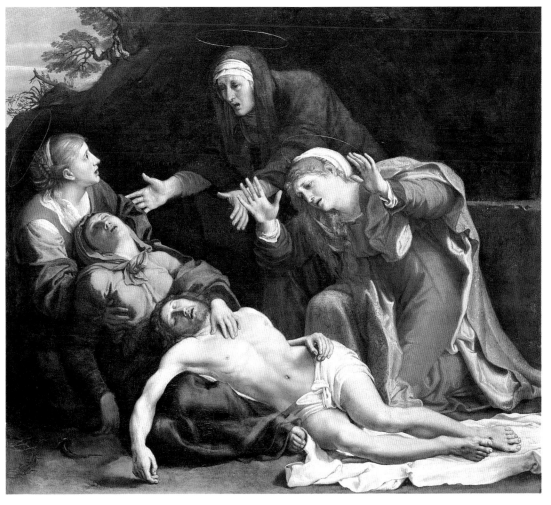

Annibale CARRACCI (1560–1609)
The Dead Christ Mourned

Carracci's painting must have been done in Rome, not very many years after Caravaggio's *Supper at Emmaus*, and it too aims to be an intense, affecting drama, exciting not awe but pity. Like Caravaggio, Annibale Carracci was a North Italian painter, with his roots very much in that tradition. His art is full of conscious echoes, here of Correggio as well as Tintoretto, but highly personal. In this painting he is less concerned than Caravaggio with 'realism', either in concept or technique. There is dignity and rhetoric in the grief expressed, notably by the Magdalen on the right, which does not detract from the painting's effect. And it was this elevated manner, rather than Caravaggio's, that ultimately exercised the greater influence.

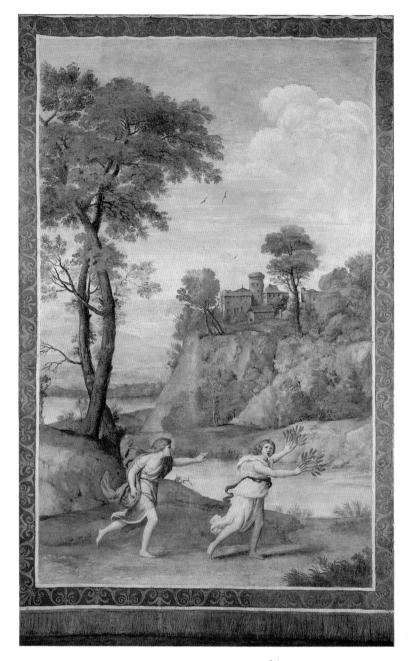

DOMENICHINO (1581–1641)
Apollo pursuing Daphne

Domenichino was a Bolognese painter attracted to Rome, where he worked for a time under Annibale Carracci. He showed a particularly keen response to landscape, and was able to give full rein to it in the commission for a series of frescoes (of which this is one) dealing with Apollo's life. These were to be placed in a garden-pavilion of the Villa Aldobrandini at Frascati. The countryside here is frankly re-arranged and consciously composed, to make a noble prospect. Even in re-ordering nature, however, Domenichino pays tribute to its profound appeal; and the pair of interlinked tall trees at the left are not only a poetic invention but instinct with life and interest – greater, perhaps, than anything in the pair of figures.

GUERCINO (1591–1666)
Angels weeping over the Dead Christ

In Guercino's long career this small and early painting by him cannot rank as important. Yet its quality makes it worth pausing over. There is none of the high emotional drama of Annibale Carracci's treatment of mourning over Christ's body (p.89). The angels grieve intimately – as it were, humanly – over their Creator. The subject is essentially devotional, suitable for private meditation, and Guercino's delicate touch and subdued tones make a perfect nocturne.

Guido RENI (1575–1642)
Lot and his Daughters leaving Sodom

Like Domenichino, Reni was a Bolognese who came under the influence of the Carracci. He rose to great fame, had many pupils and was to enjoy, especially in England, high posthumous respect. No great haste is suggested in this flight of Lot and his daughters, although they are leaving a city about to be destroyed by divine fire. Reni creates a dignified frieze, suggesting by glance and gesture the colloquy of the three figures. The elegant, well-wrought pitcher held by the daughter on the left is no mere ornamental accessory but is probably intended to allude to the subsequent incident, when the two women make Lot drunk with wine.

Bernardo STROZZI (1581–1644)
Fame

There is a Venetian richness of colour about this painting, which must have been painted in Venice after Strozzi moved there from his native Genoa. It is typical of him that Fame should be a rather countrified girl, certainly not idealised, seated solidly on the ground and dressed in thickly painted garments. Only the pair of wings provides an allegorical touch. This figure of Fame clasps two musical instruments, symbolising the good and bad aspects she disseminates: a gilded metal trumpet and a plain wooden recorder. And perhaps it is the latter, held in her right hand, that would best represent the good aspect of this Fame.

Salvator ROSA (1615–1673)
Landscape with Mercury and the Dishonest Woodman

In Aesop's *Fables* is told the story of how, after an honest woodman was rewarded with a golden axe by the god Mercury, a dishonest woodman claimed to have lost a golden axe. Mercury recovered the axe and showed it was only a piece of iron. For Rosa the woody landscape is of greater importance than any woodman – though the moral tale is characteristic of the seventeenth century. Nature here, in the shape of mighty trees, some with trunks broken and fallen picturesquely into the water, dwarfs mankind, and even a god, and takes on a wild majesty.

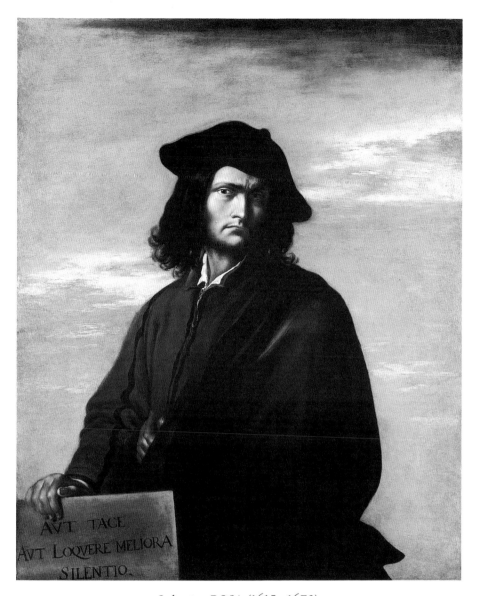

Salvator ROSA (1615–1673)
Self Portrait

'Either be silent', admonishes the Latin wording on the tablet grasped by the
painter, 'or speak things better than silence.' Rosa shows himself understandably tight-
lipped, as well as tense, as he stands wrapped in a brown cloak, possibly personifying
the stoic virtue of Silence. As a portrait of the artist, the image – silhouetted against the
sky – has a proudly brooding, lonely air, anticipating later Romantic concepts. For
all its injunction about being silent, the painting is eloquent in its assertion
of the painter's individuality.

Luca GIORDANO (1634–1705)
Phineas and his Followers turned to Stone

Giordano, a Neapolitan master famed for speed and sweep of execution, tells on
a huge scale a rather difficult narrative – and tells it with great clarity and excitement.
The hero Perseus was attacked at his wedding banquet by his disappointed rival
Phineas, with his followers. To defeat them he held up the head of the Gorgon, Medusa,
which turned all who looked on it to stone. Giordano carefully shows Perseus averting
his own gaze as he holds up the head, while petrification begins to take effect on his
opponents. The scene is more thrilling than horrible, with the overturned tables
and the fighting and fleeing figures all making up a feast of effects patently
enjoyed by the artist.

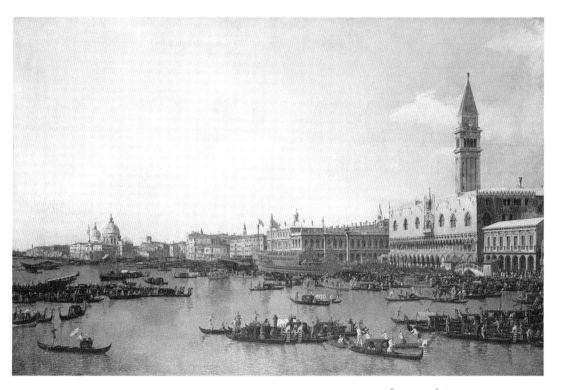

Giovanni Antonio Canal, called CANALETTO (1697–1768)
Venice: The Basin of San Marco on Ascension Day

This panoramic view of Venice shows the public and official side of it, not solely as a city but as the Most Serene Republic. Moored not far from the Doges' Palace, the seat of government, is the scarlet and gold *bucintoro*, the state barge, ready to take the Doge out across the Lagoon for the great annual celebration in which Venice symbolically wedded the Adriatic — a sign of its presumed perpetual domination over the sea. With marvellous precision Canaletto records it all, down to the tiny blob of yellow paint that represents the umbrella held over the Doge as he passes through the crowd on his way to board the *bucintoro*. But he captures also the general sparkle of light and air, and shares with the onlooker unending wonder at the spectacle of the city's magnificent buildings rising from the water.

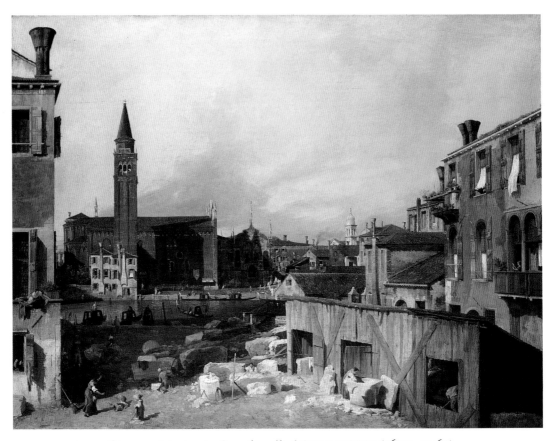

Giovanni Antonio Canal, called CANALETTO (1697–1768)
Venice: 'The Stonemason's Yard'

The scene is no familiar tourist one but a small and obscure square, or campo, near the church of S. Vidal (S. Vitale), which was partly rebuilt at the beginning of the eighteenth century. The stone littering the campo is probably connected with building operations, and the whole composition is a celebration of buildings, walls and roofs, weathered brick and stone and tile. This is Canaletto's own city, seen by morning light and astir with the private daily life of its ordinary inhabitants. The painting comes from fairly early in Canaletto's career and is outstanding, even among his many fine pictures, for its powerful organisation and atmospheric feel, combined with such attention to minute detail that across the water, just beyond the shadow of the church, is visible a line of washing.

Francesco GUARDI (1712–1794)
A View on the Venetian Lagoon

What Canaletto had done for Venice was hardly to be duplicated, least of all by a painter of different temperament and technique. Whether or not Guardi understood that, he increasingly diverged from all that Canaletto stood for. In his finest paintings people and buildings tend to be subordinated to atmosphere. It is as if air and water have subtly eaten away objects until there is little left but the elements themselves, as they merge here in a harmony of blue and grey. Only the mast of a fishing boat and the ruined tower of the old Venetian fortifications break the long low line of the horizon with its almost disturbing suggestion of infinity.

Pietro LONGHI (1702[?] –1785)
Exhibition of a Rhinoceros in Venice

A novelty at the Venetian carnival of 1751 was this unfortunate creature, paraded across Europe from Nuremberg, and it was painted more than once by Longhi. A group of masked Venetians are shown staring somewhat vapidly at it – and out of that encounter Longhi makes his painting. It is typical of his small scenes of life in Venice in the eighteenth century, scenes that were collected by local patricians but rarely by anyone else, and which, for all their charm, have a bland, faintly enclosed air to them, unsalted by satire or by any very pointed observation.

Giovanni Battista PITTONI (1687–1767)
The Nativity

Pittoni was one of the leading figure-painters of his day in Venice, where religious
subjects like this continued to be in demand. He treated the theme of the Nativity
frequently but only in this large-scale composition, an altarpiece presumably, did he
enhance the scene with a vision of God the Father and the Holy Ghost appearing in the
Bethlehem stable. It adds a note of decorative rococo grace to the simpler elements of the
manger, and was to be painted out by some nineteenth-century, probably British, owner
of the painting – less, it seems, for aesthetic than doctrinal reasons. Only after the
picture had been acquired for the Gallery was the upper portion revealed.

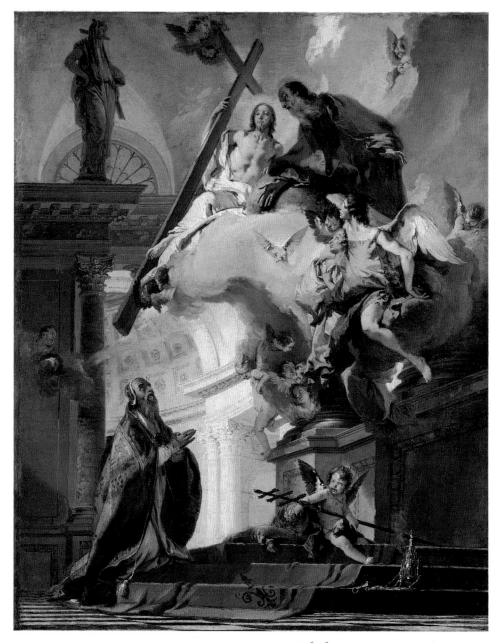

Giovanni Battista TIEPOLO (1696–1770)
The Vision of the Trinity to Pope Saint Clement

This brilliant, unusually highly finished painting is the preliminary *modello* for
Tiepolo's large altarpiece (now in Munich), painted for a German patron, the
Archbishop-Elector of Cologne, Clemens August. The patron's name sufficiently
explains the choice of an otherwise rather obscure sainted Pope, the first of that name,
as the subject. Indeed, the Pope's life appears largely devoid of incident, as far as is
known, and Tiepolo seems to have had to devise the vision he here enjoys as he kneels,
richly clad, in a magnificent church, attended by a baby angel guarding his large tiara
and triple cross. No painter of the eighteenth century could conjure up more
successfully than Tiepolo heavenly visions in sumptuous settings, in a
spirit of unfailing optimism.

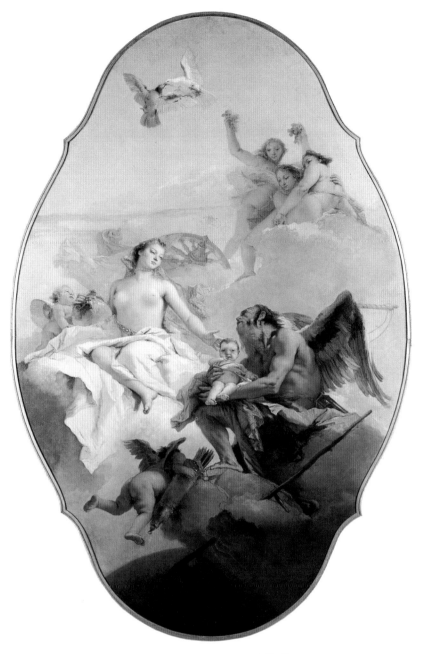

Giovanni Battista TIEPOLO (1696–1770)
An Allegory with Venus and Time

Tiepolo is the last great exponent of the Venetian tradition of colour and
sensuousness in painting, certainly the heir to Veronese but also to Titian and
Tintoretto. This painting was once on the ceiling of one of the Contarini family palaces
in Venice and was possibly executed to celebrate the birth of an heir. Whatever the exact
allegory, Venus seems here to confide to Time a boy to whom she has given birth, while
above the Graces scatter flowers in celebration. And under all the delightful, decorative
trappings, the artist seems to be saying something serious and personal, as though for
him Time is always the servant of Beauty (unlike the 'message' of Batoni's picture
on p.102) and Beauty herself confident, triumphant and immortal.

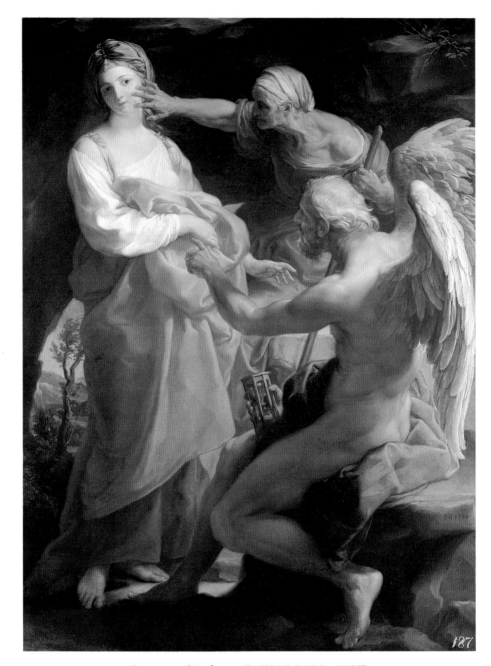

Pompeo Girolamo BATONI (1708–1787)
Time orders Old Age to destroy Beauty

Batoni is most familiar as the portraitist of British visitors to Rome on the Grand Tour but he was also a painter of 'history' pictures. The present one was painted, with a companion-piece, in 1746-7 for a patron in his native Lucca. Its strange and somewhat displeasing subject perhaps possesses a moralistic base, but in style the painting is coolly elegant, firmly drawn and attractively coloured. There is a distinct sculptural feel to it, and the pose of Beauty derives from a famous seventeenth-century statue in Rome, Duquesnoy's *Saint Susannah*. Altogether, the picture represents decorative ideals rather different from the less 'learned', more painterly ones associated with Venice in the eighteenth century.

Early Netherlandish Painting

Although the name of Jan van Eyck was always a famous one in the history of art (and he was traditionally credited with the invention of oil painting), he and other fifteenth-century Netherlandish painters were not keenly sought after by great collector-connoisseurs in the period leading up to the foundation of the Gallery. The 'Primitives' might interest antiquarians but found no natural place in such a public Collection, and that was particularly true of the Netherlandish and other Northern artists.

It is hard to realise this when one contemplates the Gallery's holdings today. Although not large, they are of great choiceness, rarity and quality. They cover the period from Campin to Pieter Bruegel the Elder and include works by all the leading artists, with the exception of one of the most strikingly original, Hugo van der Goes, whose paintings are now seldom available.

At a time when the Netherlandish School was still not much esteemed in England, it is remarkable that the Trustees should have made their first purchase as early as 1842 – with a unique masterpiece, Jan van Eyck's Arnolfini portrait (p.104). Within a few years, two other paintings by van Eyck were purchased, one of them the *Man in a Turban* (p.106). Few galleries can claim ownership of three paintings by Jan van Eyck. During Eastlake's directorship the School was considerably strengthened. He bought the first Rogier van der Weyden, the beautiful *Magdalen Reading* (p.107), as well as paintings by Dieric Bouts and other fifteenth-century artists. Two large-scale bequests, those of Wynn Ellis in 1876 and George Salting in 1910, brought several further fine Early Netherlandish paintings. The Salting Bequest included Campin's *Virgin and Child before a Fire-screen* (p.107) and Memlinc's *Young Man at Prayer* (p.110). In Wynn Ellis's bequest was another male portrait, of great intimacy and charm, by Bouts (p.109). A complete triptych by Memlinc, one commissioned by an English patron, the *'Donne Triptych'* (p.111), came to the Gallery as late as 1957.

The sixteenth century is represented in the Collection chiefly by David and Gossaert and by paintings associated with Quinten Massys. Bosch was not a painter to appeal to Victorian tastes, though the Gallery's sole example of this rare artist (p.114) was already in England in the nineteenth century. It was acquired by the Gallery in 1934.

Acquisitions to supplement the Early Netherlandish holdings are bound to be few, given the rarity of fine items that could ever come on the market and the concomitant fierce competition that would arise. What the Gallery possesses is a nucleus, revealing that Northern Europe had its own Renaissance in painting, with achievements – crystallised in the Arnolfini portrait – to match those of Italy.

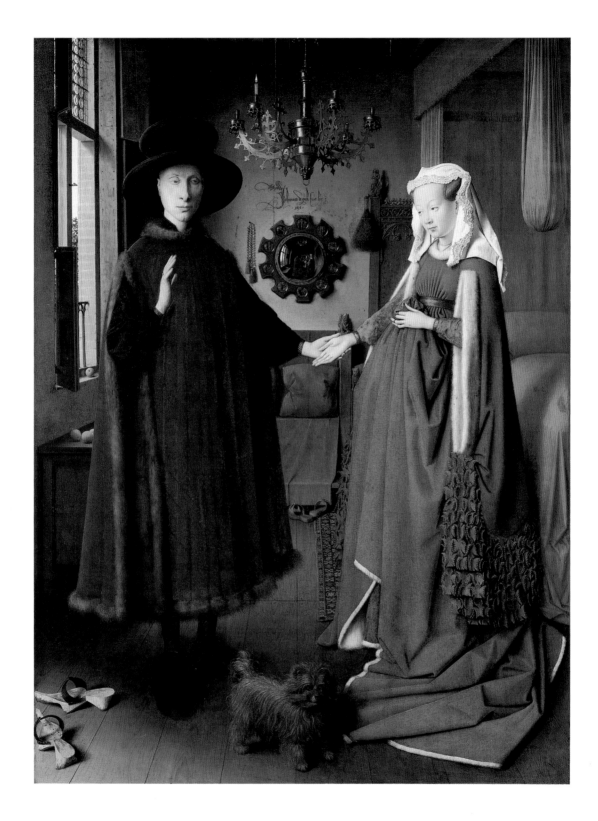

Jan van EYCK (active 1422, died 1441)
The Marriage of Giovanni Arnolfini

Solemnly signed in Latin, in a witness-like way ('Jan van Eyck was here/1434'), this painting is a double portrait unique for its date. Giovanni Arnolfini was a merchant from Lucca who lived a great deal in Bruges, where he died in 1472; his wife was also Italian, the daughter of another merchant from Lucca, who lived in Paris. But it is also more than portraiture. The couple are seen in a room, presumably in Bruges, realised so completely that minute figures can be seen reflected in the central mirror, entering the interior from where the spectator stands, to witness the ceremony of wedding or betrothal.

That some sort of ceremony or special occasion for man and woman is depicted seems clear from the gestures particularly of Arnolfini. Also, some features of the composition, like for example the single candle burning in the chandelier by daylight, add to the sense of a more than ordinary scene. Yet the painting can be appreciated in several ways. Among its most remarkable qualities is its precise realisation of all the minutiae of the Arnolfini couple's environment, down to the pattern of the bedside rug and the pair of wooden, outdoor shoes. Solemn though the scene may be, the effect is strongly secular. Jan van Eyck is thoroughly 'Renaissance' in stressing the importance of human beings, while his depiction of the environment here, wonderfully detailed and glowing with light, announces the theme of pure genre painting, to be developed, in Holland above all, several centuries later.

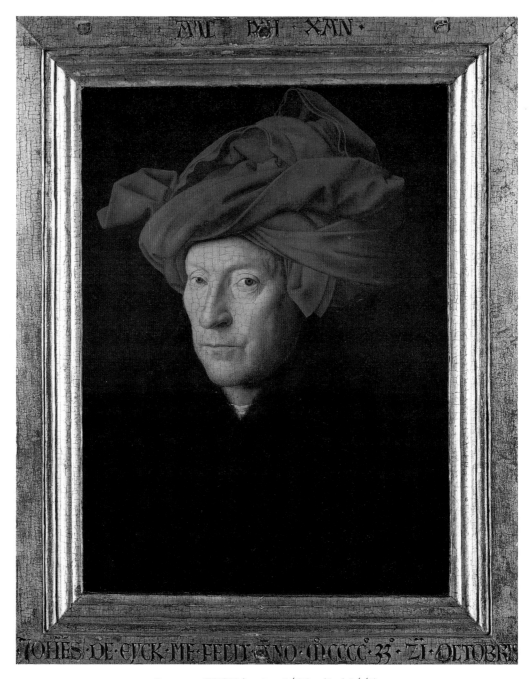

Jan van EYCK (active 1422, died 1441)
A Man in a Turban

The wintry precision which breathes from this small but intense painting is emphasised by the precision with which Jan van Eyck has dated it: 21 October 1433. The slightly pinched features, the border of the fur at the neck and the intricate folds of the bulky red turban surmounting the shrewd face are all mapped with rigorous, almost (as it seems) puritan clarity. If, as has sometimes been thought, this is a self portrait of the painter, he scrutinised himself with the same intellectual severity as his other sitters. In any event, he made out of the cloth head-dress something transcending reality, of abstract beauty, with all the formal coherence of a complex geometrical object.

Robert CAMPIN (1378/9–1444)
The Virgin and Child before a Fire-screen

Campin was active in Tournai and is one of the earliest exponents of new 'realism' in Netherlandish painting, more relaxed in his naturalism than van Eyck, more homely perhaps and less intellectual. He cannot organise space as successfully as van Eyck – the tiled floor here fails to recede illusionistically – but he too surveys the world with great precision. He captures the busy life of a town glimpsed through the window and also the snug, retired feel of the room where the Virgin nurses her naked Child. The plaited, circular fire-screen makes an apt yet entirely naturalistic halo for her head, and in a half-witty additional touch the circumference is broken by one flickering tongue of flame – natural enough but hinting at divine illumination.

Rogier van der WEYDEN (*c.*1399–1464)
The Magdalen Reading

Rogier trained under Campin and became the city painter of Brussels. Unlike Jan van Eyck, he seems never to have signed his work, but his style is highly personal and emotional and was to be extremely influential. A heart beats more obviously in his paintings than in Jan van Eyck's, and he is less of a dispassionate cartographer of people. The reading Magdalen is only a fragment from a larger altarpiece, which must have had at its centre the Virgin and Child. Yet the figure, itself mentally detached and self-absorbed, detaches very well from the rest. With his other gifts, Rogier is a subtle colourist, choosing a beautifully fresh green for the Magdalen's dress, and setting off its freshness by the pure porcelain-white of the slim jar standing beside her.

Rogier van der WEYDEN (*c*.1399–1464)
Pietà

In certain ways, Rogier van der Weyden is the Netherlandish counterpart to
Giovanni Bellini. Both painters seem to experience emotion but understand very well
that for the greatest impact it must be controlled and channelled in art. The subject of
the Pietà gains from such restrained tenderness, as is seen here, as the Virgin caresses
her dead Son's head and clasps His rigid body. With unobtrusive tact, Saint Jerome puts
out one hand to touch the back of Christ's head, while with the other he ushers the
respectfully praying donor onto the scene. Two worlds meet without shock, and the
very human, vividly characterised donor is privileged to kneel close to a
corpse which is that of his Saviour.

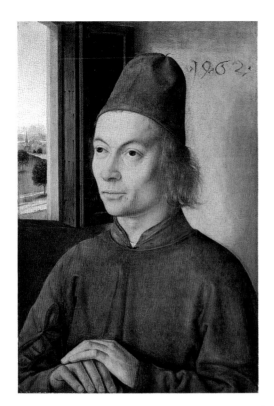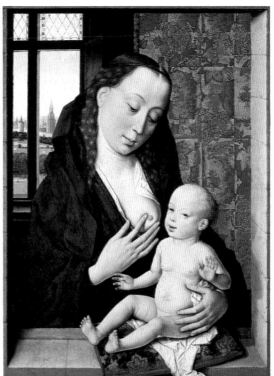

Dieric BOUTS (living 1448, died 1475)
Portrait of a Man

Conscious of the window aperture of a room as the source of light in it, and intrigued perhaps by the shape of its folding wooden-framed glazed shutters, Bouts has virtually created a new type of portrait with this composition. The sitter may not be quite gazing out of the window but he is juxtaposed to the view beyond the opening, whereas earlier Netherlandish portraits had shown faces against a plain background. Bouts paints the play of light convincingly, letting it gently bathe the sitter's head and the wall behind. Mood matches execution, for this portrayal is gentle, unidealised and oddly tender. It was probably planned as a work of art in its own right (not part of a diptych), and in that too it seems quietly revolutionary.

Dieric BOUTS (living 1448, died 1475)
The Virgin and Child

Here it is not so much the window, in the background, that is remarkable as the stone embrasure Bouts has conceived to frame his central group, increasing the sense of looking in to the intimate scene and also serving as a ledge on which to prop the lively Child. As well as the exquisite strip of brocade hanging conveniently behind the Virgin, and painted with great feeling for texture, Bouts provides a brocaded cushion, admittedly a rather unplump one, to prevent the Child's flesh from contact with the stone sill. The cushion also serves, in terms of composition, to break the straight line of the sill. Altogether, in a small devotional painting that might at first appear unremarkable, subtle artistry is everywhere at work.

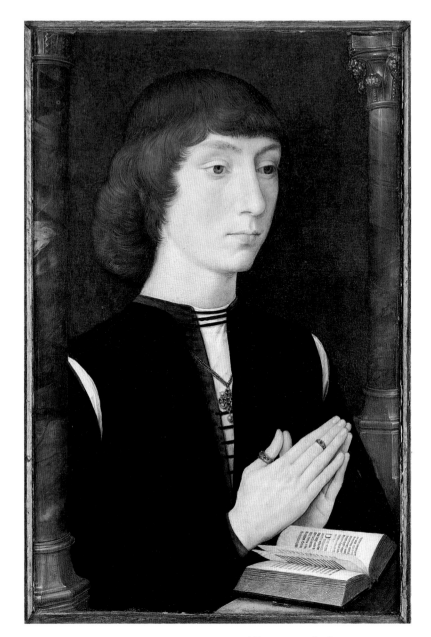

Hans MEMLINC (active 1465, died 1494)
A Young Man at Prayer

Netherlandish painting evolved a highly personal form of the folding diptych,
where two panels open to face each other. One half showed a devotional image, most
often the Virgin and Child, and the other a portrait, usually bust length, of the diptych's
commissioner. (An example from a different School is the *'Wilton Diptych'* on p. 210.)
Two strands of Netherlandish painting were thus brought together. Memlinc's young
man was probably painted as the left half of such a diptych, yet he may actually gain, in
artistic terms, by having become separated at some date from the companion panel.
Certainly the spectator can savour the sitter's care in appearing before the Virgin and
Child in tasteful costume, with well-brushed hair and discreet jewellery. It was proper
that he should sit thus for posterity, and that the painter should convey a firm sense
not merely of his piety but of his whole personality.

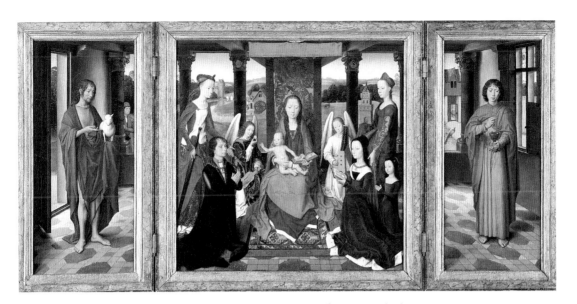

Hans MEMLINC (active 1465, died 1494)
'The Donne Triptych'

Grander than the average diptych was the triple-panel painting, the triptych,
where two side wings opened to reveal a central scene. Some of these were large-scale
works, fixed as altarpieces. Others were smaller and portable, as is this one,
commissioned from Memlinc by Sir John Donne, an Englishman and Yorkist adherent,
who is known to have more than once visited Flanders. Saint John the Baptist and Saint
John the Evangelist are suitably shown on the wings, and Sir John himself, with his
family, kneels amid the saints and angels worshipping the enthroned Virgin and Child.
Memlinc's is a cool and always competent art. Whether the scene here is meant to be on
earth or in heaven, the setting is a spacious, light-filled loggia. Everyone present is
placidly at ease, and the world, in all its agreeable aspects, seems not too far away.

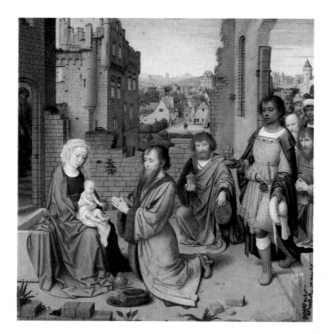

Gerard DAVID (active 1484, died 1523)
The Adoration of the Kings

By the time David was active, the first great Netherlandish painters were dead. New ideals were arising but David seems happy to cling to old ones, and no doubt it suited him to stay in the conservative atmosphere of Bruges, as it slipped into being an artistic backwater. When one looks at David's paintings, it is hard to realise that he outlived Raphael. Yet there is great charm in the tranquillity of mood he depicts and in his delight in clear, bright colour. Half-exotic and yet half-homely, his three Kings are undisturbing arrivals in a delightful Northern Bethlehem, where the stable is a noble ruin and the Virgin and Child demurely receive their homage.

MASTER of SAINT GILES (active *c.*1500)
Saint Giles and the Hind

It is from this painting and its companion-piece in the Collection that the anonymous Master is named. He worked in Paris but seems to have been trained in the Netherlands. Fond of fine, decorative detail, he achieves here an effect that is tapestry-like in its proliferating leaves and flowers, amid which courtly figures take their places. The King of France kneels in respectful apology to the hermit Saint Giles, whose pet hind has been shot at by a royal huntsman. The saint puts one hand consolingly about the deer's neck while in his other the offending arrow is still embedded. Many tapestries of the period show hunting-scenes, but the 'message' of this painting is resolutely against blood-sports.

NETHERLANDISH School (16th century)
A Landscape

This fascinating composition may possibly be a fragment of a larger painting, but
in any event it pays tribute to the steady Northern concern with landscape, beginning by
the sixteenth century to develop as a subject in its own right in art. There is something
lulling about the sinuous line of the wide glassy river flowing past the high and faintly
fantastic mountain peaks. The effect is almost that of a landscape in a dream, so vivid is
everything (down to the snaking shape of a raft in the river) and heightened beyond
normality. Most fascinating of all is the tiny figure of an artist, sketching at the base
of the tall tree at the left — a hint of new attitudes to nature, with men going
out to scrutinise and record the world around them.

 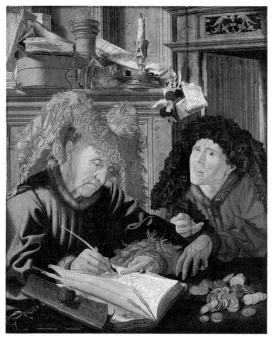

Hieronymus BOSCH (living 1474, died 1516)
Christ Mocked

Bosch is a master of weird, often pungent and disturbing effects, always painted with a precise delicacy that increases their haunting quality. This painting is not entirely typical of him but it has an authentic, nightmare element. Bosch does not intend the spectator to avoid the horror of Christ's ordeal. There is a claustrophobic air to the composition as from the four corners of the picture grotesque faces close in on the fragile figure of Christ. He gazes out, as yet scarcely aware of the impending brutal impact of that crown of thorns that the spectator sees clutched in a mailed fist behind Christ's head, fearful in the unnaturally long spikes of every thorn.

MARINUS van Reymerswaele (active *c*.1509 [?] , died after 1567 [?])
Two Tax Gatherers

The taxman has seldom been other than an unpopular figure in folklore, and the extraordinary pair thought up by Marinus are quintessential bogeymen, fantastically attired, grown withered and half-demented in their feverish grasp on other people's money. Yet there is more to the painting than satire. An interest in grotesque faces can be traced back to Leonardo da Vinci (and beyond, to medieval carving of gargoyles), while to accompany the human study, the painter has created a still life of powerfully modelled forms, assembled from boxes, papers, a book and a thickly dripping candle, that is a remarkable achievement in itself and an indication of serious artistic purpose.

Jan GOSSAERT (active 1503, died 1532)
An Elderly Couple

Gossaert was a fully Renaissance figure, aware of developments in Italian art (he visited Italy) and a painter of mythologies, altarpieces and portraits of the 'warts and all' kind. The present work seems to be his sole double portrait and is somewhat devastating in its depiction of a couple whose life together has certainly not left on their features any trace of amenity. They seem to have asked of the artist only that he should portray them as they were – prosperous bourgeois, verging on old age, neither at prayer nor enjoying any worldly relaxation. And there is poignancy in the resulting double image of bleak truth.

JOOS van Wassenhove (active 1460– *c*.1480/5[?])
Music

There are paintings which seem, perhaps unfairly, more interesting than their
authors. This panel of *Music* is intriguing as a composition and also for its history. The
painter seems to be identifiable with Justus of Ghent, who went to Italy and worked at
the court of Federico da Montefeltro in Urbino. Federico was a great artistic patron as
well as an enlightened ruler and an intrepid soldier. It was probably for his palace at
Gubbio that this highly Italianate painting was done, as part of a decorative series for a
room (the Gallery owns another panel from the series). The inscription along the top of
the picture refers to Federico's position as 'Standard-bearer of the Church'. What the
painting evokes so convincingly is a climate of courtly civilisation, where there
is belief in the reality and virtue of the art of Music, to whom everyone, by
implication, should do homage.

German Painting

Outside the Germanic countries, the German School is rarely well represented in European galleries. In England it has never enjoyed great esteem, with the exception of Holbein, who (in this somewhat comparable to Handel) may be accounted almost English, having settled and died here. Yet the Gallery's holdings, modest though they are numerically, are surprisingly effective; and they carry one from the 'International Gothic' of the beautiful Austrian *Trinity* (p.118) into the seventeenth century, with several fine paintings by Elsheimer.

Little or no effort was made in the Gallery's earliest years to acquire German paintings. The first significant group of early works came in 1854, as the result of a sensible initiative in going to Germany and purchasing a collection of mainly Westphalian pictures. Also in 1854 a striking portrait by Baldung was purchased (p.123), though in the belief that it was by Dürer. Less admirable was the decision to sell off a number of the paintings acquired *en bloc* in Germany. They fetched derisorily low prices. Today, most of them would be welcome in the Collection. No subsequent sale of paintings from the Collection has ever taken place.

Following the death of the Prince Consort in 1861, Queen Victoria presented several paintings in his memory. Thanks to this enlightened gift, the Gallery contains a rare work by Lochner (p.119) and an attractive panel by the Master of the Life of the Virgin (p.121), as well as the anonymous but enchanting *Lady of the Hofer Family* (p.119). The gift also included a large-scale work by a leading painter from the end of the fifteenth century, the Master of the Saint Bartholomew Altarpiece, by whom the Gallery has more recently added other paintings, including the delightful small-scale *Virgin and Child with Angels* (p.122).

Representing Dürer as a painter would never have been easy. The sole work to be associated with him in the Collection is the portrait of his father (p.123), bought in 1904, sometimes doubted as an original. It has historical interest, however, in being almost certainly the painting presented by the city of Nuremburg to Charles I. Holbein was not represented until 1890 with the purchase of his unique and superb double portrait of *'The Ambassadors'* (p.126), painted in London, though the sitters are not English. The only other Holbein in the Collection is of equal rarity and of even greater 'heritage' interest, his sole full-length female portrait, of Christina of Denmark (p.127), painted for Henry VIII. This was dramatically saved for the Gallery in 1909, with the aid of a large last-minute donation, and presented by the National Art-Collections Fund.

In recent years efforts have been made to strengthen representation of other artists, for instance Cranach. A major acquisition in 1980 was the large panel of *Christ taking Leave of His Mother* (p.125) by Altdorfer, a pioneer in atmospheric landscape painting and an artist of European stature. This is a rare example of a fine German painting that had entered a mid-nineteenth-century English private collection. Its heritage status was recognised, and its acquisition made possible by a very generous grant towards purchase by the National Heritage Memorial Fund.

AUSTRIAN School (15th century)
The Trinity with Christ Crucified

This is the central panel of an altarpiece and shows the Trinity as a Throne of Mercy — a type of devotional image popular particularly in Northern Europe. The unknown artist obviously delights in the opportunity he has to create a highly complex architectural throne, partly Gothic and linear, and partly more solidly modelled with awareness of perspective. The whole painting exhibits an international style, characteristic of the years around 1400. It is courtly, sophisticated and colourful. Against the gold background the tall pinnacles of the throne and the exciting, jagged shapes of the angels' wings make for strong decorative patterns, and pattern-making extends to the reverse of the panel, painted all over with green leaves on a white ground.

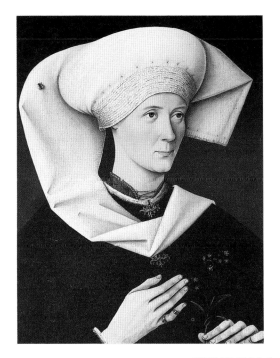 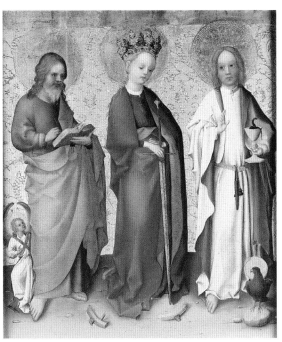

SWABIAN School (15th century)
A Lady of the Hofer Family

While the lady is at least identified, by an inscription at the top of the picture, as born a Hofer, the painter remains unknown. Clean, keen draughtsmanship gives to the sitter, her costume and the composition generally memorable candour and charm. The sprig of forget-me-nots she holds has worked its spell remarkably effectively. From her slim hands to her elegantly goffered head-dress, the sitter survives down the centuries. The painter further shows off his own art by putting a trompe-l'œil fly on the crisp linen of the head-dress — symbol of mortality, perhaps, or just part of the painting's artistic high spirits.

Stephan LOCHNER (active 1442, died 1451)
Saints Matthew, Catherine of Alexandria and John the Evangelist

Very few paintings by Lochner survive (those that do remain chiefly in Germany). 'Master Stefan' was a famous painter in Cologne, and when Dürer was there in 1520 he gave two pfennigs to have Lochner's great altarpiece (now in the cathedral) opened for him. The present painting is the left-hand wing of another, smaller altarpiece, painted by Lochner for a church in Cologne. It shows his almost flower-like delicacy of colour and his gentle, pious sentiment, which is much closer to Germanic artistic ideals than conventional suppositions about gruesome scenes of martyrdom or ubiquitous 'expressionism'.

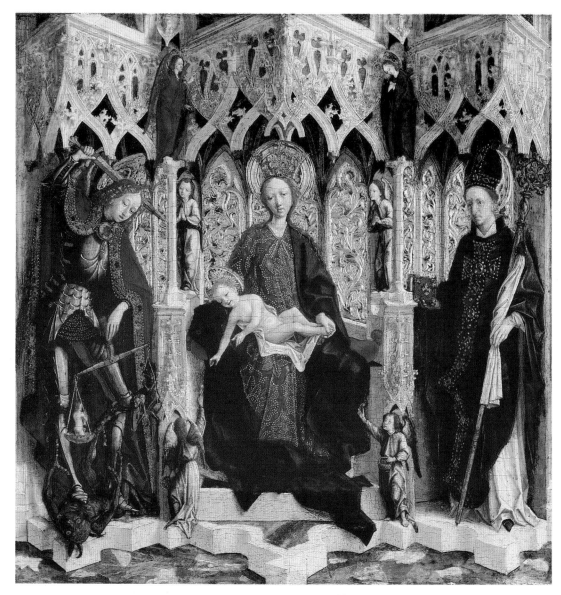

Circle of Michael PACHER (active 1465[?], died 1498)
The Virgin and Child Enthroned with Saints and Angels

Pacher was active in Salzburg and the Tyrol as both painter and sculptor, and some flavour of his distinctive style can be experienced in this admittedly small-scale painting, of uncertain authorship. The highly elaborate sculptural canopy over the figures and the types of those, each as if carved and placed in a niche, seem conscious echoes of his work. The tonality is unusual and individual. No lack-lustre 'follower' devised the deep plum-coloured chasuble and matching mitre of the bishop-saint, both richly sewn with gleaming pearls, as is the Virgin's dress. Quality is allied to rarity here. The actual panel provides some clue to location — if not to the artist. It is made of silver fir, suggesting that this unusual work originated in the area of the South Tyrol.

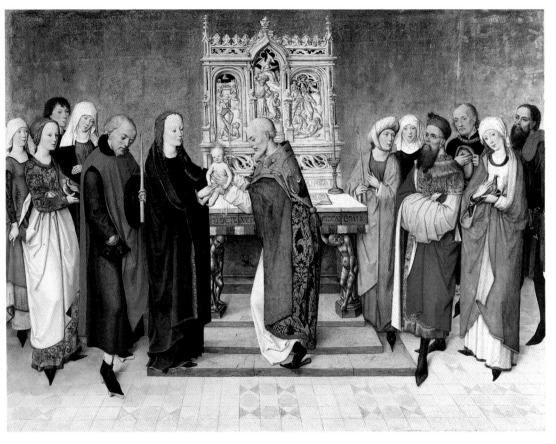

MASTER of the LIFE of the VIRGIN
(active 2nd half of the 15th century)
The Presentation in the Temple

The Master is named after a series of eight panels depicting scenes from the
Virgin's life (all except the present one in the Alte Pinakothek in Munich). The series was
painted for the church of St Ursula in Cologne and commissioned by a local councillor,
Dr Johann von Schwartz-Hirtz, possibly around 1460. The scene represents the
Purification of the Virgin, as well as the Presentation of Christ, and hence the doves held
by women on each side of the central incident. The painter was presumably German but
deeply – and agreeably – under Netherlandish influence, especially that of Rogier van
der Weyden. From that source derive the choice colours of the costumes and the
strongly characterised heads. Notable in both these ways is the bearded man
to the right of the altar, who seems to be a significant yet perhaps pagan
witness of the Christian rites.

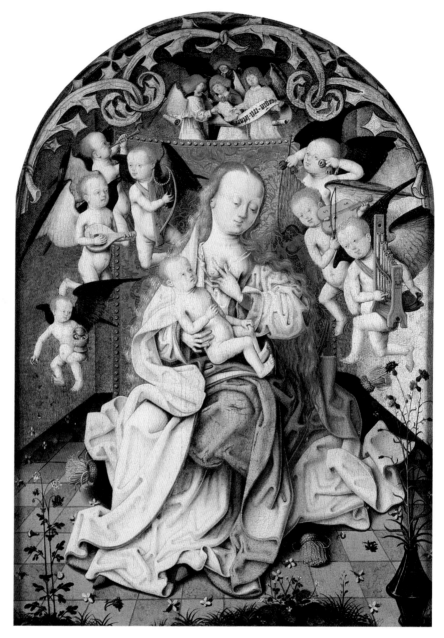

MASTER of the SAINT BARTHOLOMEW ALTARPIECE
(active late 15th/early 16th century)
The Virgin and Child with Angels

Anonymous though the Master is (named after an altarpiece now in Munich but painted for Cologne), he is one of the most lively and original of early German painters. He is capable too of conveying a variety of moods, depending on the purpose and scale of the work. In this small panel, the mood is one of undiluted joyousness. Almost mischievously, lively airborne young angels serenade the Virgin and Child, while the smallest one, who is perhaps too young to join the orchestra, scatters flower-petals as his contribution to the celebrations. Everything contributes to a sense of delight, and the message of the composition is reiterated by the words written on the scroll above the Virgin's head, 'Queen of Heaven, rejoice'.

Ascribed to Albrecht DÜRER (1471–1528)
The Painter's Father

Dürer painted and drew his father on several occasions. He also wrote about him
in what remains of his 'family chronicle', describing him as a man who had had a hard
life and who was unsocial, taciturn and god-fearing. This image seems to accord well
with those words. According to the inscription along the top it was done when the sitter
was aged seventy, in 1497. Whether or not the portrait is Dürer's original, it is the best
surviving replica of the design, and shows his father as very much a plain, old-style
unostentatious craftsman – he was a goldsmith – very different from Dürer's
presentation of himself, graceful and often smartly dressed, in his self portraits.

Hans BALDUNG Grien (1484/5–1545)
Portrait of a Man

Baldung may have studied with Dürer, and it was perhaps Dürer's example that
encouraged his own almost obsessive vision, which was to produce a fascinating range
of paintings, as well as superb graphic work. Baldung is too little known outside the
Germanic countries. Portraiture was only one aspect of his art, but he could fasten on a
sitter – as here – with an intensity of gaze that is almost sinister. The results are far
more nervous and idiosyncratic than in contemporary Netherlandish portraits. The
textures of the sitter's hair, beard and heavy fur collar seem invested with a life of their
own, springing and curling like so many tiny coiled wires, as vibrant and tense as are his
steep eyebrows and pale, staring eyes. A final near-surreal touch is provided by the cap-
badge swinging at the side of the face, like a detached, jewelled, third eye.

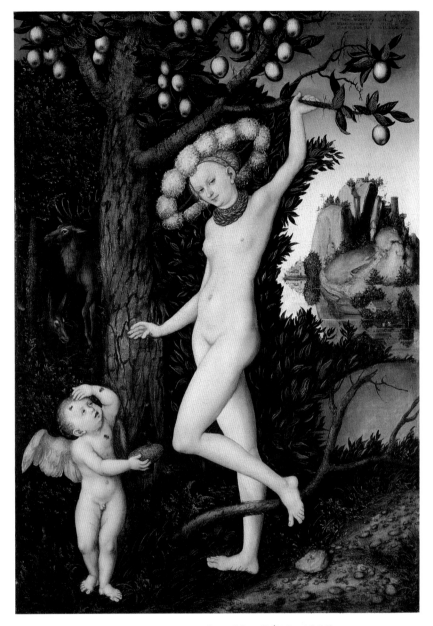

Lucas CRANACH the Elder (1472–1553)
Cupid complaining to Venus

Cranach is the perfect court-artist of Germany. In his highly enamelled mythological paintings he fondly includes the mountains, lakes and forests of the North, making the mountains steeper and the forests even darker and deeper than in reality. Provocatively naked, wearing only a necklace and a fashionable hat, his Venus adapts herself very well to a Northern climate and seems to be as at home as the deer amid the thick undergrowth. She barely listens to Cupid's complaint that the bees whose honeycomb he stole are stinging him, appearing more concerned to allure the spectator. The subject derives from the Greek classical poet Theocritus. Here a moral admonition is written on the painting, stating that thus are we stung when seeking pleasure. Like a more reckless Eve, Cranach's Venus seems determined to give the lie to any such restrictive attitude, offering at once herself and apples of pleasure galore.

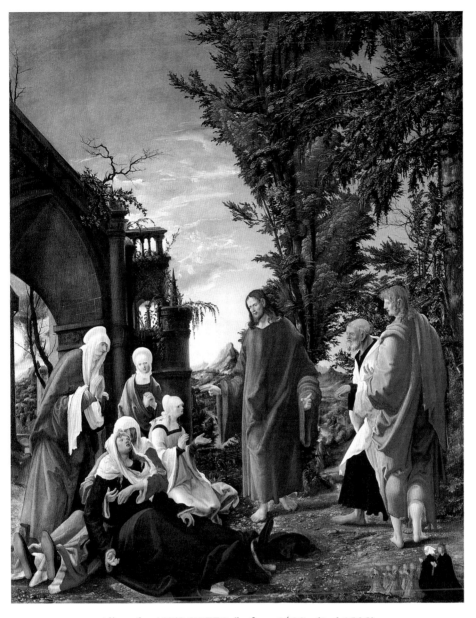

Albrecht ALTDORFER (before 1480, died 1538)
Christ taking Leave of His Mother

The Gospels do not speak of Christ taking leave of His Mother before going out to begin His ministry, but medieval and later texts refer to it and it became a subject for Passion plays. Altdorfer was possibly influenced by the drama and pathos of such spectacles in his own treatment, where the Virgin sinks in a swoon at the moment of parting. The scene is set outside a Northern city-gate, with some of the Holy Women wearing head-dresses similar to that of the lady born a Hofer (see p.119). Above all, Altdorfer seizes the opportunity to create a Northern, positively Danubian, landscape of soaring tree-trunks and bright foliage against a radiant sky of alpine blue. Emotion has heightened everything, including the tall figure of the scarlet-clad Saint John, and by contrast there is something solemn and affecting in the minute figures of the donor and his wife and their children, kneeling to witness this highly charged sacred incident taking place in the familiar surroundings of their native land.

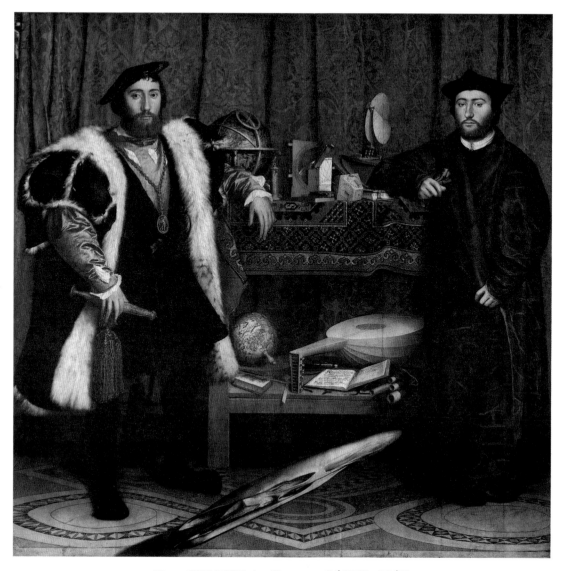

Hans HOLBEIN the Younger (1497/8–1543)
'The Ambassadors'

Apt and well-established as is the popular title of this painting, it is not strictly correct. The two men shown – Jean de Dinteville and Georges de Selve – never served as ambassadors together, though Dinteville was the French ambassador at the court of Henry VIII when this complex double portrait was painted, in London, in 1533. Together they admirably stand for state and church: Dinteville resplendent at the left and at the right the more sober Selve, a bishop, who had come over to London to visit his friend, the ambassador. Between them Holbein assembles a host of musical instruments and other objects expressive doubtless of their tastes. The composition is like a High Renaissance re-working on a bold scale of Jan van Eyck's Arnolfini portrait (p.104), commemorating not a marriage but a meeting and friendship. Pride and pleasure in life might seem to breathe from the painting, but Holbein adds a presage of mortality. When seen from an angle close to, the distorted foreground object takes shape as a skull, putting into perspective, as it were, human existence.

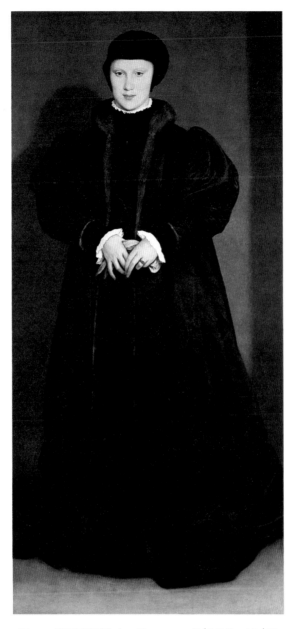

Hans HOLBEIN the Younger (1497/8–1543)
Christina of Denmark, Duchess of Milan

In 1538, at the age of only sixteen, already married and widowed, Christina of Denmark, dressed in mourning, posed in Brussels for 'thre owers space' to Henry VIII's painter, Holbein. The King was seeking a fourth wife, and the sitter, niece of the Emperor Charles V, appeared a desirable candidate. She escaped that fate, and Henry VIII seems to have parted with this subtle full-length portrait which Holbein must have painted on his return to London, based on a study done on the spot. The very fact of Christina posing in mourning aided Holbein's effect, conveying her height by the dark silhouette against the blue-green background, and setting off her ivory-pale hands, whose beauty was much praised, against the varying textures of her black robes. If *'The Ambassadors'* is almost too rich in display of virtuosity, here Holbein succeeds by simplicity – though it is a simplicity achieved by equal artistic cunning.

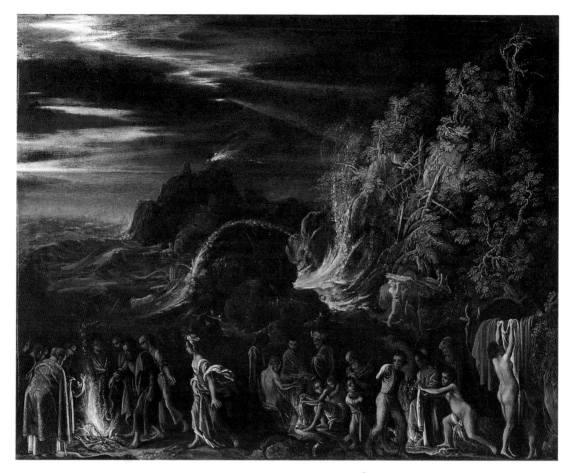

Adam ELSHEIMER (1578–1610)
Saint Paul on Malta

It is typical of Elsheimer, sensitive and keenly responsive to unusual effects of light, that he should set this scene, which occurred by day, according to the *Acts of the Apostles*, in a dark and stormy night, illuminated by lightning flashes and glowing fires. In some ways, Elsheimer is Altdorfer's heir; he is certainly a poetic interpreter, most often on a small scale, as here, of nature and atmosphere. He left Germany and by 1600 was settled in Rome. For the remaining decade of his life he developed his own interpretation of religious and mythological themes, usually with landscape elements, creating paintings which are among the most original and attractive of all the splendours of seventeenth-century art. They had their influence on Claude, and Elsheimer's premature death was to be lamented by Rubens.

Flemish Painting

The two greatest exponents of seventeenth-century Flemish painting were Rubens and van Dyck. Both were bound to be familiar to collectors and connoisseurs in this country since both had been directly patronised by Charles I. Van Dyck, in particular, as an artist living and dying here, and as the portraitist not only of the King and his family but of English society in general, might have been expected to be strongly present in the Gallery Collection from the first.

Yet the position proved much less straightforward, though both painters were included among the Angerstein pictures purchased at the Gallery's foundation in 1824. Van Dyck's finest British portraits tended to remain in the families of the sitters, while certain characteristic aspects of Rubens' art — like his large-scale religious paintings — were little to the taste of Protestant collectors. It was, rather, Rubens the landscape painter who was esteemed here; and a superb and personal example, a great atmospheric panorama, the *View of Het Steen* (p.134), was given by Sir George Beaumont in his gift that instigated the founding of the Gallery. In 1828 the Duke of Sutherland made a munificent gesture by presenting *Peace and War* (p.132), painted for Charles I, and significant for its 'heritage' aspect, in addition to its aesthetic quality. Unafraid, it seems, of conventional Victorian values and admirably free from prudery, the Trustees bought Rubens' sensuous *Judgement of Paris* (p.132) in 1844, paying no less than 4,000 guineas for it. When Sir Robert Peel's collection was purchased in 1871, great Flemish as well as Dutch paintings came to the Gallery, including Rubens' *Susanna Lunden*, better known as *'Le Chapeau de Paille'* (p.133) which had inspired several later painters, culminating in Lawrence's portrait of Lady Peel.

Not until 1881 was a truly major portrait by van Dyck acquired. In that year, with the Blenheim sale, the Trustees were able to buy the great equestrian portrait of Charles I (p.137), painted for the King but sold abroad at the time of the Commonwealth, returning to this country as a gift to John, 1st Duke of Marlborough. Other leading Flemish painters, like Jordaens and Teniers, were represented at first only fitfully. Jordaens' *Holy Family* (p.135) was presented by the Duke of Northumberland in 1838, and Teniers' fine view of Het Sterckshof (p.140) was bought in 1871. Acting, it seems, largely on aesthetic grounds, the Gallery made a quietly inspired purchase in 1883 of the *Portrait of a Boy* (p.138) by Jacques van Oost (though the painting was then supposed to be Dutch and by Isack van Ostade).

During the twentieth century, opportunities have been taken to build up representation notably of both van Dyck and Rubens, aided by some generous gifts. Rubens as a figure painter on a large scale remained not well represented (the Collection still lacks an altarpiece by him) and acquisition in 1980 of his fairly early masterpiece, *Samson and Delilah*, done in Antwerp on his return from Italy, was particularly welcome. In the last few years several paintings by van Dyck have been purchased, the latest, the *Balbi Children* (p.136), bringing a major example of van Dyck's brilliant Genoese period, which was previously unrepresented in the Collection.

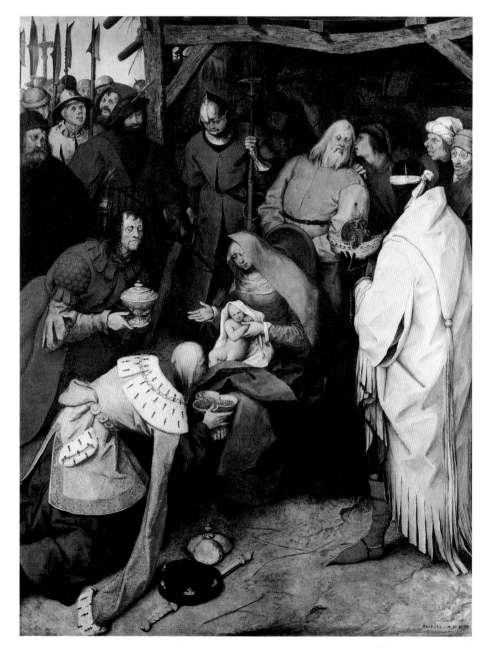

Pieter BRUEGEL the Elder (active 1551, died 1569)
The Adoration of the Kings

There could be few more radical re-thinkings than this of a subject familiar
enough and normally the occasion for placid depiction, with a certain amount of luxury
and exotic display. Bruegel surely means to shake, if not shock, the spectator into fresh
awareness of the implications of the subject. His semi-foetus-like Christ Child has been
born in a harsh, peasant environment, in a crude, bare barn of a stable and is being
gawped at by the round-eyed, not unthreatening soldiery. Apart from the standing
negro King, holding his beautifully crafted gift of a shell-shaped *nef*, the Kings seem
doddering figures, blindly worshipping without fully comprehending. Thus, Bruegel
asserts, is how it might be if Christ were to be born again, in the Netherlands of the
painter's own day.

CATHARINA DE
HEMESSEN
PINGEBAT
1551

Katharina de HEMESSEN (1527/8– after 1566[?])
Portrait of a Lady

It may be true that women artists have tended to be under-valued or even ignored in conventional art history. Katharina de Hemessen's name is certainly not a familiar one, though she was by no means an obscure figure in her day. The daughter of an Antwerp painter, she specialised in small portraits, usually of women, in a style very similar to this one. Her lively grasp of character is revealed here and confirmed in other portraits. For all the sitter's finery, she and her pet dog are seized with quite unflattering honesty, and the miniature scale has not prevented the painter from portraying features marked, it seems, not only by life but by thought.

Sir Peter Paul RUBENS (1577–1640)
The Judgement of Paris

For all the earlier achievements of Flemish painting, there had been no adequate preparation for the arrival on the scene of a genius of the stature of Rubens. He is a painter of all-round accomplishment. Not since Titian had a painter shown such gusto in dealing with the theme of the female nude. In this quite late work, Rubens' mastery extends from the bodies of the contending goddesses to the lush country setting. Paris proffers the apple to the blond central Venus – whom Rubens himself would probably have chosen – but the sensuous shape of Juno's bare back, set off by a sweep of fur-lined, rich robe, is itself worthy of an award.

Sir Peter Paul RUBENS (1577–1640)
Peace and War

It was his involvement in European diplomacy that brought Rubens to England in 1629, and he was to be knighted by Charles I. Passionately concerned with the cause of peace between nations, Rubens here creates in paint the vision for which he strove in his diplomatic activity. Suitably enough, he presented it to Charles I. Mars, the god of war, is being led away by Minerva, leaving Peace free to nourish the infant Plutus, god of wealth, while the fruits of the earth and the blessings of prosperity take on solid, sumptuous shape. In his own idiom, Botticelli had once painted *his* vision of cosmic peace (see p.32), and Rubens restates the concept for a new Baroque age.

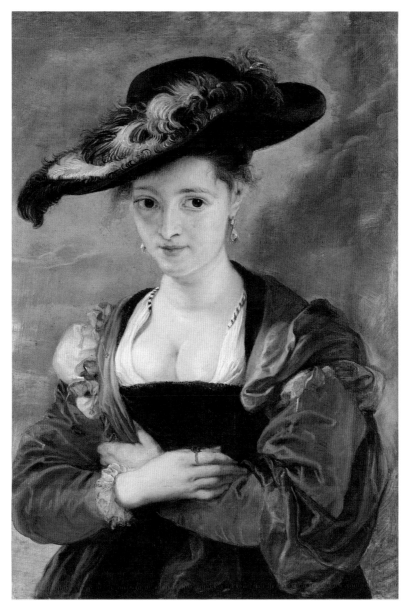

Sir Peter Paul RUBENS (1577–1640)
Susanna Lunden ('Le Chapeau de Paille')

'Spectator, I married her', might seem what the creator of this wonderfully vivacious and enchanting portrait is proclaiming here. It was in fact the sitter's younger sister whom Rubens was to marry, some years after this painting was done, when his first wife had died. All the same, it may have been painted as a wedding portrait, possibly executed around 1633 when the sitter married Arnold Lunden. The paint is laid onto the panel with a freshness and energy which leave the whole surface tingling. Managing pigment with almost musical effect, Rubens modulates the tempo of it, making it writhe in the curling feathers on the hat and the flying tendrils of hair escaping from under it and then move more slowly, clotting to conjure up the creamy skin and the bewitching, faintly shadowed face. Wide-eyed and forever on the brink of a demure smile, Susanna Lunden comes alive under Rubens' brush with a force that remains astonishing.

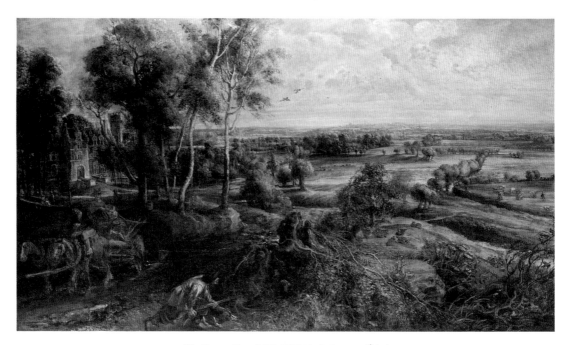

Sir Peter Paul RUBENS (1577–1640)
An Autumn Landscape with a View of Het Steen

In 1635 Rubens bought the lordship and manor of Het Steen, some way from Antwerp, and increasingly he passed his time there. Purchase of the house was not in itself the instigation for his painting landscapes – they had long been an aspect of his wide-ranging art – but it must have deepened his feelings for the land. In this panorama of an autumn morning, he lets his gaze rove over the gently rolling, well-wooded countryside as it stirs into activity at sunrise and the first rays of distant sun strike across the composition to glint in the windows of his own house. The painter's never-failing delight in the physical world is movingly conveyed; in the medium of paint he robustly echoes Milton's lines in *L'Allegro*, written only a few years earlier: 'Straight mine eye hath caught new pleasures/Whilst the landskip round it measures.'

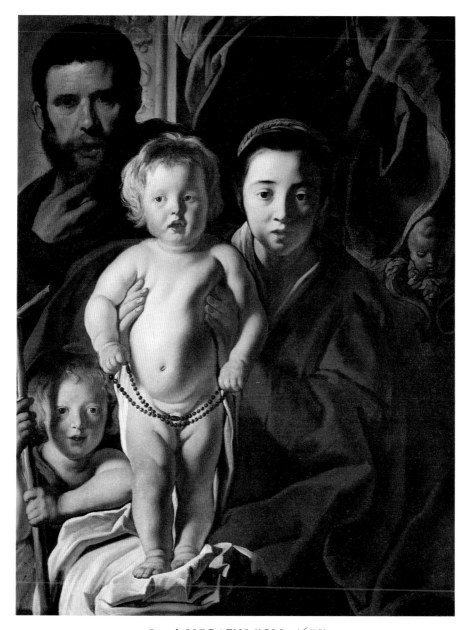

Jacob JORDAENS (1593–1678)
The Holy Family

In terms of age alone, Jordaens was the next senior painter in Antwerp after Rubens. A painter of hardly less boldness, he perhaps suffers in esteem today and is partly overshadowed by Rubens. Although he came from the Catholic Southern Netherlands, he developed Protestant sympathies and was to be buried across the border, in the Northern Netherlands. In this painting his imagery is strongly Roman Catholic (the Christ Child holds a rosary), but he depicts the Holy Family as very much an ordinary, almost homely family. The figures positively confront the spectator, and the sense of confrontation is emphasised by strong, Caravaggesque contrasts of light and shade.

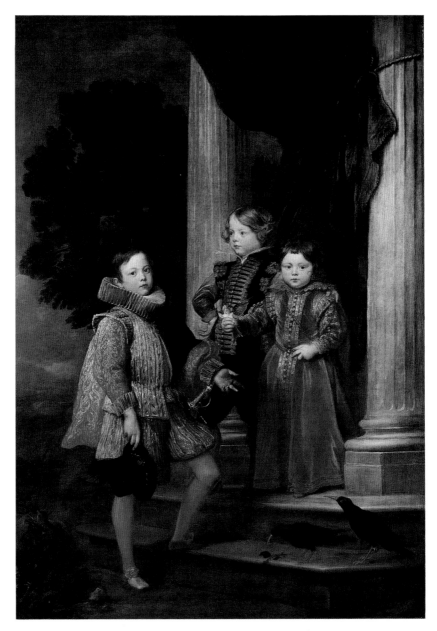

Sir Anthony van DYCK (1599–1641)
The Balbi Children

Destined to a hectic life and an early death, van Dyck was an independent painter
by the age of seventeen. He arrived in Italy from his native Antwerp in 1621, making a
virtual base in Genoa. There he found in the local patricians, their wives and especially
their children material for his highly sensitive, half-romantic portrait ability. Partly
inspired by Titian, whose *Vendramin Family* (p. 76) he later owned, he created a series
of marvellous images, grand and intimate by turn – and occasionally, as here, a mixture
of both. The rich red and black tonality of this group portrait – which extends to the
pair of tame choughs – seems to follow Titian's famous dictum that those colours, with
white, are sufficient for a painter. What is strikingly novel in van Dyck's art is the
importance given to children, painted full length and shown as poised between
the shelter of their palatial home and the outside world.

Sir Anthony van DYCK (1599–1641)
Equestrian Portrait of Charles I

The tablet prominently hooked on a tree-trunk at the right declares that this is
Charles, King of Great Britain. Around his bare-headed, armoured sitter, mounted on a
fine bay horse and riding out proudly in the countryside, van Dyck has woven
impressive associations of chivalry, personal glamour and royal status that scarcely
need words to confirm. Charles I took van Dyck into his service in 1632 and gave him a
knighthood. Van Dyck gave the King something much greater – immortality. The
physically slight, if dignified, monarch, a notable patron of the arts but no adroit ruler,
becomes the perfect image of kingship. No premonition of Civil War or of the execution
of the King mars the painting's artistic confidence and triumph.

Jacques van OOST the Elder (1601–1671)
Portrait of a Boy aged Eleven

The boy's age is given on the painting, along with the painter's initials and the date 1650, but his identity is unknown. This scarcely matters. He and his winter costume, inclusive of muff, made sufficient impression on a fairly obscure artist, active in Bruges, for this memorable portrait to result. Its tonal subtlety and restriction (recalling by chance Boltraffio's male portrait on p. 70) are accompanied by subtlety of characterisation. A little pensive, a little conscious of posing for his portrait and even perhaps a little proud of his fur hat and muff, the boy was to be seen by Walter Pater as the youthful incarnation of his philosopher-figure, Sebastian van Storck, in an 'imaginary portrait' published in 1886, three years after the Gallery acquired the picture.

Gonzalez COQUES (1614 or 1618–1684)
A Family Group

Although now little regarded, Coques was a leading portrait-painter in Antwerp, specialising in small-scale compositions, like this one, with figures full length. This prosperous family takes the air in presumably its own handsome garden, with a nice mingling of dignity in the father and liveliness in the younger children. Coques' deft touch captures convincing likenesses and all the details of costume – not least the profusion of fine lace displayed. Such art is more than mere record-making. For this family Coques was at his most spirited and responsive, and he signs off, artistically speaking, with the little flourish of the two foreground frisking dogs.

David TENIERS the Younger (1610–1690)
A View of Het Sterckshof near Antwerp

This painting was traditionally supposed to represent Teniers' own country
house, whence it followed that he and his family appeared as the figures receiving the
tribute of a fish offered by a peasant. Although that cannot be quite correct, the mood of
the painting is not greatly affected. The scene combines portrait-like people and rustic
daily life, set in an atmospheric landscape – all painted with the greatest delicacy.
Teniers was far more esteemed in the eighteenth and nineteenth centuries than today,
but his art deserves fresh appreciation. In one way he marks the end of an artistic line
descending from Bruegel, whose granddaughter he married. Yet it seems symbolically
apt that within his lifetime occurred the birth of Watteau.

Dutch Painting

The artistic links between England and Holland are very long standing and take one back at least to the time of Anne of Denmark, the mother of Charles I, who died in 1617 and whose own collection of paintings included some 'Dutch Kitchens'. By the mid-seventeenth century English collectors and connoisseurs were well aware of the achievements of the flourishing contemporary Dutch School, and later generations of collectors were to confirm a national predilection for Dutch painting which could be said to rival that for Italian art.

As a result, the Gallery's Collection is both extensive and of superb quality, though its character derives so strongly from British private taste and connoisseurship that it tends to lack examples of history or large-scale figure compositions (an aspect of Dutch art that did not appeal to collectors here). Thus although paintings by Rembrandt were in the Collection from the time of its foundation, no large, major subject-painting by him was acquired until 1964, when *Belshazzar's Feast* (p.175) was purchased.

In the early rather haphazard days of the Gallery's existence there seems to have been no particular policy or activity pursued with regard to representing the Dutch School. Even under Eastlake, this aspect of things did not greatly change, though with his successor, Sir William Boxall, the first painting by Pieter de Hooch was purchased, in Paris in 1869, the *Woman and her Maid in a Courtyard* (p.169). De Hooch's was not then a widely familiar name, and even less known was Vermeer, whose *Young Woman standing at a Virginal* (p.171) had been in the collection of his nineteenth-century champion, Thoré, and was bought in 1892.

It was the purchase in 1871 of the larger part of Sir Robert Peel's own collection that dramatically improved the holdings of Dutch art. Peel had exercised discrimination of a fastidious kind, supported by enormous wealth. Landscape was obviously one major aspect of his taste, and the Gallery thus acquired Hobbema's *Avenue* (p.151) and Ruisdael's *Pool surrounded by Trees* (p.146), as well as the glowing Italianate scene by Berchem (p.148) and Cuyp's *Ubbergen Castle* (p.149).

Five years after purchase of the Peel collection the Gallery benefited substantially from the generous bequest of Wynn Ellis, among whose many Dutch pictures were the Jan van de Cappelle *River Scene* (p.155) and the delightful *Architectural Fantasy* (p.165) by Dirk van Delen. In 1910 there was an even more substantial bequest, by George Salting, whose fine Dutch pictures included an exceptionally evocative and poetic Steen (p.164) as well as the calmly luminous church interior by Saenredam (p.168).

At most subsequent periods the opportunity has been taken to buy judiciously and strengthen the already notable collection. A very rare Fabritius portrait (p.173), possibly of the painter, was bought in 1924. In recent years the Dutch acquisitions have ranged from a tranquil masterpiece by ter Brugghen, *The Concert* (p.157), to Hals' brilliant *Boy with a Skull* (p.162). Still life is an area where representation has been unexpectedly weak, and the Gallery therefore was the more grateful for the bequest in 1978 by R.S. Newall of a splendid still life by Kalf (p.167).

Hendrick AVERCAMP (1585–1634)
Winter Scene with Skaters near a Castle

Knowing that Avercamp was a deaf-mute may make one too glibly detect a
compensating expressive eloquence in the action and gestures of the people who
animate his typical winter scenes. Yet it is true that his figures mime their parts with
convincing vivacity, as on skates they dash and dance, slide or tumble over the ice.
Winter has had a carnival effect, creating an open-air ballroom on the frozen water, and
a whole society comes out to enjoy it. The circular shape of this composition
encourages one's sense of peering into a lively peep-show, where the different
generations are shown having fun in different ways, and where atmosphere also is
subtly perceived, from the bare foreground tree, on whose cold branches a few
birds perch, to the distant roofs receding amid delicate veils of chill mist.

Bartholomeus BREENBERGH (1599/1600[?] –1657)
The Finding of Moses

Breenbergh is only one of numerous examples of the beneficial effect of Italy on Dutch painters who went there. The present painting is dated 1636 and was executed on his return to Holland after a stay in Rome of some years. In it the painter recalls the Italian landscape, partly under the influence of artists he must have met in Rome, but blends it with elements of pure fantasy, to give a vaguely 'Egyptian' air to the scene. The result is delightful and none too serious. A grain of humour seems to have crept into the foreground figure-group, where Pharaoh's daughter gesticulates at the cheerful, rustic woman clasping the infant Moses, and the little negro train-bearer stares stupefied at the incident.

Jan van GOYEN (1596–1656)
A Windmill by a River

Goyen is one of the early leading interpreters of the Dutch landscape at its most undramatic, drawing as well as painting it with obsessive concern in a busy career. And the less obvious the subject, the more effectively does Goyen respond to it. Drawing can be felt to underlie this painting, with its rapid, scribbled pencilling of pigment and its tendency towards monochrome tonality. A rather frail-seeming windmill on an expanse of low-lying land, unobtrusively peopled by a few blobs of tiny, hunched figures (mainly seen in silhouette from the back) and almost merging into water at the river's edge, constitutes the composition. Goyen allots by far the larger proportion of space to the sky, where light breaks from muffled cloud and passes in gleams over land and water, giving a wonderful sense of atmospheric mood and movement that Constable might have envied.

Salomon van RUYSDAEL (1600/1603[?] –1670)
River Scene

The uncle of the famous landscape painter, Jacob van Ruisdael, Salomon van Ruysdael is a distinguished painter in his own right. Uncle and nephew must have been well aware of Goyen's art, and in fact Goyen is recorded in 1634 – two years before this picture was painted – working in the house of Salomon's brother in Haarlem, where the family had settled. The long shape of the painting here is typical of Salomon's earlier output, when arguably he was at his most sensitive. He is fond of echoing the long shape with the motif of a long, receding rim of tree-lined banks by the edge of a wide river, fixing the strip of land between expanses of water and sky. The tonality of this painting is darker and more dramatic than is Goyen's, and the painter declares himself very much his own master.

Jacob van RUISDAEL (*c*.1628–1682)
A Pool surrounded by Trees

This is one of Ruisdael's most majestic compositions, diminished only by not being in perfect state. It comes from Sir Robert Peel's collection and appears to be the very Ruisdael he indicated to a visitor as giving him, 'in an interval of harrassing official business', feelings of tranquillity. At the centre of the scene is a less than tranquil incident of a hare swimming for its life, pursued by hounds urged on by hunters. Nature, as always with the artist, seems superior to mankind. Even the stricken and fallen trees have a sort of majesty, though they contrast with the healthy, full-foliaged ones that fringe the pool, itself enlivened by the crop of water-lilies. The seventeenth century was the great age of landscape, and this painting has affinities, unexpectedly perhaps, with a closely contemporary painting from Southern Europe, Rosa's *Landscape with Mercury and the Dishonest Woodman* (p.92).

Philips KONINCK (1619–1688)
An Extensive Landscape

Koninck provides the antidote to any feelings of claustrophobia induced by Ruisdael's deep woods and overgrown pools. His typical panoramas, of which this is an outstanding example, send the eye on an exhilarating journey through space, skimming over alternations of light and shade as they streak the flat countryside, to encounter here the glinting line of distant water on the low horizon, dividing the land from the great cloudscape above. Prized today as the master of such effects, Koninck was known in his own period chiefly as a genre and portrait-painter.

Jacob van RUISDAEL (*c.*1628–1682)
The Shore at Egmond-aan-Zee

This deceptively simple-looking painting is not the most typical work by Ruisdael, being more seascape than landscape, but it is powerfully stamped as his work through the intense response to the elements which breathes from it. The restless, foam-crested waves rolling in along the beach, under an unsettled, ominously livid sky, create a mood that is at once stirring and melancholy. It seems inevitable that these forces will wear away the land, and indeed before the middle of the eighteenth century the sea had engulfed the dunes and the church Ruisdael depicts at the right.

Nicolaes BERCHEM (1620–1683)
Peasants with Cattle by an Aqueduct

Perhaps Italy could never be quite as enchanted as it appears here, where a lonely
part of the Roman campagna is flooded with Southern sunlight that pours like wine
over the ruins of an aqueduct and washes its flanks, as well as those of the cattle cooling
off in the stream at its base. This is Berchem's dream of the Italy he had known,
recollected in a Northern climate when he probably realised that he would never revisit
the South. Berchem may have gone to Rome in his early thirties, and after returning to
Holland settled down to become the leading Dutch painter of Italianate pastoral subjects,
as well as producing enchanting, fanciful harbour scenes. In them, he seems to look
forward to the rococo, whereas here the motif of the creeper-covered antique ruin,
rising against the glowing sky, presages Romanticism.

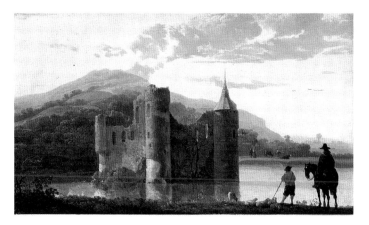

Aelbert CUYP (1620–1691)
Ubbergen Castle

Cuyp has for long been popular with British collectors. In the Gallery Collection he is represented by a good group of paintings, though none shows him at his finest on a large scale. In quality alone, however, this small example takes its place with his best work (and it too, unsurprisingly, belonged to Peel). Cuyp was no great traveller outside Holland and remained active in his native city of Dordrecht. The ruins of Ubbergen Castle, just outside Nijmegen, provide him here with sufficient pretext for a lyrical interpretation of light effects: from the radiant cloud-flecked sky to the flawless mirror of the river. Light clusters like lichen on the castle walls, and in the liquid prism Cuyp has devised everything floats with magic luminosity.

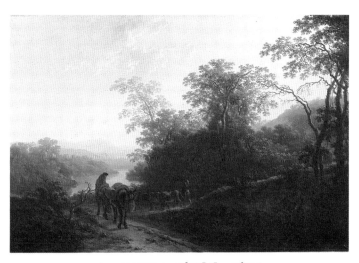

Jan BOTH (*c.*1618[?] –1652)
Peasants with Mules and Oxen near a River

Both preceded Berchem to Rome and must have received rather similar inspiration from Italian light and scenery. He too returned to Holland but had barely a decade of activity before him. In that period, however, he created his own vision of the Italian landscape, where misty distances are interspersed with bursts of glittering foliage. This painting is one of his most delicate, suggesting a tremulousness in nature as the day gradually unfolds. Such work uncannily anticipates, not least in its poetic approach, some of Gainsborough's later landscapes.

Jan van der HEYDEN (1637–1712)
The Huis ten Bosch

The 'house in the wood' is the small palace on the outskirts of The Hague, built, when van der Heyden was a boy, for the wife of Prince Frederik Hendrik of Orange. This view is of the garden side of the original building and captures – among other things – the charm of leisured life in a sunny, well-tended garden setting, where nothing is too grand or awe-inspiring. Van der Heyden likes bright sunlight, in which he can define each shape, not least the undulating line of the foreground hedge. His eye for buildings made him a great painter of city-scapes, and he is as much the inspired interpreter of the urban scene as Ruisdael is of the countryside.

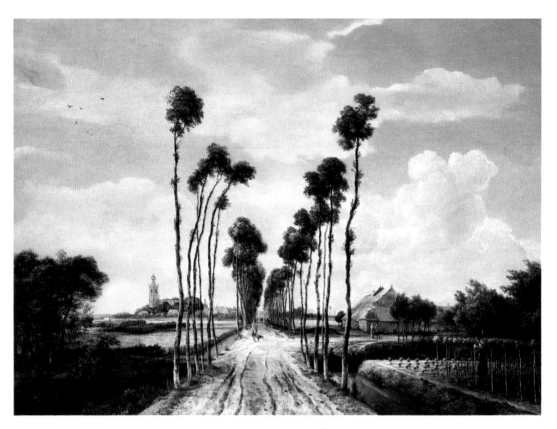

Meyndert HOBBEMA (1638–1709)
The Avenue, Middelharnis

So many truly great and original landscape painters were produced in seventeenth-century Holland that it is not easy to see why a merely competent artist like Hobbema enjoys the repute he does. *The Avenue* may be a partial explanation, for it is a highly memorable composition, as result of which it occupies a position in painting somewhat equivalent to that in poetry of Gray's *Elegy*. Middelharnis is a village on the island of Over Flakee, and the avenue of trees shown in the painting was planted in 1664. Hobbema apparently records the scene with great accuracy, though as it must have looked a good many years after the trees had grown. Obvious though the device is of the central, receding perspective, it remains extremely effective, and the suggestion of a faint breeze blowing on a day of unsettled weather enlivens the composition.

Paulus POTTER (1625–1654)
Cattle and Sheep in a Stormy Landscape

Potter was a painter of marked originality and well into the nineteenth century enjoyed considerable fame for his pictures, usually on a small scale, of animals in landscapes. For most painters, cattle and sheep might not offer obvious inspiration but Potter here makes skilful use of the pawing, dangerously alert bull, outlined against a sweep of livid cloud in a landscape bare except for two savagely storm-tossed trees. The sky is really the main protagonist, and Potter wonderfully succeeds in giving the spectator the vicarious sensation of a gust of rain-spattered wind full in the face.

Isack van OSTADE (1621–1649)
A Winter Scene

The sad brevity of Ostade's career is not always remarked on. He was long outlived by his elder brother, Adriaen, whose pupil he was and whose peasant interiors he began by imitating. He became more interesting when he turned to outdoor scenes, often winter ones — of which this is a notably fine example, with a tang of atmospheric chill to it. It is thoroughly naturalistic when compared with Avercamp's scene on the ice (p.142), not only in technique but in its emphasis on winter conditions as experienced by the poor. Even the figures tying on their skates seem preparing less for diversion than for the best means of getting about at a harsh time of the year. Ostade's sympathy appears more than sentimentality, just as his art is more than picturesque. How he would have developed, had he lived beyond his twenties, cannot be gauged.

Aert van der NEER (1603 or 1604–1677)
A Moonlit View

Winter seems to have been the season preferred for depiction by van der Neer, and evening the preferred time of day. Unfortunately for his reputation, at least with posterity, he painted rather too many such scenes, with too little variation. Nevertheless, he had a vein of authentic sensitivity and response before the spectacle of twilight and moonlight, and this small painting possesses a half-desolate atmospheric air which plays on the nerves. Van der Neer seems rarely to have painted an actual place, and that perhaps indicates the inner vision haunting him, to which he steadily sought to give expression.

Hendrick DUBBELS (1621[?]–1676[?])
Shipping Becalmed Offshore

Recorded at one point as a shopkeeper in Amsterdam, and shortly after as bankrupt, Dubbels was never a very famous – never perhaps a very successful – artist. The present painting for long passed as by Jan van de Cappelle, though in certain ways it is more simplistic than his work and more naïve-seeming in its technique. In its simplicity lies part of its appeal, deepened by Dubbels' feel for tonal beauty. The moth-brown sails and the drifting cobalt cloud, like a cloud on a piece of blue-and-white china, have a placid rightness, regardless of all naturalism.

Jan van de CAPPELLE (*c.* 1623/5 – 1679)
A River Scene

Cappelle was part of an established tradition of marine painting in Holland
Conscious of this, he included examples of his predecessors' work among his very large
collection of, for example, drawings by Goyen, Avercamp and Rembrandt. He was
wealthy and not prolific, but he developed a type of calm, naturalistic marine picture
which seems to express, without bombast, a sense of Holland ruling the waves.
Somewhere or other, in most of his paintings, the Dutch colours are being flown (here
on a States yacht in the middle distance). Yet the final effect of his art suggests a concern
less with shipping or navies as such than with serene water and vast, cloudy,
though unthreatening skies.

Jan BEERSTRAATEN (1622 – 1666)
The Castle of Muiden in Winter

The castle of Muiden, which survives today, lies a few miles from Amsterdam. It had been begun as a fortification in the thirteenth century but by Beerstraaten's period was largely famous as the peaceful meeting-place for a circle of Dutch poets and scholars. For the painter it has obvious appeal as a darkly looming feature. In this icy landscape he does not bother to be topographically accurate yet manages to convey bitter winter weather, with the frost-gripped branches of the trees almost sinister against a purplish, metallic sky, heavy with the threat of more snow to come. By a typical paradox of art, such well-conveyed atmospheric bleakness gives the spectator a feeling of pleasurable warmth.

Hendrick ter BRUGGHEN (1588[?]–1629)
The Concert

Ter Brugghen is yet one more example of a Dutch painter attracted to Italy, though in his case it was not the landscape or the light that drew him, it seems, as much as the work of Caravaggio and his followers. He spent some time as a young man in Rome and then returned to Utrecht, where the rest of his life was spent. He painted figure-pictures in a style which — for all its Italian inspiration — is thoroughly personal, intimate rather than dramatic. This composition of half-length figures is typical of his best work and is possibly ter Brugghen's masterpiece of secular painting. Its mood is tender and reflective. A single candle is sufficient illumination for the music-making trio, and its soft light is beautifully caught by the painter as he lingers over folds of glowing drapery and the features of the faces, creating a paint surface that blooms under his brush and accords perfectly with the picture's mood.

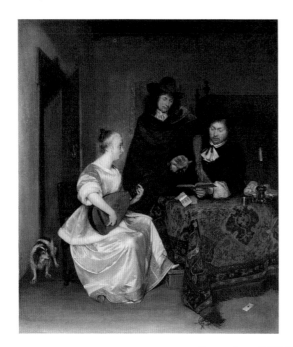

Gerard ter BORCH (1617–1681)
A Woman making Music with Two Men

Dutch interiors of the kind painted here are so familiar an aspect of European art that one can overlook the quite novel category of picture that they represent. They speak for a society much concerned with seeing its diversions, its costumes, and its homes reflected in painting with great fidelity. That is very much part of the 'natural' revolution of seventeenth-century painting. Ter Borch is a leading creator of genre subjects like this, one of the most sensitive painters in his feeling for nuances of atmosphere as well as for textures. And, for all its apparent truth to natural appearance, this is highly conscious art. Not only is the composition skilfully devised but its theme of prosperous people making music – people less timeless and gipsy-like than ter Brugghen's (p.157) – has a hint of gallantry. Music, it seems, is still the food of love.

Gerard ter BORCH (1617–1681)
Portrait of a Young Man

Despite his preference for working on a small scale, ter Borch was an artist of wide range. It is another aspect of his originality that he should virtually create a fresh type of painting – the full-length portrait, as here, in miniature. His sensitive response to materials is given full play in the elaborate, fashionable costume worn by a sitter whose expression is, almost cruelly, seized as one of some uncertainty. Either his dandified dress or life itself has caused him an understandable tremor, and the painter no more fails to note it than he fails to record the play of light on the fringe of the tablecloth.

Willem DUYSTER (*c*.1599–1635)
Two Men playing Tric-trac

After ter Borch's subtle art, Duyster's might seems a little too glossy and hard,
accomplished though it is. Yet he is of an earlier generation – almost a Dutch
Caravaggist on a small scale, with a shrewd eye for physiognomy and gesture. His two
smokers here are adroit, contrasting studies of action and repose. Indeed, in the isolated,
meditative smoker in the background, so patently detached from the players at the table,
Duyster seems to verge on making some critical comment on the game of life.

Thomas de KEYSER (1596 or 1597–1667)
Constantijn Huygens and his Clerk or Page

The sitter would make this an intriguing painting even if the highly detailed
composition held less fascination than it does. Not since Holbein's *'The Ambassadors',*
it may be, had tastes been so strongly conveyed in a portrait, and de Keyser also sets
Huygens in a personal environment. Huygens was a figure of impressively diverse
talents – diplomat and royal councillor, and a scholar concerned with the sciences, as
well as the fine arts. On the comparatively small scale of the composition, the painter
manages to convey the variety and also the activity involved, as Huygens turns from
what appear to be architectural plans to receive a letter from a respectful messenger –
thus nicely suggesting the student who is equally a man of the world.

Jan MOLENAER (1609 or 1610[?] – 1668)
Children making Music

Children are something of a discovery as a subject for painters all over Europe in
the seventeenth century. Princely, as with van Dyck (p.136), or peasant-like and
poor, as with the Le Nain brothers in France and with Molenaer here (in a painting once
supposed to be by the Le Nain), they bring a new aspect of nature and the natural to art.
Molenaer's cheerful trio make rather improvised music – the girl beats on a helmet
with two spoons – but seem content enough in their humble, scullery-like environ-
ment. They might almost be youthful wandering players who had paused on their
journey. Poor they definitely are, though Molenaer does no more than record the fact,
concerned rather to show their grinning countenances, expressive perhaps of
their carefree attitude to the harsh facts of existence.

Frans HALS (*c*.1580[?] – 1666)
A Boy with a Skull

Hals is a master of several moods, though in only one style – a style of vigorous slashing brushstrokes and rapid-seeming application of pigment, which is well exemplified in this brilliant study. He can be an intensely sober and dignified portraitist (notably in group portraits) and he can also show off his abilities as a sheer manipulator of oil-paint. If the message intended by this composition is one of mortality, the effect is counteracted by the vitality it exudes. Grim as it may be, the skull is almost eclipsed as an image by the long flaunting plume of feather stuck with such bravura in the boy's cap.

Judith LEYSTER (1609–1660)
A Boy and a Girl

Children are again the theme here for a painter who married Jan Molenaer. The boy clasps a cat and seems to be holding up an eel, conceivably an illustration of some Dutch proverb but perhaps just part of the general message of childhood as a lively, carefree time, which the animation of the two children seems to emphasise. The daughter of a brewer living in Haarlem, Judith Leyster (who often signs, as here, with a punning star) was precociously talented. She may have become a pupil of Frans Hals, and certainly paintings like this one show his influence.

Nicolaes MAES (1634–1693)
Interior with a Sleeping Maid and her Mistress

Maes established a distinct type of domestic genre painting vaguely related to the Delft School and the work of Pieter de Hooch (p.169), with some echoes in it of Rembrandt's style. Unlike de Hooch, he later stopped painting genre and concentrated on portraiture. The shadowy atmospheric interior here — made more intriguing by the view of the upper room in the background — has its own effective mystery. The subject itself, however, is a little more disturbing today than Maes may have intended. The sleepy maid could simply be exhausted by the labour required of her — a not inconsiderable pile of washing-up faces her on the floor — rather than naturally idle. Certainly it is hard to warm to Maes's smug housewife as she invites the spectator's complicity in sighing over the Dutch seventeenth-century servant problem.

Gabriel METSU (1629–1667)
A Woman Drawing

Metsu is one of the most attractive of Dutch genre painters. If he lacks the stature of de Hooch and Vermeer, he largely manages to avoid the over-finished, somewhat finicking manner of his presumed master, Dou. The subject here has its own attraction — not least in showing pursuit of artistic studies, in a learned-looking environment and by a woman (which is not common in Dutch art). The pleasure of being absorbed in such work, on one's own, is clearly conveyed. And a final touch of serious intent comes from the resolutely unpretty features of the woman herself.

Jan STEEN (1625 or 1626–1679)
Skittle Players outside an Inn

Steen was the son of a brewer and late in life kept an inn, but neither fact seems to have much relevance to this enchanted scene, with its hint of *déjeuner sur l'herbe* and life passing agreeably, at a slow tempo, on a summer's day outside The White Swan, a little house half-lost among tall trees. Steen is a painter of the greatest delicacy, regardless of his often uproarious subject-matter, yet even he rarely equalled the atmospheric sensitivity of this open-air scene, where light seems forever filtering through the glistening foliage and lending its glamour to a jug, a patch of linen or the fence at the verge. Action is suspended. The skittle player poises about to bowl, and the silhouette of the girl in the lane is fixed as she goes towards the inn, her cap a bright blob of luminosity, seized before it and she pass out of sight into the shady penumbra formed by the trees.

Dirk van DELEN (1604/5–1671)
An Architectural Fantasy

Amid the strong bias towards naturalism displayed by Dutch seventeenth-century painting at its most typical, there stands out the work of such a painter as van Delen. He painted architectural scenes in a style very different from that of van der Heyden (p.150) or Saenredam (p.168), relishing the piling of fantasy upon fantasy to create the delightfully improbable, glossy assemblage of buildings here. It could never be mistaken for real architecture. What the artist displays is the power of his invention, in a deliberately capricious way that is really an inheritance from the Renaissance.

Harmen STEENWYCK (1612– after 1665)
Still Life: An Allegory of the Vanities of Human Life

Steenwyck seems to have made a speciality of the 'Vanitas' still life, a category of
painting that became popular in Holland quite early in the seventeenth century. It offers
the painter the opportunity for exploring a variety of shapes, and in Steenwyck's
assemblage there is the unexpected novelty of a Japanese sword, in a scabbard richly
inlaid with mother-of-pearl. It may represent wealth or rank – a collector's rarity too,
perhaps, as is the fine sea-shell. Although the artist dutifully conveys the moral that all
is vanity, he paints with a respect for each object that turns a truism into art.

Willem KALF (1619–1693)
Still Life with the Drinking Horn of the Saint Sebastian Archers' Guild

Not every Dutch still life harps on worldly vanity. Some, like this one, preach a rather different lesson, urging in a frankly opulent way the pleasures of good food and wine. Kalf's art seems to have suited an opulent clientèle in Amsterdam, one that could afford lobsters and Turkey carpets, if not actually own the highly-wrought drinking horn (which survives today), a sixteenth-century treasure mounted in elaborate silver carving that includes a lion holding the shield of the city. Kalf is more than a mere purveyor of rich food and objects in paint. Some of the richness here arises from his strong sense of texture and colour, and perhaps the virtuoso highlight of the composition is the half-peeled lemon.

Pieter SAENREDAM (1597–1665)
The Grote Kerk, Haarlem

Concentrating on church interiors, faithful as a draughtsman of them, and precise
to a degree (often dating his drawings by the day and the month, as well as the year),
Saenredam might seem the pattern of the good architectural recorder, and not much
more. In fact, he can be shown to have taken frequent liberties in his paintings, entirely
for artistic purposes, and from his library we know that he was interested in optics and
perspective. What is striking about this painting is its austere tonal beauty and its grasp
on forms, so that the interior of the Grote Kerk takes on an ideal aspect, purer, more airy
and more intellectually satisfying than in reality. For it, Saenredam executed a
preliminary drawing (dated 29 May 1636) on the spot – no great problem for him as
Haarlem was where he early settled and largely worked.

Pieter de HOOCH (1629–1684)
A Woman and her Maid in a Courtyard

De Hooch's open-air scenes are arguably his most original, and in them there can
be little or no posthumous rivalry with Vermeer. It was in Delft, where he lived for
about seven years from 1653, that he produced his finest work. The architecture of the
city exercised its appeal on him, as is apparent in this view, which contains elements
rearranged of the old city wall and other motifs, like the summerhouse, which recall
Delft. The painter's eye lingers over every detail of the pump, the bare garden, the half-
open shutters, even the discoloured brickwork, and yet fuses them all into a single tonal
whole of uncanny conviction. Against the warm red of the fence and gateway, he sets
the figure of the standing woman, suppressing individuality by showing her entirely
from the back. Indeed, her function is chiefly that of being a foil in terms of tone, her
white cap and black and white jacket providing the final note of restricted richness.

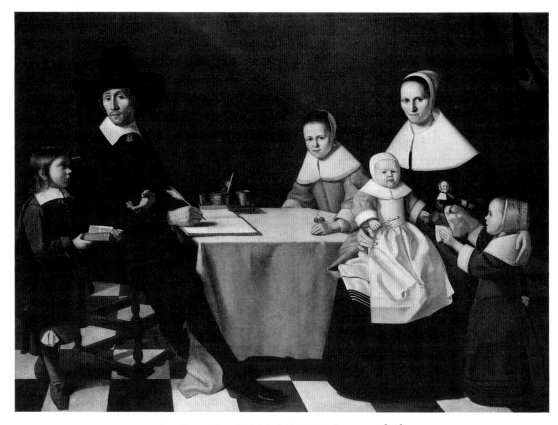

Attributed to Michiel NOUTS (active 1656)
A Family Group

Although this large-scale painting has undergone vicissitudes, being damaged
and partly repainted, and at one point cut in half, it retains a distinctive air and is not
easily paralleled in the Gallery's varied Dutch collection. It was probably painted in
Delft, possibly by the somewhat mysterious Nouts. As a family group of sober, even
stern, appearance, truthfully portrayed, and perhaps embodying Dutch virtues, it may
be contrasted with Coques' elegant Flemish family (p.139) who take on an almost
wilfully hedonistic air. Here thrift is suggested by the plain interior, and industry by the
preoccupied father who barely interrupts his own work to supervise his son's learning
of a lesson. No comfortably ageing matron as envisaged by, say, Maes, the mother
dutifully, if somewhat grimly, tends children as solemn-seeming as herself. The
presence of a doll adds a mitigating touch amid such resolute high seriousness,
though it – one suspects – might yet be confiscated before bedtime.

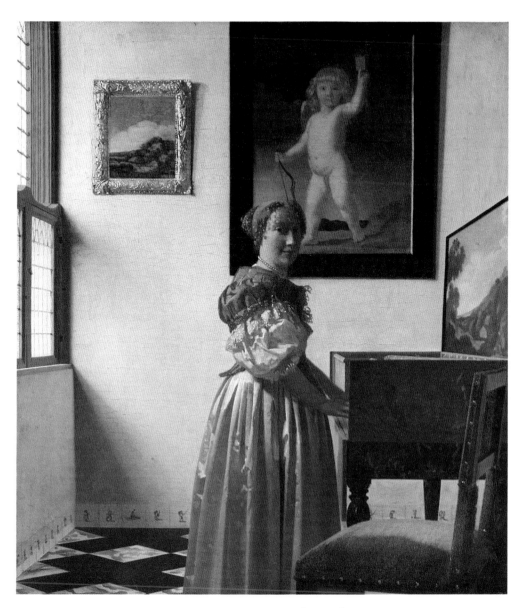

Johannes VERMEER (1632–1675)
A Young Woman standing at a Virginal

There are comparatively few men in Vermeer's paintings. Women are the inhabitants he normally chooses for his interiors, and music is a favourite occupation. The solitary woman here may be thought to be just touching the instrument, hardly disturbing the silence of the room which forms a perfect environment for her still, straight figure. By the time he painted this picture, around 1670, Vermeer had purified his style and his approach. The composition is a masterpiece of subtle contrivance, raised above the level of ordinary genre and painted with obedience not to what is present but to what light defines. Thus the woman's curls, her pearl necklace and the ribbons of her wonderful blue and white sleeve are aglow with almost liquid luminosity, absorbing detail and transcending it. Every shape is clear and concentrated, with firmly defined horizontals and verticals, framing, for example, the woman's face as well as the painting of Cupid. In its geometry as much as in its cool colour and its blond light, this is a Vermeer to take its place beside the work of Piero della Francesca.

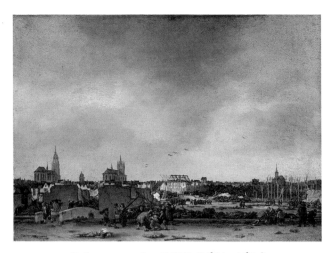

Egbert van der POEL (1621–1684)
A View of Delft after the Explosion of 1654

The explosion of a powder magazine on the morning of Monday, 12 October 1654
destroyed a large part of Delft and killed numberless people – among them Carel
Fabritius (see p.173). Van der Poel was a native of Delft and may have witnessed the
scene (he dates this picture to the day of the catastrophe). It became something of a
speciality in his work, previously restricted largely to peaceful rustic compositions, and
at least a dozen versions exist by him of the aftermath of the explosion or its actual
moment. Such a scene of desolation comes as a shock in the fairly even tenor of Dutch
seventeenth-century art.

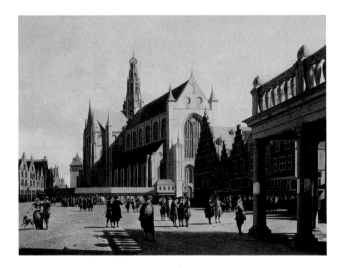

Gerrit BERCKHEYDE (1638–1698)
The Market Place at Haarlem

The prominent church is the Grote Kerk (St Bavo), which looks very similar in
appearance today. Like Saenredam, Berckheyde was a native of Haarlem, and views of
the city represent a considerable portion of his work. Here, calm activity and civic
prosperity are enhanced by the long shadows and the bright, early evening light. The
portico at the right – which serves Berckheyde so well as a motif – is of the town hall
and had been put up only a few years before the painter's birth.

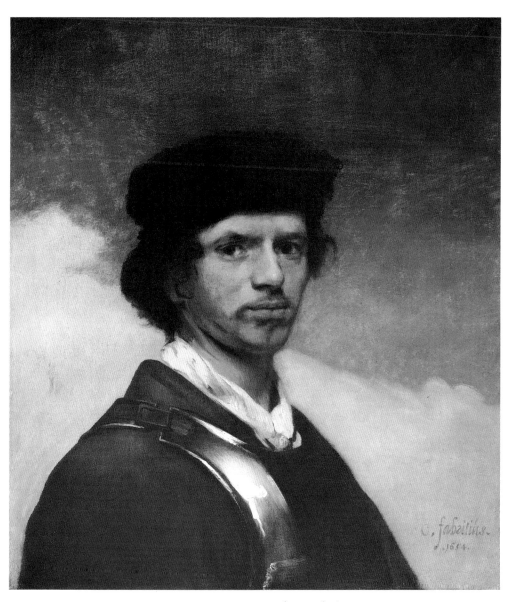

Carel FABRITIUS (1622–1654)
Self Portrait (?)

In this impressive portrait, dated in the year of Fabritius' accidental death, at the age of thirty-two, it is tempting to see a self portrait, though there is no firm evidence to prove that. Fabritius had spent a period in Rembrandt's studio, and the slightly dressed-up costume, the sitter's searching gaze, and especially the bold handling of paint, all suggest some influence of Rembrandt. Yet, at the same time, what is remarkable is the painter's individuality of manner and presentation. Nearer to Rosa (p.93) than to Rembrandt, he sets the figure against a cloudy sky. He lights it very fully, and he paints it with masterly directness which in its vigour recalls Frans Hals (p.162), different though the result is. The thick highlight on the breastplate looks almost dashed-in, though probably it was carefully calculated, as doubtless was the rough paint that conveys the texture of the woolly fur cap. Few paintings by Fabritius survive (the Gallery is fortunate enough to own two), but in the best of them his originality is profoundly evident.

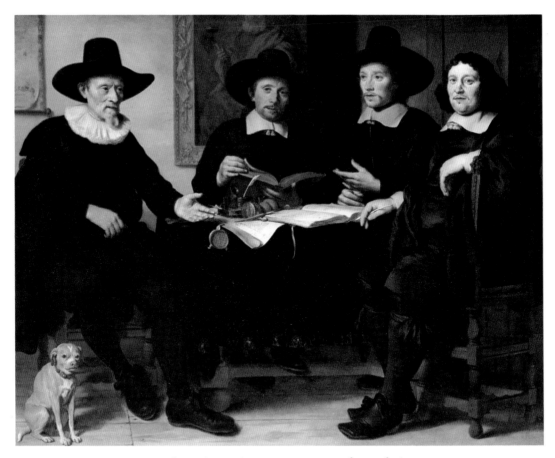

Gerbrand van den EECKHOUT (1621–1674)
Four Officers of the Amsterdam Coopers' and
Wine-rackers' Guild

This is a type of professional group portrait fostered in seventeenth-century
Holland, and Eeckhout seems admirably equipped to give the sitters exactly what was
required: convincing likenesses and a solid rather than brilliant or dramatic
presentation of themselves (the solid calves of the plump seated man at the far right are
recorded with disarming honesty). Details of the seals and books of their trade – with a
framed picture in the background of their patron saint, Saint Matthias – all add to the
location of these four plainly dressed, business-like officials in the society of
their own city and period.

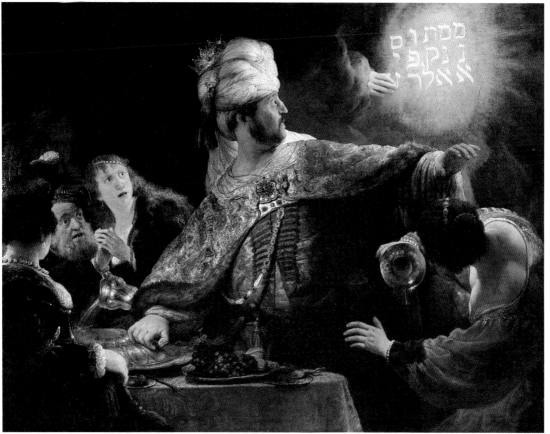

REMBRANDT (1606–1669)
Belshazzar's Feast

Rembrandt is very much of his period in tackling the large-scale historical or mythological subject-picture; and about the time Rubens was painting his *Judgement of Paris* (p.132), in the mid 1630s, Rembrandt painted *Belshazzar's Feast*. Each painting tells much about its creator. The Old Testament subject of Belshazzar was a popular one in art, offering obvious opportunities for exotic and dramatic effects. The King of Babylon's 'great feast' is interrupted by a mysterious hand writing on the wall the words 'Mene, mene, tekel upharsin' (words which, when interpreted, prophesy the King's death and the destruction of his kingdom). Rembrandt gives the message in precise Hebrew form and makes the occasion one of serious, fearful import. For all Belshazzar's splendour, his feast is depicted on a small, semi-intimate scale. Significance comes from the clash between a figure of almost gross physical and oriental magnificence and the gleaming, ethereal vision, in which he – and we – can already read his doom.

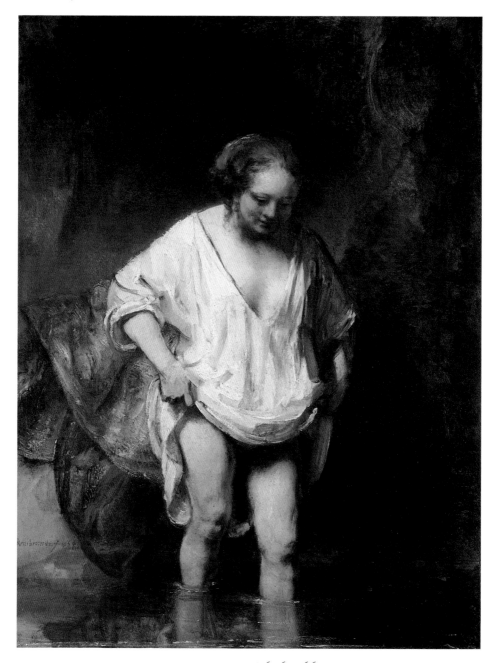

REMBRANDT (1606–1669)
A Woman bathing in a Stream

Intimate study though this painting might seem, it is signed and dated 1655 and may well be of a definite, possibly Old Testament subject and executed as a commission. The features of the woman are very similar to those of Rembrandt's mistress, Hendrickje Stoffels, condemned by the Reformed Church after admitting 'she had stained herself by fornication with Rembrandt', whose child she had given birth to in the year before this picture was painted. The picture's technique is very much part of its intimacy and indeed its pensive charm. It is painted with the greatest freedom — no lingering over the gold robes on the bank or the folds of the woman's white shift — and every stroke of paint seems to enhance the mood of privacy and reflection.

REMBRANDT (1606–1669)
Margaretha de Geer

Margaretha de Geer must have been not far from eighty when she sat to
Rembrandt for this portrait in which fragility and indomitability are movingly
combined. She had married Jacob Trip (whose portrait in old age by Rembrandt is also in
the Collection) before the painter was born, and she was to outlive him, as well as her
husband. She occupies her chair in an almost regal way, as unchanging in attitude, one
feels, as in resolute adherence to the fashions of ruff and gown that had been current
more than forty years earlier. Yet old age has deeply marked her, and part of the power
of the image resides in the sympathetic touches of pigment that catch the rusty
complexion, the puckered mouth and sunken eye-sockets. The living head is almost
severed by the great plate of ruff, crisply starched and as it were expressive of a
personality still crisp even though physically needing to grasp with
one bony hand the support of her chair-arm.

REMBRANDT (1606–1669)
Self Portrait aged Sixty-three

The date of 1669, the final year of Rembrandt's life, can be read on this painting,
which is thus one of his last works, as well as one of his very last self portraits. The
image could scarcely be more simple or the self-scrutiny more intense. As a young
painter Rembrandt had delighted in painting himself in flamboyant costumes. At a later
date he had painted himself as a painter, and as someone confronting the world, defiant
or resigned. In this portrait, the world itself seems to have receded, leaving the artist to
confront a plainly-dressed, elderly man, of undistinguished appearance and without
any particular avocation. Restraint is its keynote. The paint too is handled in a restrained
way, rubbed onto the canvas with an inspired economy that recalls Titian's late style.
And everything is concentrated on the head and the expression, as Rembrandt
seeks – it might be felt – to go against the Shakespearian adage and show
the mind's construction in the face.

Emanuel de WITTE (1615/17–1691 or 1692)
Adriana van Heusden and her Daughter at the New Fishmarket in Amsterdam (?)

Behind the lengthy title of this painting lies an interesting story, quite apart from the considerable interest of the composition itself. Adriana van Heusden was the wife of the painter's landlord in Amsterdam, at a period when everything de Witte painted was to belong to the landlord in exchange for board and lodging, plus a cash sum. One of these paintings was almost certainly the present one. For some reason de Witte failed to surrender it, and it subsequently became part of a complicated legal dispute between the painter and Adriana van Heusden, involving copies and substitutions, which would make a good plot for a novel. The painting's combination of portraiture and open-air genre is attractive — rather more so than de Witte's behaviour over it. At the same time, there is perhaps a hint in Adriana van Heusden's demeanour of someone who might be difficult — if only over the price and quality of fish.

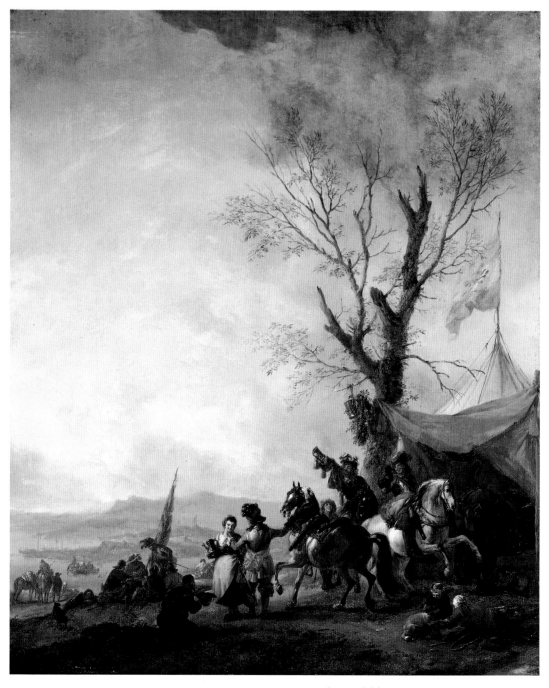

Philips WOUWERMANS (1619–1666)
Cavalrymen halted at a Sutler's Booth

Wouwermans was one of the seventeenth-century Dutch painters most appreciated in the subsequent century, especially in France and England. He was highly prolific and also – unlike, say, Rembrandt – a success in his lifetime. One vein of his art takes as its theme soldiers, horses, camps, battles and such light-hearted semi-military scenes as the present one. About his always accomplished work there hovers a graceful, decorative air, not to be despised in itself and markedly anticipating aspects of the rococo style.

Spanish Painting

Spanish paintings were to enter the Gallery from a quite early date, and though this aspect of the Collection is still not sufficiently representative (there is, for example, no full-length portrait by Goya), the quality of the works is remarkably high. Velázquez, in particular, is shown with a range of paintings that is hard to parallel outside Spain; and even within Spain there is nothing comparable to the *Toilet of Venus* (p.186).

The most generally popular Spanish painter in the nineteenth century was Murillo, by whom the Trustees bought the splendid large-scale *Two Trinities* (p.191) as early as 1837. His *Peasant Boy* was already in the Collection, having been presented by M.M. Zachary. The first Velázquez to be acquired was *Philip IV hunting Wild Boar* (p.185), purchased in 1846, a painting sometimes assigned to a pupil or assistant but clearly in large part by Velázquez himself. A painting by Zurbarán was added in 1853, being purchased from the King Louis-Philippe sale.

Eastlake's directorship did not result in any notable Spanish acquisitions, but in the later years of the nineteenth century a number of significant additions were made. The very fine full-length portrait of Philip IV by Velázquez (p.184), a rare item indeed outside Spain, was purchased for 6,000 guineas in 1882, and in 1892 Sir William Gregory bequeathed the early Velázquez *bodegón* of *Christ in the House of Martha and Mary* (p. 183). Sir J.C. Robinson presented the first example of El Greco's work (*Christ driving the Traders from the Temple*) in 1895. In the following year the Gallery purchased, at a sale in Madrid, its first Goya, and also added Goya's brilliant portrait of Doña Isabel de Porcel (p.193). These were somewhat daring purchases, since the painter was still little known or esteemed in England.

The *Toilet of Venus ('The Rokeby Venus')* had entered England at the time of the Peninsular War and had been bought for the Morritt collection at Rokeby in Yorkshire. It was sold by the family in 1905 and subsequently purchased by the newly formed National Art-Collections Fund, who presented it to the Gallery in 1906.

Spanish religious art represented a more difficult area, and it is remarkable that Ribalta's strangely haunting but hardly popular *Vision of Father Simón* (p.188) should have been purchased in 1913. Zurbarán's delightful *Saint Margaret* (p. 187), bought in 1903, is a less obviously pious work, though artistically of superior quality.

During the last thirty or so years several outstanding purchases have been made, though in 1970 the Gallery failed — through no fault of its own — to raise the necessary sum to retain in this country Velázquez's magnificent portrait of Juan de Pareja. Murillo's moving and dignified self portrait (p. 190) was bought in 1953, having been in this country for over two hundred years. In 1961, with generous aid from the Wolfson Foundation and an Exchequer Grant, Goya's portrait of the Duke of Wellington (p.194) was purchased. More recently, the Gallery has bought a number of fine eighteenth-century Spanish paintings, among them a superb still life (p.192) by Meléndez, the great painter of the day who specialised in this category of work.

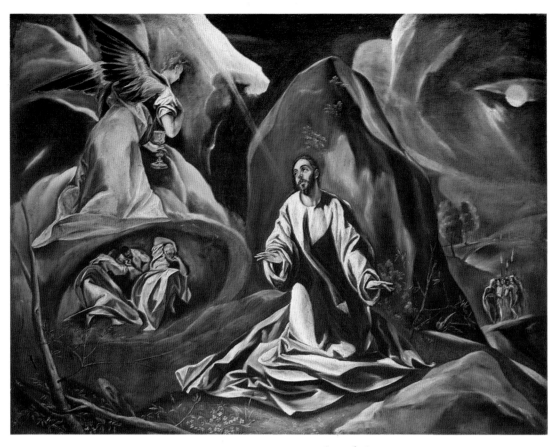

Studio of EL GRECO (1541–1614)
The Agony in the Garden

Although a slight hardness in the actual painting of this picture indicates its studio status, the composition is one of the most original ever conceived by El Greco. Not surprisingly, he repeated it several times. Coming from Crete, training in Venice and settling in Spain, in Toledo (by 1577), El Greco was the product of varied traditions and influences, out of which he fused an intensely personal and visionary style. Here the subject gains from the painter's sense of heightened reality, so that the Garden of Gethsemane becomes a blanched, lunar landscape, far stranger, far less stable and more alien than, for example, Mantegna's (p.49). Rocks and clouds assume threatening shapes in a dark night made ominous by the floating, half-veiled orb of moon. The loneliness of Christ's ordeal is fiercely conveyed, but so also is His acceptance of it.

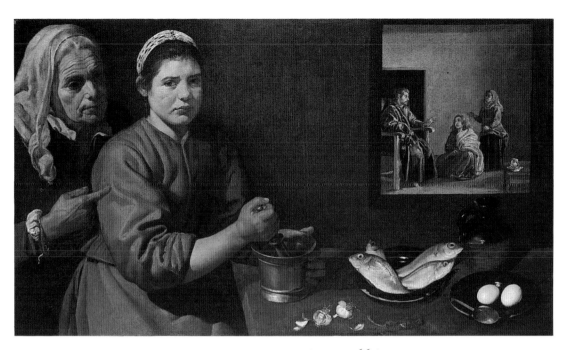

Diego VELAZQUEZ (1599–1660)
Kitchen Scene with Christ in the House of Martha and Mary

Velázquez is seldom thought of as precocious, yet he seems to have been studying
as a painter in his native Seville by about the age of thirteen and painted this picture at
the age of nineteen. It is typical of his early 'kitchen' compositions in both shape and
handling, though unusual in combining the homely genre elements in the foreground
with the scene of Christ preaching to Martha and Mary. Velázquez's intentions here may
have a moral basis not yet fully comprehended, but it can hardly be chance that the
Biblical subject illustrates the contrast between Mary, who sits listening at Christ's feet,
and Martha, cumbered with domestic chores and expostulating about her sister's
apparent selfishness. The achievement of the picture lies, however, not in that scene but
in the austere, vigorously painted still life on the table — the earthenware plates, the
cloves of garlic, the fish and the two eggs, all of which have an artistic and almost
sacramental solemnity.

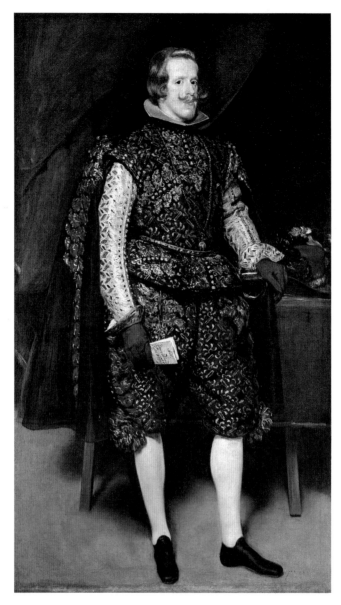

Diego VELAZQUEZ (1599–1660)
Philip IV of Spain in Brown and Silver

In 1623 Velázquez – still quite young – entered royal service in Madrid, and was promised that he alone should paint the King, himself then aged only seventeen. For the rest of their lives, painter and monarch were bound together. No painter has ever served one patron so faithfully, and Velázquez died in the King's service. In this portrait of the mid 1630s the King wears an unusually splendid costume, perhaps for a state occasion, and holds a paper on which the artist has signed the picture as 'painter to Your Majesty'. Philip IV sought no flattering image from his portraitist – and received none. Velázquez records the royal features as they were, painting them with great care, and then allows his brush the freedom of creating the costume with a fluency and boldness that remain astonishing. In the hat alone is foreshadowed Manet.

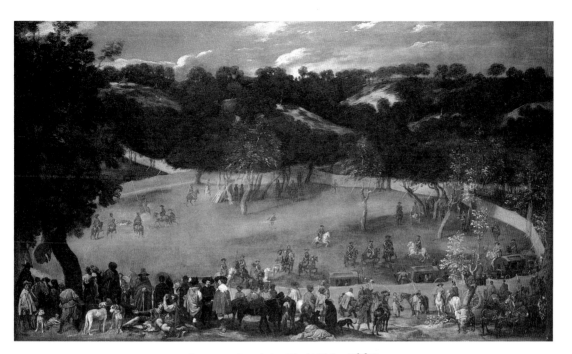

Diego VELAZQUEZ (1599–1660)
Philip IV hunting Wild Boar

In Velázquez's pictures royalty are normally shown in a strictly court context, and this absorbing composition is unique in showing all levels of Spanish society extending downwards and outwards from the King, in an open-air panorama. The 'sport' is of a peculiarly unsporting kind, as is clear from the details of the composition, not least the canvas enclosure within which the boars are hunted. Philip IV is identifiable at the right spearing a boar, but more remarkable is the varied crowd of larger foreground figures, some engaged in conversation or quenching their thirst, indifferent, it seems, to the spectacle. While duly executing what must have been a royal commission, Velázquez puts the ostensible subject into the widest possible perspective, with the result that the Spanish landscape and ordinary Spanish people dwarf the ruler of it and them.

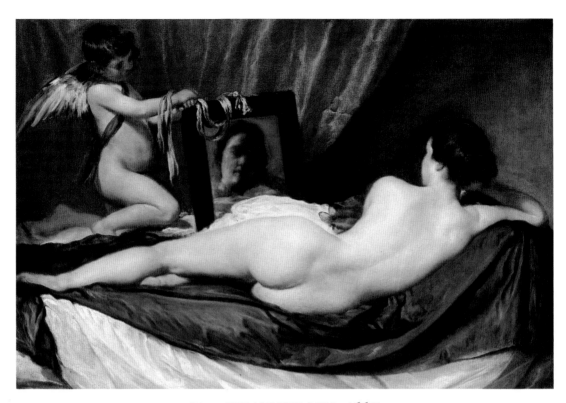

Diego VELAZQUEZ (1599–1660)
The Toilet of Venus ('The Rokeby Venus')

Only the presence of the winged Cupid gives any mythological nuance to what would otherwise be an almost timeless, 'modern'-seeming study of a woman gazing at herself in a mirror as she reclines naked on a bed. At once chaste and sensuous, Velázquez's Venus – the sole surviving female nude by the painter and a rare subject altogether in Spanish art – is a profoundly self-absorbed figure, and the setting of curtains and rumpled drapery increases the feeling of claustrophobia. In the pose of Venus's body there is a sort of implied modesty, yet a strong sense of flesh and blood exudes from what is seen of that body, whose pale colouring is excitingly contrasted with the unexpected blue-grey of the sheet on which it presses so positively and luxuriously. As always, it is Velázquez's handling of oil-paint, combined with his unflinching observation of what he sees, that creates the overwhelming effect. By the time he painted the *Toilet of Venus* – no later than 1651 and possibly a year or two earlier – his mastery of the medium was total.

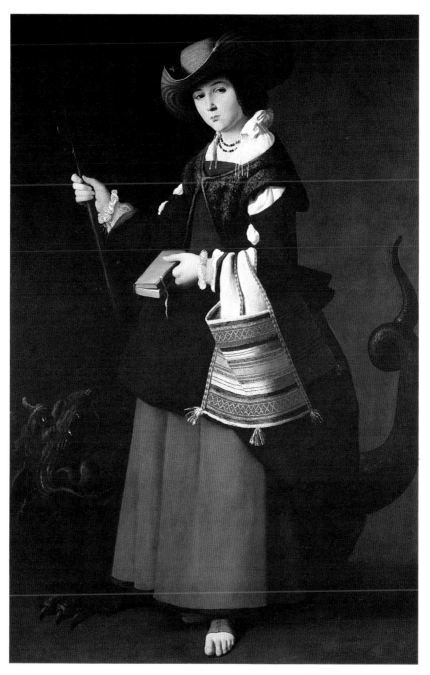

Francisco de ZURBARAN (1598–1664)
Saint Margaret

The saint is shown as a shepherdess – a Spanish one – but discreetly
accompanied by the dragon which is part of her legend. Zurbarán is chiefly concerned
to convey the physical actuality of the saint herself, who is very much *there* as a person,
without a halo and with conceivably the features of a real woman. In all that he may be
typical of Spanish seventeenth-century painting generally, but Zurbarán aims at an
almost sculpted stillness and gravity, in which shapes are painted with a clarity that
creates supra-realistic effects – as here, for example, in the ruffles of white linen at
the saint's wrists and neck.

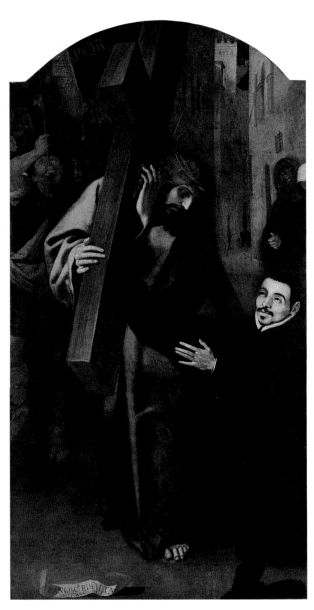

Francisco RIBALTA (1565–1628)
The Vision of Father Simón

There is much that seems quintessentially Spanish about this strange painting. It
depicts the vision of a once famous ascetic, a parish priest in Valencia, whose
meditations in the city by night on the theme of the Road to Calvary culminated in the
vision of Christ carrying the Cross, surrounded by His executioners and followed by the
Virgin and Saint John (just glimpsed at the extreme right). Father Simón died in 1612 –
the year this painting is dated – and became a cult figure, though a controversial one.
Attempts to have him beatified were strongly resisted, and images of him were soon
ordered to be removed from altars. Ribalta probably painted this composition, now sadly
cut down, as an altarpiece in Father Simón's own church in Valencia. For Christ's pose
he borrowed from Sebastiano del Piombo, but the kneeling priest's face is an accurate
portrait. Most convincing of all perhaps is the shadowy, nocturnal, empty street of
high houses in which there is suddenly manifested the vision itself.

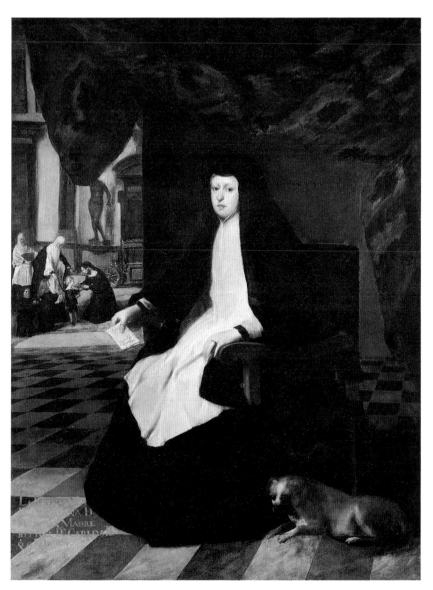

Juan Bautista del MAZO (c.1612/16–1667)
Queen Mariana of Spain in Mourning

The Queen, widow of her uncle, Philip IV, wears a nun's habit but is depicted not
in pious retreat but as Regent, occupying a room in the Alcázar, a royal palace in Madrid
later destroyed by fire. In the background can be seen dwarves and female attendants
surrounding her five-year-old son, King Charles II. Like the style of painting, the
composition is full of echoes of Velázquez. It is intriguing because it lifts a curtain –
quite literally – on the Spanish court after his death and that of his great patron. Mazo
entered Velázquez's studio and married his daughter. His certain paintings are few, and
this one has additional interest in being signed by him, as well as dated (1666).

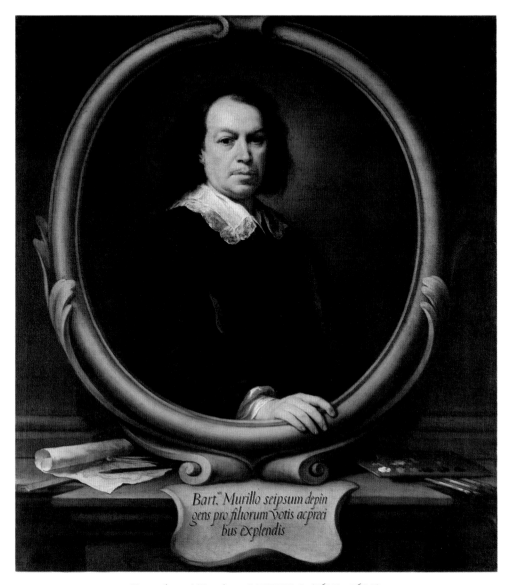

Bart.^{mé} Murillo seipsum depin
gens pro filiorum votis acpræci
bus explendis

Bartolomé Esteban MURILLO (1617–1682)
Self Portrait

Murillo must have been in his fifties when he painted this dignified yet frank and direct image, set in an elaborate frame of a kind appearing in engravings, with a compass and a red chalk drawing on the ledge at the left and a palette on the right. The solemn air of the composition is increased by the prominent Latin inscription which declares that Murillo portrays himself to fulfil the wishes and prayers of his children (*or* sons). Pride in the profession of artist is no less earnestly declared, and altogether the portrait takes on something of a testament and even monument. Murillo is a great painter, sober and forceful on occasion, as here. His actual works belie his one-time reputation as sentimental and over-pious – as the group of them in the Gallery rapidly establishes.

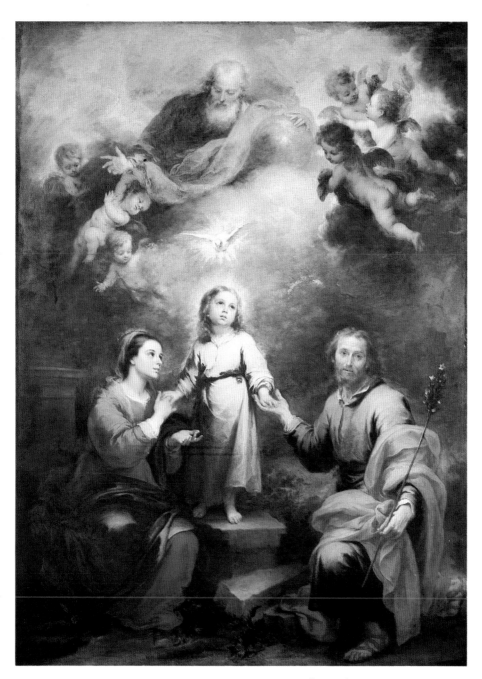

Bartolomé Esteban MURILLO (1617–1682)
The Two Trinities ('The Pedroso Murillo')

This handsome painting by Murillo would seem destined for an altar but its
original location is unknown. It comes from the Pedroso family collection in Cadiz, a
city for which Murillo painted a good deal. The subject combines the trinity on earth,
made up of the Virgin and Saint Joseph and the Christ Child, whose hands they here
hold, with the heavenly Trinity. Murillo blends the two spheres in a characteristically
graceful, decorative way, making heaven softer and more vaporous than earth where
vigorous painting, especially of the Virgin, shows how seriously the artist
continued to take his own art.

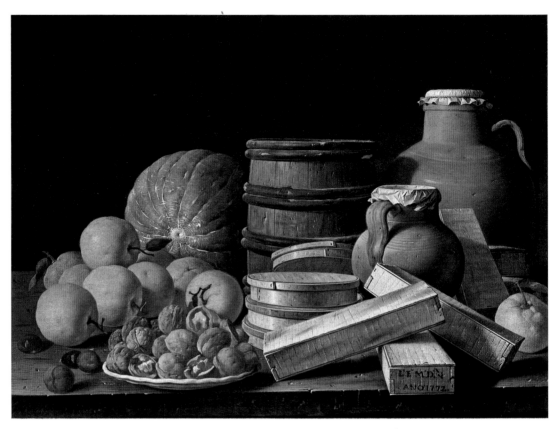

Luis MELENDEZ (1716–1780)
Still Life with Oranges and Walnuts

Only in recent years has the work of Meléndez come to public attention. He began
as a portrait-painter (a fine self portrait by him is in the Louvre) but later turned to still
life – the category of picture by which he is now best known. He painted a large number
of such pictures for the royal palace at Aranjuez. The present painting, signed and dated
1772, is imposing in composition – almost majestic – and made the more effective by
its restricted, warm tonality. The swelling shapes of the oranges and the gourd of melon
are echoed by those of the earthenware pitchers and the barrel. Without too obvious
plotting, every object has taken its place in an arrangement which exudes a solemn,
satisfying sense of rightness, while Meléndez does full justice to the range of texture,
including that of the wooden boxes, which probably contain a form of preserve. In
Meléndez's work there seems something residually Spanish, and a germ of it already
exists in such a still life as that created by Velázquez in his *Kitchen Scene with
Christ in the House of Martha and Mary* (p.183).

Francisco de GOYA (1746–1828)
Doña Isabel de Porcel

Goya exhibited this bravura and beautiful portrait in Madrid in 1805, and the composition has a bold air to it, as if both painter and sitter quite enjoyed the idea of being on show. The sitter is dressed in the costume of a *maja*, a popular costume often adopted by fashionable Spaniards in the early years of the nineteenth century. She wears it with great aplomb, and it gives Goya the opportunity to handle the folds and fall of black lace with brilliant freedom. At the same time, subtle portraitist as he is, he characterises Doña Isabel as no merely flaunting, proto-Carmen figure, despite her lustrous eyes and full mouth. Very much an individual, she seems to have her own life and thoughts; and it is part of the painting's spell that under all its surface vivacity there lurks a hint of pensiveness.

Francisco de GOYA (1746–1828)
The Duke of Wellington

Into the life and career of Goya — as into the life and career of Jacques-Louis David — great European events erupted. Goya lived to see his country torn by war after decades of peace, and the future Duke of Wellington enter Madrid on 12 August 1812, having defeated the Napoleonic forces at the Battle of Salamanca. As one of his rewards for that victory Wellington was awarded the Order of the Golden Fleece, which Goya shows him wearing among other orders and decorations. Although Goya probably made some changes to the painting in 1814, he basically portrays the man he saw in the summer of 1812 — a still youngish, sunburnt and somewhat tense-looking, perhaps battle-weary, soldier. There is no allegorising and no lofty pose for the victorious commander. Goya's artistic directness and penetration should have suited Wellington, but though Goya was to paint other portraits of him, no record seems to exist of the relations between the two men.

British Painting

In the nucleus of the Angerstein collection, purchased to found the Gallery, British painting was chiefly represented by an important and famous series of pictures, Hogarth's six scenes of *Marriage à la mode* (see p.196). British painting was also represented among the first Trustees by Sir Thomas Lawrence.

As with other aspects of the Gallery's activities in its earliest years, there seems to have been no clear policy about acquiring good works by the British School, past or present. An outstanding late landscape by Gainsborough (*The Watering Place*) was presented by Lord Farnborough in 1827. A Reynolds portrait (*Lord Heathfield*) had been among the Angerstein pictures. After Constable's death in 1837, a body of subscribers presented an example of his work, *The Cornfield* – a highly finished painting, which had several times been exhibited by the artist. A large collection of mainly nineteenth-century British pictures was given by Robert Vernon in 1847, though there was by then no space to display them at Trafalgar Square.

The settlement in 1856 of Turner's will resulted in the nation gaining the bulk of his work, inclusive of drawings and watercolours. Among the paintings were *Ulysses deriding Polyphemus* (p.206), *Rain, Steam and Speed* (p.207) and – perhaps Turner's most famous painting – *The 'Fighting Téméraire'* (p.205). During Eastlake's directorship Reynolds' fine full-length portrait of Captain Orme (p.200) was purchased, as well as some portraits by Gainsborough.

With the foundation of the Tate Gallery in 1897 as the national collection of British art (and of modern foreign art), only a selection of first-rate British paintings remained at the National Gallery, and that has continued to be the position. Henry Vaughan had presented Constable's popular *Haywain* (p. 204) in 1886 and bequeathed at his death in 1900 Gainsborough's *The Painter's Daughters chasing a Butterfly* (p.198). Gainsborough, Reynolds, Constable and Turner have been the chief stars at Trafalgar Square. Representation of Gainsborough's stylistic range was greatly strengthened when purchase in 1954 of his late and airy *Morning Walk* (p.199) was followed six years later by purchase of his early and as it were earthy portrait of another married couple, *Mr and Mrs Andrews* (p.197).

Lawrence's death had precipitated no move, sadly, to represent his brilliant art. Not until 1927 was a purchase made, of his youthful but highly accomplished full-length portrait of Queen Charlotte (p.203). Older British painters like Stubbs and Joseph Wright, now recognised as great figures, were even more fitfully treated. Stubbs' impressive and characteristic *Melbourne and Milbanke Families* (p.202) was bought as recently as 1975, while Wright's no less impressive and 'British' interpretation of portrait and landscape combined, *Mr and Mrs Coltman*, was acquired in 1984.

Selection and representation among later British painters will doubtless always be difficult. One other great portrait-painter is again represented at Trafalgar Square today by a masterpiece which the sitter himself, a Trustee of the Gallery, presented: Sargent's full-length *Lord Ribblesdale* (p.208). It cannot be expected that every Trustee will inspire a great portrait *and* subsequently be generous enough to present it to the Collection.

William HOGARTH (1697–1764)
The Marriage Contract

This is the first of the six paintings in the series of *Marriage à la mode*, painted by Hogarth around April 1743, and the picture is arguably the most subtle of the sophisticated, allusive and ultimately more tragic than satiric set. A poor but proud nobleman and a rich, ambitious City of London merchant, seen together at the right, have settled on the marriage of their son and daughter respectively − for reasons solely of cash and status. The couple to be yoked in unholy and unhappy matrimony appear at the left, already emotionally divorced, sharing only proximity. Such a cynically arranged match leads − as the series discloses − to the husband's murder and the wife's suicide. But Hogarth does more than illustrate a moral tale (one, incidentally, of his own devising). He paints with delicacy as well as mordant humour. And in this composition all the pointed allusions and the sharp observation of contemporary costume and furnishings seem shot through with an angry regret at how human behaviour selfishly conspires to turn what should be happiness into pervasive misery.

Thomas GAINSBOROUGH (1727–1788)
Mr and Mrs Andrews

Gainsborough was only about twenty when he returned, after training in London, to his native Sudbury. There he began to work chiefly as a portrait-painter, on a small scale, exploiting his wonderful gift for a likeness but never failing to respond also to 'nature' in the sense of the countryside. Mr and Mrs Robert Andrews, who had married in Sudbury in November 1748, sat to him a year or two later for a portrait which turned into one of the masterpieces of British painting. The freshness of the approach is combined with a lyrical freshness of paint as such – the artist revealing an instinctive feel for the medium – that time has not impaired. With typical, total candour, Gainsborough precisely depicts Mr and Mrs Andrews – very much the squire and his lady – and also portrays the land that is partly theirs, with the corn stooked and the sheep in a well-fenced field, and rolling countryside beyond, all under a cloudy, atmospheric sky.

Thomas GAINSBOROUGH (1727–1788)
The Painter's Daughters chasing a Butterfly

Gainsborough, a close friend recorded of his performance on the viola da gamba, 'always played to the feelings'. And so, one might add, he painted. His lively feeling for people is partly communicated through the application of paint, and it is not surprising that he should have found in his two daughters inspiration for several enchanting portraits. Like babes in the wood, hand in hand, the two dark-eyed girls here solemnly pursue the butterfly poised on a thistle. Youthful hopes and also, perhaps, the elusiveness of happiness are suggested by the theme, one to stir the father as well as the artist. Mary and Margaret Gainsborough grew up talented but somewhat unstable, both suffering unsatisfactory emotional experiences. They were to live long (Mary, the elder, not dying until 1826), together at the end of their lives as they had been when Gainsborough depicted them, half butterfly-like themselves, vivid, spontaneous and absorbed in an uncontrived, perfect image of childhood.

Thomas GAINSBOROUGH (1727–1788)
The Morning Walk

The given elements of this painting are very much the same as those of *Mr and Mrs Andrews*, even down to the presence of a pet dog. The sitters were a newly married young couple, Mr and Mrs William Hallett, and again they are seen in an open-air, country setting. Yet everything, it seems, has changed: from the scale, now large, to the painter's style, with its fine feathery handling. *The Morning Walk* – a modern title – is one of Gainsborough's late works, done about 1785 and in London. He has now learnt how to set people in motion, and this contented couple stroll gracefully through no Suffolk landscape but a hazy, enchanted woodland almost as silken and fluid as Mrs Hallett's millinery, accompanied by a silky-coated dog, its tail a plume to rival those in her hat. Gainsborough's range and bold stylistic development – unparalleled in British painting – are summed up in these two double portraits; and to the alpha of *Mr and Mrs Andrews, The Morning Walk* is the unexpected omega.

Sir Joshua REYNOLDS (1723–1792)
Captain Robert Orme

With none of Gainsborough's instinctive gift for a likeness – and lacking any real facility in the handling of paint – Reynolds might indeed seem to have chosen the wrong profession. Yet this fairly early portrait, dated 1756, is an impressive assertion of all Reynolds' qualities. He responds with almost romantic fervour to the status and aura of his sitter. He conceives the gallant young soldier as ardent for action, mettlesome like his restless horse, and consciously posed against a pale sky from which thick clouds are stormily receding. Orme had served as aide-de-camp to General Braddock, who was ambushed and killed in 1755 by the French at Fort Duquesne (modern Pittsburgh), and Reynolds seems to suggest that incident in the sketchy background scene. Orme himself had been wounded in the ambush and here takes on a heroic, though not exaggerated, air as the very type of brave, modern warrior.

Sir Joshua REYNOLDS (1723–1792)
Anne, Countess of Albemarle

Reynolds was wonderfully varied in his response to his sitters, who were to come
from a wide range of fashionable and intellectual society. Lady Albemarle was the
mother of Admiral Keppel, with whom Reynolds was very friendly and whom he often
portrayed. Blanching of the paint of the sitter's face has probably increased the effect of
her age and severity. Lady Albemarle was widowed and in her fifties when she sat for
this portrait, with its strong emphasis on domestic activity of an elegant kind, quite in
accord with her rich, Frenchified dress. There is none of Gainsborough's effortless grace
in Reynolds' stolid treatment of the lace, silk and damask of the costume but there is a
firm attempt to fix the sitter's features and clothes – and her environment. The result is
a pattern of quiet, ageing, aristocratic femininity, as marked in its way as the martial
type of *Captain Orme*. And if Gainsborough's vivid ethos frequently carries one back
to the seductive vitality of Rubens' *'Chapeau de Paille'* (p.133), Reynolds here
seems far closer to Rembrandt's *Margaretha de Geer* (p.177).

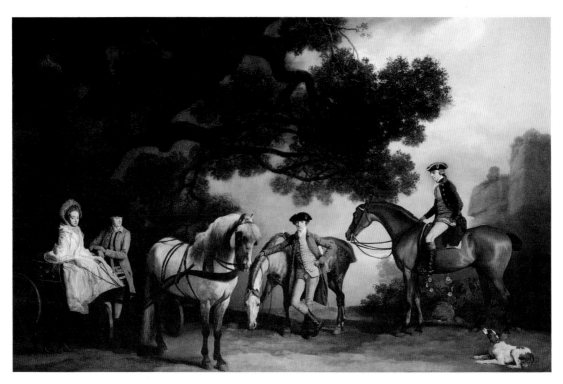

George STUBBS (1724–1806)
The Melbourne and Milbanke Families

It would be wrong to say that Stubbs is a modern discovery but it is certainly true that only in fairly recent times has the quality of his art become widely appreciated. In his own day he is recorded as discontented at being treated as merely a horse-painter — though as a painter of horses he is superb. This painting, which Stubbs exhibited in 1770, explains better than any words what sort of artist he really was. The subject itself is not particularly inspiriting. It is the English squirearchy in the somewhat unanimated shape of Sir Ralph Milbanke and his daughter Elizabeth at the left, his son John, and his son-in-law Pennington Lamb (later Lord Melbourne), shown on horseback. Stubbs marvellously invests these people and their animals with a profound artistic integrity as he scrutinises them and grants them existence in paint. They become, for him, like the pots and pans of a Chardin still life; and both artists know the secret of how to space objects in a composition. Stubbs's figures possess a stubborn prosaicness without triviality, and are able to inhabit a setting of timeless poetry, grouped under the artfully spreading boughs of a noble tree, beside the expanse of a misty lake.

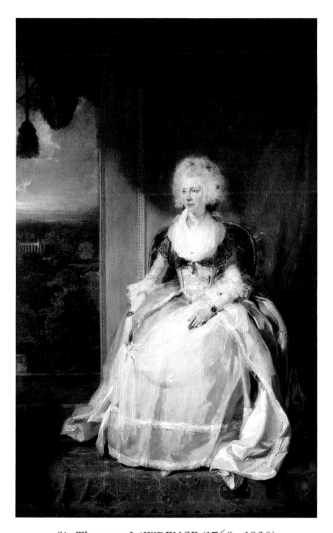

Sir Thomas LAWRENCE (1769–1830)
Queen Charlotte

Lawrence was just twenty when he received a summons to Windsor to paint Queen Charlotte, the wife of George III. His career as a fashionable portrait-painter could hardly have started more auspiciously, or so it seemed. The royal family disliked Reynolds' work, and their favoured painter, Gainsborough, had died the previous year. This brilliant, sympathetic and accomplished portrait shows how Lawrence responded to the commission. It is at once glittering and dignified. Paint crackles as it captures the gleaming folds of dress and the sweep of curtain and conjures up Eton College Chapel among russet, autumn foliage.

Yet the portrait failed to please. The Queen was no easy or conventionally handsome sitter. She thought Lawrence 'rather presuming' in his efforts to have her talk and look animated, and the painting remained with Lawrence until his death. By then he was indeed recognised and established as the most gifted portrait-painter of the period. Queen Charlotte's son, George IV, had more than compensated for her failure to take up the young artist, by sustained patronage of a kind not given by a British sovereign to a painter since the days of Charles I and van Dyck. And it is tempting to wonder whether sight of his *Queen Charlotte* ever brought Lawrence's mind back in successful later life to the circumstances of this first royal commission.

John CONSTABLE (1776–1837)
The Haywain

Painted in London in 1821 (both place and date accompany Constable's signature on the picture), *The Haywain* has become one of the most famous of all his paintings – one of the most famous, perhaps, of all British paintings. The scene is near Flatford Mill and shows at the left the house of Willy Lott, who lived there all his life and was to die there in 1849, at the age of eighty-eight. Examined today, the painting seems drenched in nostalgia, beginning with that of the artist living in a city, looking back on the countryside of his boyhood. Peaceful, rural England on a hot summer's day, with no event more momentous than a farm waggon halted in a stream for the horses to cool off, is evoked with an almost aching feeling of affection. Yet it was not its vision of England but its bold, painterly technique which caused the picture to be admired by young French painters like Delacroix when Constable showed it in Paris in 1824, three years after it had been shown at the Royal Academy. At the Salon, *The Haywain* won the painter a gold medal – and that too is now in the Gallery's possession.

Joseph Mallord William TURNER (1775–1851)
The 'Fighting Téméraire'

The full title of this always famous work underlines what is patently apparent in
the composition and which profoundly colours the painting's mood: *The 'Fighting
Téméraire' tugged to her Last Berth to be broken up, 1838.* Between the warm, setting
sun and the cool sliver of newly risen moon, the old wooden ship, a veteran of the Battle
of Trafalgar, is conducted by modern steam-tug on its last journey. The end of its days
had been witnessed by Turner on 6 September 1838, and the 'great blazing sunset' was
stated as a fact by a fellow-witness, as was Turner's activity at the time in making little
sketches. Associations of a myriad kind cluster around the subject. That Britain's decline
from a heroic and possibly more prosperous period is implied in the final painting may
well be so, but deeper, more directly human and affecting, is a hovering sense of
inevitable, ubiquitous mortality.

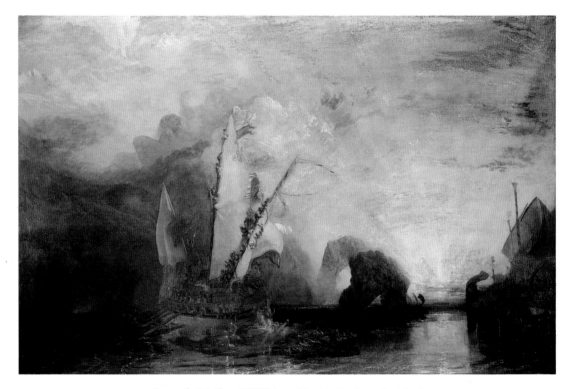

Joseph Mallord William TURNER (1775–1851)
Ulysses deriding Polyphemus

Turner took his subject from Book IX of the *Odyssey*, using Pope's translation, where the hero Ulysses escapes from the clutches of the monstrous Cyclops, Polyphemus, by blinding his single eye. In the very choice of subject, Turner proclaimed the painter's freedom to make pictorial poetry and go beyond the merely natural, creating more gorgeous and stirring effects than are normally provided by nature. The result is like a grand opera of the elements – a romantic opera akin to Weber's closely contemporary *Oberon*.

Wonderful as is the aerial pageant, with the cloudy figure of the writhing Cyclops almost evaporating under the impact of the fiery, triumphantly rising sun, more magical still are the quieter motifs of the twin blue profiles of the high, arched rocks and the burnished glassy surface of the sea. Turner was at his most daring, perhaps, in devising the phosphorescent Nereids who guide Ulysses' ship over the waves towards liberty. And yet they too are successfully part of nature enhanced: mere flashing foam, it might be, gathered about the ship's prow, or some mysterious manifestation of the deep, briefly glimpsed by lonely sailors in southern seas.

Joseph Mallord William TURNER (1775–1851)
Rain, Steam and Speed

Amazement and admiration seem to have been the chief emotions aroused in the press when Turner exhibited this painting at the Royal Academy in 1846 – at a time when the 'railway mania' was at its height. And it arouses similar emotions today. The full title of the painting is something of an advertiser's dream: *Rain, Steam and Speed – the Great Western Railway*. Turner was, and possibly still is, mocked for some of the more wordy titles for his pictures, but the three nouns he chose to define this painting sum it up perfectly. There is tremendous expressive power in the diminishing diagonal of the bridge which, along with the pulsing, glowing shape of the train, stands firm under the assault of a storm which seems of truly cosmic dimensions. To an abstract concept, 'speed', Turner has given as much visual reality as he has to the hardly less elusive facts of steam and rain.

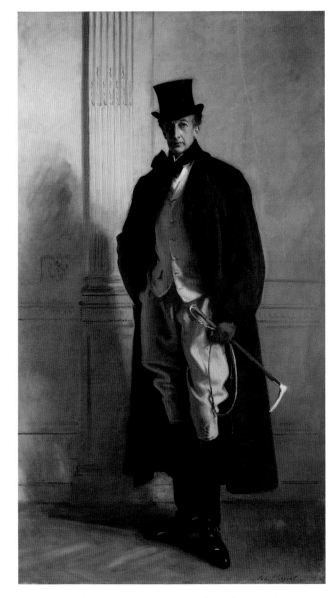

John Singer SARGENT (1856–1925)
Lord Ribblesdale

Sargent saw Lord Ribblesdale at a public dinner, was struck by his distinguished appearance and asked to paint him. That was a few years before the present portrait (signed and dated 1902) was executed, but Sargent was already a successful, much sought-after portrait-painter. That it was he who chose the sitter is probably one reason for this brilliantly effective, yet unforced result. Lord Ribblesdale is dressed in hunting clothes and exudes an air of forbidding, aristocratic hauteur which may now seem perilously close to the idiom of British costume films of the 1940s. That would misrepresent a masterpiece by Sargent and almost certainly the sitter's own character. He was a Trustee of the National Gallery and gave the Gallery this portrait during the First World War, in memory of his wife and two of his sons who had been killed in action. That today, after many years' absence, it again hangs on public display at Trafalgar Square, is a deserved tribute to his generosity — and a sign also of the rehabilitation of the painter.

French Painting

The history of the representation of French painting at the National Gallery is probably the most fascinating of all such histories of taste within the context of the Collection. French painting was, of course, evolving dramatically during the very century that the Gallery's own Collection was being built up. Unfortunately, strong British prejudice, combined with equally strong ignorance, meant that no advantage was taken of that fact. The broad position up to and indeed beyond 1900 was to interpret French painting as a matter largely of Claude and Poussin. Anything later was somewhat suspect – an attitude which took long to disappear entirely from the Gallery's thinking.

Because of sustained English feeling for Claude especially, there were superb examples of his work in the Collection from the first. The grand *Seaport with the Embarkation of the Queen of Sheba* (p. 214) was only one of the Claudes among the Angerstein paintings bought in 1824. Poussin was less well represented in the early days, though the profoundly poetic *Cephalus and Aurora* (p. 215) was bequeathed by G.J. Cholmondeley in 1831. And it was by bequest – not purchase – that a few eighteenth-century paintings trickled into the Collection, among them Vernet's *Sea-Shore* (p. 227), bequeathed in 1846-7 by Richard Simmons. The Gallery's sole Watteau, *'La Gamme d'Amour'* (p. 219), was a generous bequest by Sir Julius Wernher in 1912. In 1914 Sir John Murray Scott bequeathed Mignard's lightly personified portrait of the Marquise de Seignelay and two of her children (p. 218).

Meanwhile, the French nineteenth-century School had been largely neglected, although through the Sir Hugh Lane Bequest there had come in 1917 such masterpieces as Corot's *Avignon from the West* (p. 233) and Renoir's *Umbrellas* (p. 242). Awareness of the Gallery's grave deficiences and of its previous slowness to acknowledge the achievements of French art in the later nineteenth century, led to inspired buying in Paris at the Degas sale in 1918 of, for example, one version of Manet's *Execution of the Emperor Maximilian* (p. 237).

After the Second World War efforts concentrated for several years on the nineteenth century, with purchase of major works like the very late *Water-Lilies* by Monet (p. 240) and Cézanne's *Bathers* (p. 249). Thanks to the existence of the enlightened Courtauld Fund, works by yet more 'difficult' or less acknowledged painters – like van Gogh and Seurat – had already been bought for the nation in the 1920s; thus van Gogh's *Chair and Pipe* (p. 245) is today at Trafalgar Square, as is the *Bathers at Asnières* by Seurat (p. 244).

In more recent times a positive effort has been made to strengthen the eighteenth-century School, with a number of major purchases such as Fragonard's *Psyche* (p. 222) and Drouais's *Madame de Pompadour* (p. 225), culminating in acquisition of the first painting by Jacques-Louis David – his portrait of Jacobus Blauw (p. 228) – to enter a British public collection. Nor has the later nineteenth century been neglected in the Gallery, as Renoir's *Seine at Asnières* (p. 241) and Monet's *Gare St-Lazare* (p. 239) testify. The limits of the Collection have also been extended, reasonably enough as the twentieth century draws to an end and distinguished early 'modern' artists take on old master status; and a significant step forward was taken in 1979 with purchase of the portrait of Greta Moll by Matisse (p. 250).

FRENCH(?) School (*c*.1395 or later)
*Richard II presented to the Virgin and Child by his
Patron Saints ('The Wilton Diptych')*

It is a matter of considerable doubt if this exquisite work of art can be French in origin. And that is only the start of the uncertainty surrounding it. Its date and its significance are equally unclear. However, much in it is visually clear, realised with a beautiful artistic clarity beside which hypotheses hardly seem to matter. King Richard II of England, beardless and looking youthful, kneels in the presence of Saint John the Baptist, and two sainted English kings, Edmund and Edward the Confessor, to witness a vision of the Virgin and Child surrounded by angels. Richard wears a broom-cod collar and a prominent badge of the White Hart, his own personal device. What seems remarkable is that the angels all wear the same collar and badge, as if they were the King's adherents – bringing to mind the lines from Shakespeare's play *Richard II* where the King claims that for every man revolting against him, 'God for his Richard hath in heavenly pay / A glorious angel ...'.

It could possibly be that the diptych commemorates Richard's deposition and subsequent death, but perhaps the greater probability is that it shows him alive and still reigning, being singled out for divine protection. The unknown painter lavishes all his art on both portions of the diptych, in a blaze of gold and blue. Amid the colour and the refined detail, he manages too to suggest not only the King's ecstasy, but the excitement among the angels at this lyrical yet solemn scene of interaction between the kingdoms of earth and heaven.

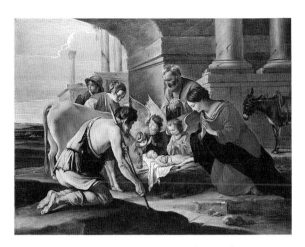

Louis LE NAIN (1595/1610–1648)
The Adoration of the Shepherds

There are several odd features in this painting – not least the distracted gaze of both the boy shepherd wearing a hat and the would-be adoring angel at the crib. They seem to indicate something occurring outside the composition, or possibly are merely acting naturally at an occasion which the painter conceives as partly 'realistic' and humbly rustic and partly idealised – as in the figure and costume of the Virgin. The three brothers Le Nain, of whom Louis is usually judged the outstanding personality, were rather mysterious artists. They came from provincial Laon to work in Paris, bringing with them a style of their own, with strong emphasis on peasant life as a theme, painted with as much dignity as delicacy. At this plain nativity, there are no troops of glorious angels but just two thoroughly human, winged children, of the same flesh – one feels – as the adoring mortals and indeed the Child Himself.

Le VALENTIN (1591[?]–1632)
The Four Ages of Man

Valentin's allegory of human mortality takes on additional resonance with the realisation that he himself died comparatively young. An air of passive melancholy invests this composition – a typical seventeenth-century one of figures grouped about a table – and even the fashionably dressed young musician, symbolising Youth, seems more haggard than hedonistic. Valentin went to Rome early and came under the influence of several painters, notably Caravaggio. His is a delicate, poetic form of Caravaggism, recalling Renaissance Venice and Giorgione's ethos.

Philippe de CHAMPAIGNE (1602–1674)
Cardinal Richelieu

Champaigne was born in Brussels but was chiefly active in Paris, where he
worked for the Queen Mother, the King, Louis XIII, and the powerful chief minister
Cardinal Richelieu, a great patron of the arts. Champaigne was a gifted portraitist as well
as a painter of dignified religious pictures. This grand-scale portrait was probably
intended to hang at Richelieu's Château de Rueil – a hint of which seems to appear at the
left – and it is very much a state portrait. More static and sculptural than a comparable
van Dyck, it is an image as firm as polished marble, combining sensitive response to the
sitter's refined features with a majestic moulding of his robes, literally heightening his
stature and distancing him from ordinary men.

CLAUDE (1600–1682)
'The Enchanted Castle'

The title of this painting is more properly *Psyche outside the Palace of Cupid*, but the palace is indeed an enchanted one and the popular title pays tribute to the evocative power of the central motif, which is less Psyche than the building rising on the rocks beside the seashore. In fact, it was in an engraving by William Woollett in 1782 that the picture was first called 'The Enchanted Castle', and probably it was through that engraving that Keats became aware of the painting. It inspired him in a verse-letter to his friend Reynolds and, less directly but most memorably, was to lie behind the lines of his *Ode to a Nightingale* which speak of 'magic casements opening on the foam / Of perilous seas in faery lands forlorn'.

Claude himself had been inspired by the love story of Psyche and Cupid told in *The Golden Ass* by Apuleius. He shows Psyche seated on the ground, either banished from Cupid's palace because she has disobeyed his injunction not to look at him when he visits her by night, or deposited by Zephyr in a strange region and about to discover the palace for the first time. The picture's mood seems more tranquil than despairing. Certainly the painting is, even more than usually with Claude, a landscape so purely realised that the figures hardly matter. What forever holds attention is 'the enchanted castle'.

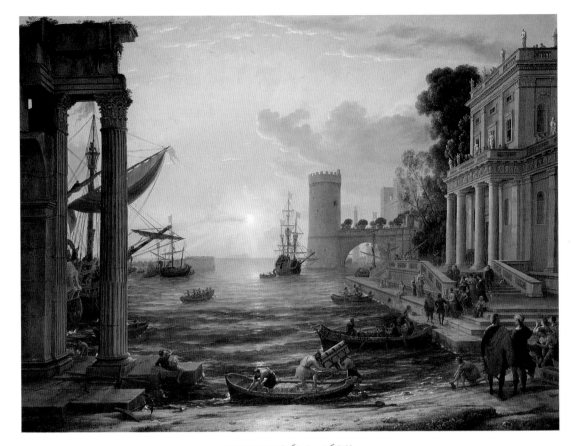

CLAUDE (1600–1682)
Seaport with the Embarkation of the Queen of Sheba

The facts of the commissioning of this picture are inscribed on it by Claude. It was painted in Rome, in 1648, for the Duc de Bouillon, who had recently served as general of the Papal army. Its pendant is the *Marriage of Isaac and Rebekah*, also in the Collection, a landscape rather than a marine scene as here, and depicted in broad daylight as opposed to the misty early morning luminosity which makes this painting so magical. Quietly but deliberately, Claude builds a seaport of his own imagining. Towers and trees and tall palaces fringe the wonderfully liquid, gleaming, faintly lapping sea. Day is slowly breaking as the Queen of Sheba with her retinue descends a huge flight of steps to begin her journey to Solomon in Jerusalem. Popular though the Biblical story was, no painter before Claude had thought to depict the Queen's setting out. It undoubtedly provided Claude with a pretext for painting a seaport at dawn, but, more than that, it gave him the freedom to construct a kingdom of the past, blended out of natural observation and imagination. Like Old Testament Ophir, Sheba is exotic and rich in associations, and to such an airy concept Claude is able to give precise location and subtle atmosphere.

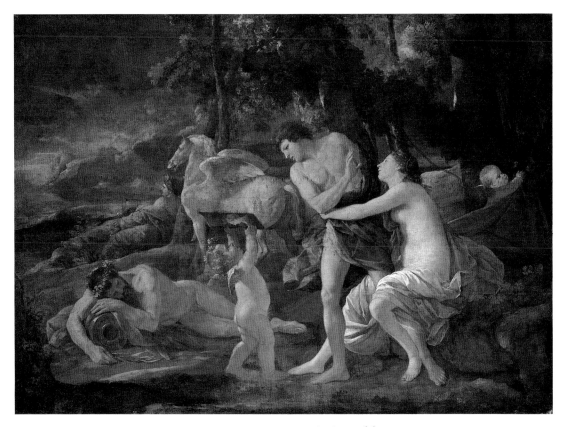

Nicolas POUSSIN (1594[?]) –1665)
Cephalus and Aurora

This is a fairly early work and not perhaps a very famous Poussin. Nor is the subject a very familiar one. It shows Cephalus, a mortal, turning away from Aurora, the goddess of dawn, at the sight of a picture of his wife, Procris, held up to him by a cupid. From this story, told by Ovid, Poussin has distilled a potent re-creation of the classical antique world, a world of nature and natural forces mingled with human emotions. All seems summed up in the poetic shape of the winged, white Pegasus standing under the trees, but no less wonderfully realised are the reclining figures of the naked, dozing river god and, beyond, the draped goddess, Earth perhaps, who watches Apollo driving his chariot through the sky to begin another day. Poussin treats the scene with the deepest seriousness yet turns everything into a pagan poetry wilder and more sensuous than he would later permit himself.

Nicolas POUSSIN (1594[?]–1665)
The Adoration of the Golden Calf

Poussin here is in stern Miltonic mood, working on a scale which is big by his standards and dealing with a theme serious and monitory. Concerned with design rather than colour, he creates out of the foolishly adoring Israelites one chain of interlinked, dancing figures, frozen in movement, and a massed gesticulating group, at the right, which leads the eye into the depth of the composition where smaller figures kneel and gesticulate. The grand, rocky landscape is filled with almost delirious excitement – conveyed by a gamut of reaction – while coming down like thunder from the mountains, Moses at the left shatters the tablets of the Law in his fury at the godless sight. Thus, it might be said, Poussin punishes and represses his own natural, pagan tendencies.

Nicolas POUSSIN (1594[?] – 1665)
Landscape with a Snake

As much as Claude, Poussin studied and absorbed nature and then re-created it in his own idiom. Poussin's natural world becomes, however, no melting, agreeable dream of 'faery lands forlorn' but is intellectually ordered, solidly constructed and ultimately austere. This composition is skilfully plotted, to lead the eye from the horrific foreground incident of a corpse entwined by a snake to the unruffled surface of the lake and then on to the distant, strongly geometrical city which it mirrors. The subject may be of Poussin's devising, though given classical dress, and probably shows the effects of terror, reverberating in degrees through the receding planes of the magnificent landscape, whose sombre serenity is on the point of being broken.

Pierre MIGNARD (1612–1695)
The Marquise de Seignelay and Two of her Children

It was in 1691, the first year of her widowhood, that the Marquise de Seignelay
was portrayed by Mignard, a leading artist of the day in Paris, in the guise of the sea-
nymph Thetis, with her eldest son as Thetis' famous child, the young hero Achilles. All
this allegorising, like the coastal setting, pays tribute to the fact that the Marquise's
husband had been Secretary to the French Navy. Such elaborate portraits were to seem
false and ridiculous by the mid-eighteenth century, yet – such are the shifts of taste –
this style of portraiture had actually had its 'natural' aspect, offering the artist freedom
from contemporary costume and some opportunity for invention, as well as for
decorative colour. Mignard seizes those opportunities, and if he cannot do much with
the Marquise's insipid features and improbable coiffure of sea-weed and coral, he boldly
devises rainbow draperies and shows true painterly response in the varied
forms of the shells delicately littering the foreground beach.

Jean-Antoine WATTEAU (1684–1721)
'La Gamme d'Amour'

Watteau probably gave this painting no specific title. The present one derives from an engraving of it executed after his death. It was part of his originality that his pictures usually lack distinct incidents and decline to tell any overt 'story'. That does not mean that they lack subject-matter or significance. Yet even if the pair of male musician and female singer here are lovers, or on the point of finding themselves in 'the scale of love', there are other less explicable figures in the leafy distance, including a child. The bust, too, is not at once an obvious object on the scene. Over a composition that might seem arbitrary, and has indeed its own capricious inventiveness, Watteau throws a veil of enchantment. The very foliage has a silken, half-autumnal charm, almost as elegant as the figures it embowers, clad in tones of autumn or sunset. And that stoutly robust stone head, which seems to have survived so long and seen so much, is perhaps an abiding presence, to remain after the music has ceased and the lovers departed.

Nicolas LANCRET (1690–1743)
A Lady and Gentleman taking Coffee with Children in a Garden

After Watteau's poetry, the art of Lancret, his closest disciple of real talent, may seem light verse – though of a most accomplished kind. Lancret was far from being a mere imitator of Watteau, and this work shows him at his charming best, quietly observant for all the elegantly artificial setting, and mildly humorous. He exhibited the painting at the Salon in 1742, the year before his death, identifying in the title the substance being drunk as coffee. The little incident of the younger girl of the family experiencing that taste for the first time provides sufficient 'subject' for what are probably portraits of a real family. And artificial though the garden is, it expresses a new delight in informal, open-air life and nature generally – even if here nature is very much 'to advantage dressed'.

François BOUCHER (1703–1770)
Landscape with a Watermill

Within Boucher's own lifetime a revolution of taste led, in intellectual circles, to the dethronement of a painter famous, successful and widely acknowledged to be wonderfully gifted. What was particularly attacked was Boucher's interpretation of nature, on the grounds that his pastoral scenes and landscapes – like this one – were not 'true'. The point might seem scarcely worth contesting but the charge has continued to damage the artist's reputation. Boucher consciously created a rustic world pleasanter and more picturesque than any actual one, though full of real, natural motifs, and he painted it with a delightful feel for water and foliage and thatched roofs. The result is a frank dream of country life – though, it is worth noting, life is shown as not all idleness, at least not for women. As an artist, Boucher claims as much right as, say, Claude to give expression to his own vision, and no less intensely does he realise it. The defence of such art – assuming defence is still necessary – might begin by citing a remark of Keats: 'What the imagination seizes as beauty must be truth.'

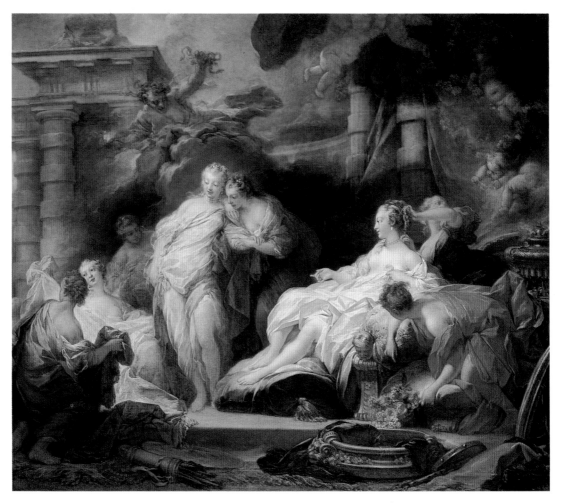

Jean-Honoré FRAGONARD (1732–1806)
Psyche showing her Sisters her Gifts from Cupid

Brilliantly talented, the young Fragonard had painted this picture by the time he was twenty-two. The composition and handling are full of echoes of various painters, especially Fragonard's master, Boucher. Infelicities as much as felicities abound – Psyche's anatomy being a good example of the former – but the painting is charged with energy and artistic exuberance. As Cupid's mistress, Psyche is showing her envious sisters the gifts the god has given her, and to that Fragonard adds hints of a 'toilet of Psyche', with an attendant typically vigorously dressing her hair, while flying cupids rain roses around her. Already there can be detected here many of the chief characteristics of Fragonard's art: its animation, its almost breathless sensuousness and *joie de vivre*, and its delight in communicating excitement through bravura brush-strokes. In all those ways, the true teacher of Fragonard may seem to be Rubens.

Jean-Siméon CHARDIN (1699–1779)
The House of Cards

The theme of this composition was obviously one that meant much to Chardin. He painted it several times, and to the theme may be added paintings by him of a boy playing with a spinning-top on a table and a boy sharpening a crayon. The formal elements – the single vertical of the half-length figure and the strong horizontals of the table – are at once calm and simple. As the boy concentrates, so does Chardin, lifting the subject into a realm beyond that of genre or portrait (though the boy is early identified as the son of Jean-Jacques Le Noir, a friend of the painter's). The intense gravity of the composition, with its almost stylised, semi-abstract shapes, rendered in beautifully saturated paint, seems to contrast with the childish diversion depicted. Yet Chardin's contemporaries saw a moral dimension in the subject, asking: are our adult projects any better based than this boy's fragile house of cards? Chardin himself declines to be so explicit, and thereby gives the scene the greater timelessness and artistic profundity.

Jean-Marc NATTIER (1685–1766)
Manon Balletti

In an age of graceful ideals, portrait-painting had also to be graceful, and Nattier was the supreme French exponent of graceful, lightly allegorised portraiture which in his hands lost nothing of truthful likeness. He seems to have understood very well that the enchanting appearance of the young Marie-Madeleine Balletti, daughter of an Italian actress living in Paris, needed no allegorical enhancement. She was seventeen and he seventy-two when he caught so directly her flower-like charm, which attracted the attention also of Casanova. Casanova may even have commissioned the painting. After a liaison with him, Manon Balletti married the distinguished architect Jacques-François Blondel and died at the age of thirty-six.

Jean-Baptiste PERRONNEAU (1715[?]–1783)
Jacques Cazotte

Perronneau is a portraitist of great power and sensitivity. He was not concerned to emphasise grace and charm as such but to convey something of a sitter's living presence. And in this portrait of a sophisticated literary figure in mid-eighteenth-century France he succeeds with astonishing force. Not just Cazotte's slightly amused features but the carriage of his head and shoulders, along with his elegant costume, all contribute to the impact of a distinct personality. Cazotte hardly appears posed for a portrait – notably does not look at the spectator – but seems engaged in easy, conversational *rapport* with an unseen interlocutor.

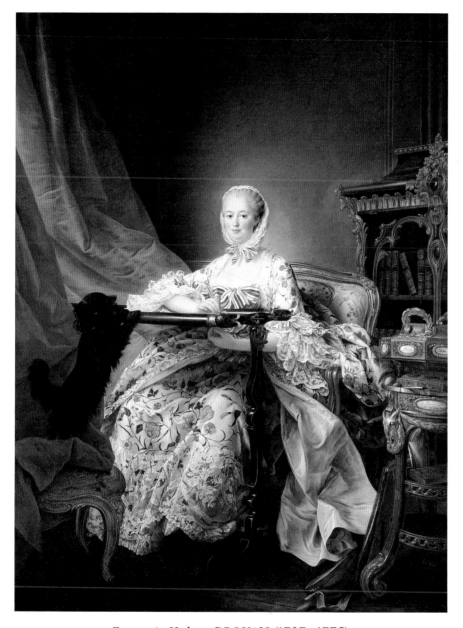

François-Hubert DROUAIS (1727–1775)
Madame de Pompadour

The painting bears Drouais's signature and an inscription that the head was done in April 1763, the picture finished in May 1764 (a month after the death of Madame de Pompadour). In fact, the head is on a separate piece of canvas, inserted into the larger composition. The sitter, born Jeanne-Antoinette Poisson, became the mistress of Louis XV and was herself a considerable patron of the arts. In health and beauty she was often portrayed by Boucher, but Drouais's portrait is of her grown prematurely matronly, no longer the King's mistress, and almost obsessively surrounded by the evidence of intellect and industry — books, music and the wools for her tapestry-work. Drouais skilfully manages to convey a maximum of detail, down to the pattern of the elaborate, floral dress, without losing the central focus on the sitter; and the resulting portrait is at once grand and homely, and also oddly poignant.

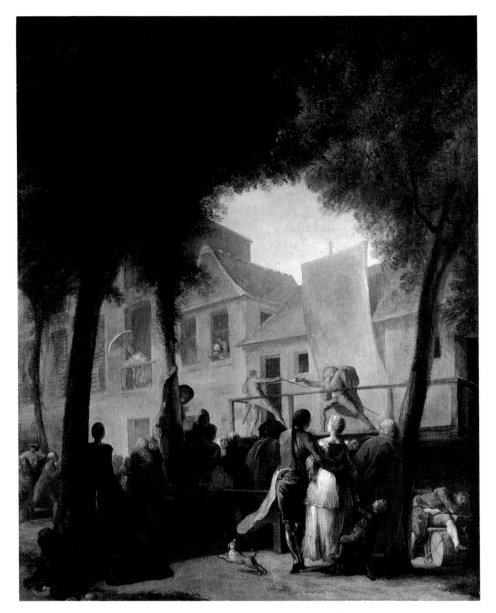

Gabriel-Jacques de SAINT-AUBIN (1724–1780)
A Street Show in Paris

This is one of the most original and vivid paintings of daily life in mid-eighteenth-century Paris, and it is a pity that the artist is not better known. His paintings are rare, for he worked chiefly as a draughtsman, engraver and illustrator, finding little official success as a painter. How much attracted he was to the contemporary scene is well shown in this ingeniously composed depiction of ordinary Parisians of all ages gathered to watch a couple of actors engaged in a mock-duel on a rough stage under leafy trees. Life seems truly *couleur de rose* here – the rose perhaps of the parasol held by the woman gazing down from her balcony. Yet Saint-Aubin, handling paint vigorously, is concerned to show the gamut of life. What is fun for the spectators is work for others; tucked away at the right of the composition is the drummer of the actors' troupe, sprawled with one leg over his drum, clumsily yet desperately asleep now his part is played.

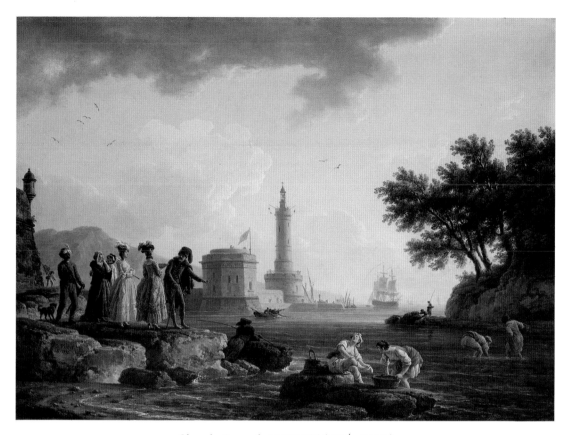

Claude-Joseph VERNET (1714–1789)
A Sea-Shore

Vernet was the leading French exponent in a category of painting – the landscape – which the eighteenth century took more seriously than is perhaps always recognised. Vernet himself enjoyed international fame and patronage, not least from the English. His early years in Italy coloured his art, in which are blended reminiscences of Claude and on-the-spot natural observation. This painting is dated 1776, long after Vernet had returned to France, but the scene is obviously Southern, vaguely Neapolitan. Its picturesque setting and warm light are vividly conveyed, and the scene is enlivened by a group of sightseers, no less keenly observed. Indeed, for the pointing hussar who escorts a party of ladies, Vernet seems to hint at attractions beyond nature's in the piquant poses of the bare-legged fishergirls.

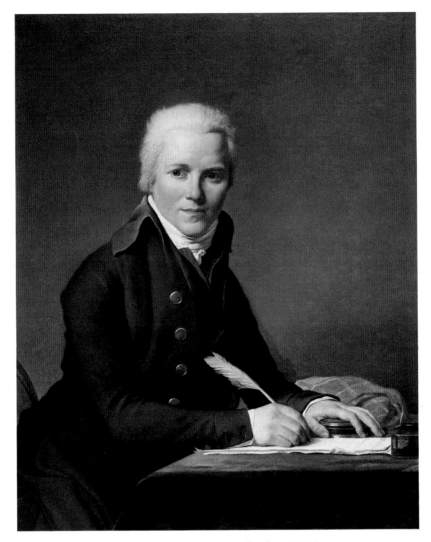

Jacques-Louis DAVID (1748–1825)
Jacobus Blauw

The date on this painting is the year 4 – in itself a defiant declaration of a break with the past and the advent of a new era. The year 4 is 1795, the fourth year of the French Republic that had replaced the monarchy. David's art may also be seen as a break with the past, at least as associated with the hedonism of Boucher and Fragonard (pp. 221-2). His style is a sterner one, uncompromising in its visual purity, akin in some ways to Chardin's, but sharper, harder and more linear. It made David a wonderful portraitist when his sympathy was engaged, as it is here in his depiction of the Dutch patriot Blauw, who went to Paris to negotiate a peace treaty between the Batavian and French republics.

David fixes Blauw in the act of writing what is probably an official despatch, and concentrates all his artistic power on precisely recording the metal buttons of Blauw's coat, the line of linen at his cuffs and the quill pen, as well as his features and pose. There is tension and economy about the total image, beginning with some tension in the sitter's face. Not accidentally perhaps, the portrait seems in every way to speak of very different ideals – in society and in art – from those expressed by Perronneau's *Jacques Cazotte* (p. 224).

Jean-Louis-André-Théodore GERICAULT (1791–1824)
A Horse frightened by Lightning

As much as Stubbs, Géricault was a great painter of horses – and the very subject
here was one treated by both painters. In some ways, Géricault's treatment is the less
'romantic' and dramatic. He isolates the animal against a sky of midnight darkness and
storm, and has lightning play with livid, rippling effect over the horse's glistening coat,
while fright stupefies him, in a manner more effective than would be any violent
movement. Nothing is known about the origin of the painting – it is not even signed –
but it is fully worthy of Géricault. The solitary horse, unsaddled and so strangely
exposed to the elements in desolate countryside, takes on a haunting quality, investing
the picture with something deeper than might be expected from the subject.

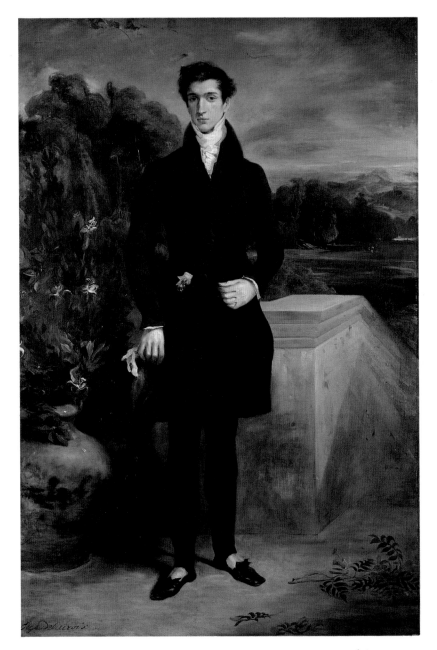

Ferdinand-Victor-Eugène DELACROIX (1798–1863)
Baron Schwiter

Both painter and sitter were in their early twenties (the sitter just twenty-one)
when this ambitious full length was painted. Delacroix had visited England in 1825, the
year before he began the picture, and had seen and been impressed by the work of
Lawrence. Some of Lawrence's panache, allied to Delacroix's own, has gone to the
concept of Schwiter − a painter and a collector − standing like a melancholy dandy, in
black, on a grandly vague terrace. The portrait was refused at the Salon of 1827, which
is a tribute perhaps to its bold handling and accomplishment. The artist was already
suspected of being opposed to the classicism of Ingres, but a more positive tribute to its
quality comes from the fact that later it was to be owned by a great admirer of
Ingres, Degas.

Jean-Auguste-Dominique INGRES (1780–1867)
Madame Moitessier

This portrait had a long and unusual history, suitably enough perhaps, for it stands as a sort of *Mona Lisa* in the career of Ingres. Ingres disliked painting portraits, and when asked to consider undertaking one of Madame Moitessier, daughter of the associate of a friend, he refused. Then he met her. He withdrew his refusal. He began the portrait in 1844, and by 1850 it was still unfinished. He then began another portrait of Madame Moitessier, standing. It was quickly completed, and Ingres returned to this painting, which was completed only in 1856. By then he had frequently changed the sitter's clothes and jewellery, though he had early fixed her pose. Eventually, the last gem was placed and polished to his satisfaction, and the image-cum-idol took its final shape, incarnate in a temple of nineteenth-century domestic luxury, superb and vacuous, a sphinx without a secret, but a monument to Ingres's obsessive concern with realising totally his vision.

Jean-Baptiste-Camille COROT (1796–1875)
A Horseman in a Wood

The horseman is a certain Monsieur Pivot, for whom Corot painted the picture around 1850. Corot's gifts as a painter are so natural-seeming that his work can look artless – which is far from the case. This small, perhaps somewhat ignored painting has a memorable air and extraordinary immediacy – as if Monsieur Pivot were turning to face an early photographer. The depth of the wood where Corot seizes rider and horse not only adds an effective, unbroken, background screen but also gives to the composition a touch of unforced mystery.

Jean-Baptiste-Camille COROT (1796–1875)
Avignon from the West

In Corot's best work there seems scarcely a pause between what his eye remarks and what his hand conveys, and the atmospheric assurance of this view of Avignon in hot summer sunlight is overwhelmingly direct and instantaneous. Here is an 'impression' painted before such Impressionists as Monet were even born. Typically, Corot puts Avignon into the distance, using the tall mass of the Popes' palace there as merely a convenient buff shape between the harsh green scrub of the foreground and the pale violet of the distant mountains. As a sheer tonal *coup d'oeil*, from which there exudes a sense of fierce heat, combined with almost pitiless light, Corot's view of Avignon and its surroundings is a perfect piece of art.

Ignace-Henri-Jean-Théodore FANTIN-LATOUR (1836–1904)
'The Rosy Wealth of June'

The title is apparently the painter's own. It unfortunately gives Victorian academic overtones to a painting that indeed was shown at the Royal Academy (in 1898) but which is full of a heavy, almost scented, floral luxuriance that is far from tame or conventional. Fantin is an extraordinarily sensitive painter of flowers – of roses particularly – composed often in simpler bunches than here, with a feel for texture, as well as tone, that is mysterious in its intensity. Although flower-painting was his speciality, he had a surprisingly wide range of subject-matter, painting several subtle portraits and some possibly less successful allegorical pictures. Fantin was a friend of Manet and is one of the figures identified in Manet's *Music in the Tuileries Gardens* (p.236).

Charles-François DAUBIGNY (1817–1878)
St Paul's from the Surrey Side

Daubigny is most often thought of, rightly, as a painter of rather mild, intimate landscapes. A city scene like this is a distinct and welcome change – as is its sub-impressionist technique. Daubigny came to London twice, the second time in 1870-1. He presumably made some drawing or oil sketch of the view, since the painting itself is dated 1873 (and was probably that included in an exhibition held in London the following year). London's thoroughly polluted, smoky atmosphere is part of the appeal for the painter. St Paul's and Southwark Bridge appear as distant grand motifs, contrasting with the rows of barges and lines of stakes along the foreground shore, all of which are painted with great directness and vivacity. Not quite stating it, Daubigny yet manages to convey the active, mercantile use of the Thames at the heart of London, very different from the use of the Seine in his native Paris.

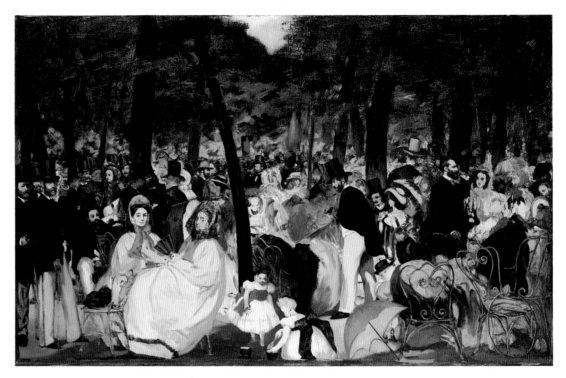

Edouard MANET (1832–1883)
Music in the Tuileries Gardens

Manet was thirty when he painted this picture and accepted, in effect, the role of 'painter of modern life', as called for by his friend Baudelaire in an essay written a few years before but not published until 1863. Manet and Baudelaire are recorded as going regularly to the Tuileries Gardens to study the open-air scene of fashionable people and children, and among the numerous portraits in the painting are those of Manet himself, at the extreme left, and Baudelaire, in profile under the thickest of the tree-trunks in the left-hand area. To the left of Baudelaire is the head of Fantin-Latour.

Manet's assemblage of modern life in the open air is painted with a freedom that contributes to its sense of vitality. Already, he paints an 'impression' of the scene, rather than records literally – and the lack of finish in the handling may have disconcerted Baudelaire; it certainly led to strong criticism when the picture was first exhibited in 1863. Today, the painting seems a key masterpiece, in the career of Manet and for the history of Impressionism, in its brilliance, boldness and visual wit. Yet it remained on Manet's hands, it seems, until a few months before his death, when his greatness as an artist was still imperfectly recognised.

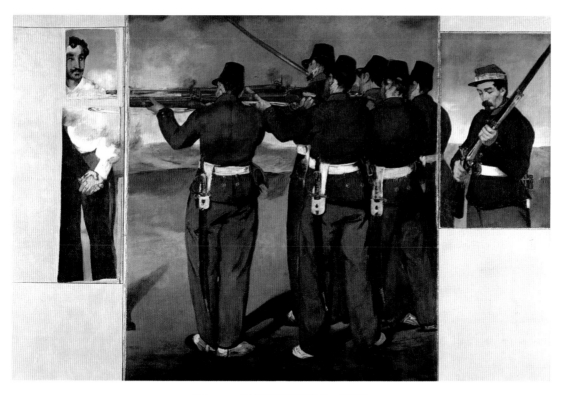

Edouard MANET (1832–1883)
The Execution of the Emperor Maximilian

These are the sole remaining fragments of a much larger composition of the subject, the second of three painted by Manet, which the painter himself abandoned and partly cut up. After his death the fragments were acquired and assembled together by Degas, a not unambivalent friend of Manet's during his lifetime but someone with an equally keen eye as an artist and as a connoisseur. Probably Degas savoured the detached-seeming way in which Manet has painted a scene he did not witness: the execution in Mexico on 19 June 1867 of the Emperor Maximilian and two of his generals.

The Emperor was an Austrian archduke, put on the throne at French instigation. He was overthrown and shot by nationalist forces after French troops had been withdrawn from Mexico, and his death deeply shocked Manet (along with a good deal of enlightened French opinion). Manet's implied criticism of France is shown by the fact that the firing squad wear French uniforms. So nervous was the government in Paris that it forbade him to publish his lithograph of the subject.

Whatever his strong private emotions, Manet has made the scene more tragic by his impassive depiction, with its powerful sense of inevitability. And, by the chance of what survives, there is great poignancy in the presence of the Emperor conveyed only by his handclasp with his loyal general at the moment of execution.

Hilaire-Germain-Edgar DEGAS (1834–1917)
La La at the Cirque Fernando, Paris

In this painting lies the quintessence of Degas's art. It is a mature work, dating
from 1879. The stunning clarity of the image, itself so unexpected that it almost dizzies
the spectator, is the result of intense study and discipline. Line is the secret. The linear
structure of the composition is in places quite explicit – as in the ribs of the roof and the
long, slightly tilted vertical of the rope running from top to bottom of the picture-area.
The body of the acrobat, suspended by her teeth high above the invisible audience, is
a study of taut, muscular action, lit as unexpectedly as it is viewed. And there is
something revelatory of Degas's nature in the way he banishes the audience, so that
La La seems to perform in an empty auditorium for him alone.

Hilaire-Germain-Edgar DEGAS (1834–1917)
Hélène Rouart

Hélène Rouart was the daughter of a life-long friend of the painter's. Degas
admired her red hair and probably decided to paint her portrait around 1886 – at a time
when he was ceasing portrait-work – out of personal feelings for herself and her family.
It is in her father's study that she is shown, surrounded by objects he had collected and
leaning on his chair, which so prominently occupies the foreground. The composition
is ambitious and unusual, conveying an environment as well as a person and, perhaps
by chance, exuding some sense of it oppressing, even imprisoning, her.

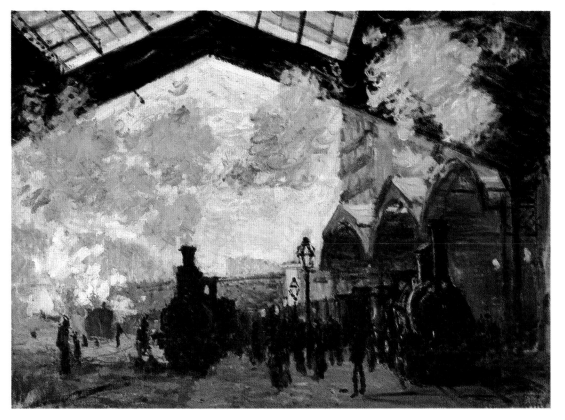

Claude-Oscar MONET (1840–1926)
The Gare St-Lazare

It was a daring, novel, unrewarding-seeming subject that Monet chose when he obtained permission in 1877 to paint inside the Gare St-Lazare. Yet the result was a series of seven canvases, each slightly different, which showed Monet no less appreciative of the urban scene, within his own terms, than of the countryside with which he had been, and was to be, chiefly associated. The present composition depicts the main tracks of the station in a purely 'impressionist' way, with the puffs of steam, the dark engines, and the architecture of the station interesting the painter far more than people. What Monet conveys most vividly is the slightly chill, shifting, drifting and partly man-made steamy atmosphere – creating a modern interpretation, as it were, of Turner's *Rain, Steam and Speed* (p.207).

Claude-Oscar MONET (1840–1926)
Water-Lilies

In 1890 Monet bought a house at Giverny, a village in the valley of the Seine, and it remained his home for the rest of his life. There he created a water-garden that was to become a major theme in his art, a motif which he could study exactly when and how he wished. The surface of the thickly strewn water-lily pond fascinated and challenged him, and over the years he was to paint it with increasing boldness. The scale of the paintings grew, as did the pond, and this is one of the large, late pictures, executed around 1916, by which time Monet was responding as much to an inner vision as to the actuality of the pond or lake. The pervasive yellowish light and the mere flecks of the floating leaves and flowers create a shimmering effect, at first sight decorative but with a deeper feel to it of calmness, timelessness and peace.

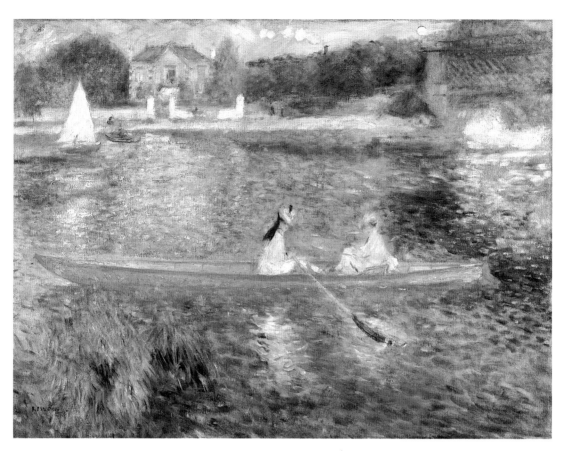

Pierre-Auguste RENOIR (1841–1919)
The Seine at Asnières

Few paintings seem to call for explanation less than Renoir's – which is not to imply any lack of art in the painter. Renoir followed a dangerous road, however, in leaving so much to his instinct, and the results can be dreadfully trivial. Yet, when the response could be as vivid as here, it is understandable that Renoir trusted his instinct. The sensation of sunlight striking water on a bright summer's day is conjured up with such astonishing freshness that the eye is dazzled. This is no artless achievement; every touch of paint has been as nicely calculated as has been the composition, with its high horizon, giving the river the role of protagonist in a positive paean to warmth and light.

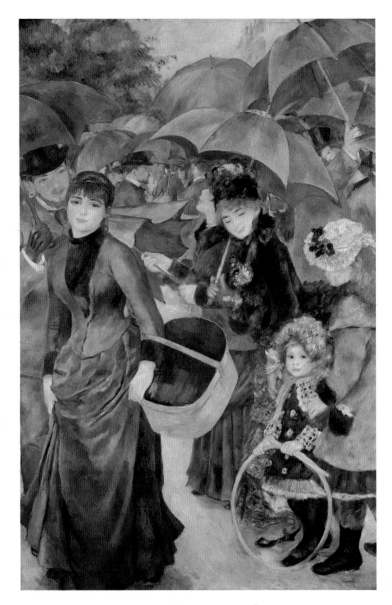

Pierre-Auguste RENOIR (1841–1919)
The Umbrellas

Thought, illness, travel and despondency played their part in the profound achievement of this painting. All had had a beneficial effect on Renoir by the time he completed the stylistically slightly schizoid composition, around 1886. The right-hand foreground figures are executed in a charming, feathery, thoroughly 'impressionist' style. The left-hand portion of the painting is far more linear, with a definition of planes by means of hatching that derives from awareness of Cézanne. In travelling, Renoir had looked also at Raphael. He had come to feel that for him Impressionism was exhausted. The result is a painting that is more than charming – the umbrellas alone are skilfully organised to rise to a crescendo of curves at the upper right – but which remains fully characteristic of its creator. Women are the heart of the matter for Renoir, whether the scene is a street or a boudoir, and it is significant that in *The Umbrellas* the sole male realised as more than a head-and-shoulders background blur is a man hopefully trying to catch the eye of the pretty foreground *midinette*.

Camille PISSARRO (1830–1903)
Paris: The Boulevard Montmartre at Night

Pissarro was as instinctive a painter as Renoir, with no less keen an eye, but one better disciplined and arguably more in control of his talent. The tonal accuracy of his best paintings is indeed unrivalled by any of the other Impressionists. An Impressionist he remained, and in this late picture – painted in 1897 – are revealed what his vision and technique could still achieve. From a hotel room he looked out on the busy Boulevard Montmartre on a rainy evening, and made that his subject. It is his only night-scene. The need to capture complex effects of gleaming lamps and wet pavements, within an overall penumbra, has increased the confident freedom of his handling. Looked at close to, the blobs and dashes of paint nearly lose their meaning but, as one draws back, the life of the street, with its trees and architecture, its carriages and crowds, springs into total visual existence.

Georges-Pierre SEURAT (1859–1891)
Bathers at Asnières

Although the subject might suggest a Renoir-like scene (and the bridge in Seurat's painting is that at the right in Renoir's *Seine at Asnières* on p.241), great differences in approach and technique are at once apparent in Seurat's picture. He sent it to the Paris Salon in 1884, where it was rejected. In fact, in several ways it is more 'academic', as it is more pondered, larger and more majestic than a typical Impressionist painting. Nothing could be less spontaneous. Like the bank and the buildings, the figures of Seurat's devising are simplified shapes, of almost sculptural solidity, fixed in the fine mesh of the technique which approximates to fresco. Yet not only does Seurat convincingly evoke the hot, lazy atmosphere of the open-air scene but – with far more concern than any Impressionist painter – he suggests the proximity of industrialisation and the sheer prosaicness of modern costume. And about the incongruously bowler-hatted foreground man, reclining awkwardly on the grass amid half-naked neighbours, hovers some anticipation of Magritte.

Vincent van GOGH (1853–1890)
The Chair and the Pipe

The chair is a simple peasant one, seen by daylight and firmly defined against red
tiles in a kitchen-like setting. Van Gogh boldly fills the composition with it, his own
chair. He depicted it at Arles towards the end of 1888 and complemented it by a painting
of Gauguin's chair, an armchair, seen at night-time. The two paintings celebrated
Gauguin's stay in Arles with van Gogh, something to which van Gogh had greatly
looked forward but which rapidly ended in a violent quarrel and van Gogh's mental
breakdown. The chair here is declared as the painter's own by the presence on it of his
pipe and a twist of tobacco. In the 'little yellow house' at Arles, van Gogh had believed he
would live happily, meditate and paint. Some of his greatest and most memorable
paintings – of which this is one – were indeed done there. But after further
breakdowns and a petition from local people, he left Arles for the asylum of Saint-Rémy
in May 1889, to survive only until July of the following year.

Vincent van GOGH (1853–1890)
Sunflowers

It was at Arles in the summer of 1888 that van Gogh conceived the idea of painting
a series of pictures of sunflowers, a form of decoration – his own word – in which the
strong yellow of the flowers would blaze out against a variety of green and blue
backgrounds. In van Gogh's fiery vision, the sunflowers become like miniature suns,
almost whirling – as well as blazing – on their stems, in a parti-coloured jug of deep
chrome and lemon yellow. To separate the lemon tones from chrome in the jug, and in
the background, van Gogh drew hasty lines of vivid blue paint – arbitrary yet thrilling
– which serve to intensify the molten gold and pure yellows that speak of almost
delirious joy in colour and light.

Henri ROUSSEAU (1844–1910)
Tropical Storm with a Tiger

Rousseau is probably the first of the naïve 'Sunday' painters, a genuinely self-taught artist who retired early from his post as an inspector at a toll-station outside Paris. His vision had its own consistency and was at its most effective in the exotic jungle scenes that he blended from studies in the Jardin des Plantes in Paris, book illustrations and dream-like fantasy. The *Tropical Storm* was the first of these scenes, exhibited in 1891 under the title *Surpris!*. Rousseau's highly finished style increases the hallucinatory power of his best work. In the present painting, it is less the storm or the tiger that matters than the dense and subtle pattern of shapes – and also textures – which makes up a weird yet compelling jungle. Reflecting on the paradox of the painter's quiet untravelled life, one might recall Degas's ironic query apropos Gauguin: 'In the Batignolles district can one not paint as well as in Tahiti?'

Edouard VUILLARD (1868–1940)
The Chimneypiece

This picture dates from 1905. Vuillard is a poet of the most ordinary and domestic aspects of life, unforced in his originality, as in his decorative instincts. The banality of the subject here has its own daring. On the chimneypiece is a frank litter of objects. The flowers are in no tidy arrangement, and medicine-bottles stand against the thickly patterned wallpaper. Some linen is drying on a clothes-horse. Vuillard lovingly records it all, managing to convey the corner of a room that is very much lived-in and which yet blooms with a magic intimacy and appeal whereby ordinariness is transcended.

Paul CEZANNE (1839–1906)
Mountains in Provence

Cézanne was born in Aix-en-Provence, and the fierce light and dry, stony
landscape of the region provided both stimulus and subject-matter for his art. As much
as van Gogh, he set out to interpret what he saw, struggling to express a harmony he
detected in nature. He had begun by exhibiting with the Impressionists but was
increasingly concerned not with surface effects so much as with underlying structure.
In this painting, done probably around 1886, the mountains are less remarkable than
the rocky bank at the roadside, carved by the sun and Cézanne into an angular series of
forms, their facets painted in varied tones of russet, umber and violet-grey. A few dabs of
green paint serve for the sparse vegetation, while in the middle distance the small,
tightly concentrated block of a farmhouse – chief intimation that the land is inhabited
– looks virtually camouflaged amid the brownish-green planes of the fields.

Paul CEZANNE (1839–1906)
Bathers

Cézanne was intensely conscious of pictorial traditions and of the art in museums. There is something challenging in his ambitious attempt, towards the end of his life, to tackle on a large scale the theme of figures in a landscape. Associations of Titian, and also of Rubens and Rembrandt, cluster around his *Bathers*, one of three canvases of similar subject, each with its own compositional emphasis. The bodies of the women are almost roughly realised, with no regard for conventional ideas of beauty or 'finish'. Their bathing is largely, it seems, a matter of sun-bathing. Certainly, the landscape they occupy appears devoid of water and is very much a summary of Cézanne's native Provence in its blues, greens and warm ochre. The figures are themselves profoundly of the earth, like outcrops of rock or giant shards of terracotta, sensuous forms at ease in and harmonising with nature.

Henri MATISSE (1869–1954)
Portrait of Greta Moll

The date of execution of this painting – 1908 – is one of the astonishing things
about it. In the lifetime of such leading Impressionists as Monet and Renoir, Matisse has
quietly but firmly replaced their concerns with an art vibrant in its clarity of line and
areas of flat colour. He portrays Greta Moll – herself a painter and his pupil – with great
acuteness; she is very much more than a mere motif, but it is the essence of a person
that is presented, in boldly simplified, clear-cut shapes. Just as obsessively as Ingres
with Madame Moitessier (p.231), Matisse changed his sitter's clothes, settling eventually
on the greenish blouse and black skirt that manage to survive artistically against the
splendid blue and white patterned material of the background. Pattern is part of the
painting's secret. Its singing lines, like its clear, cool tones, carry one back to some
of the earliest paintings in the Collection, especially to a supreme master of
design and colour, Duccio.

List of Plates

Note: the sizes are given in centimetres followed by inches, height preceding width; the number in brackets is the Gallery inventory number. A date is given only when this appears on the painting.

ALTDORFER *Christ taking Leave of His Mother* (6463) **125**
Wood, 141×111 (55×43 ½). 1520 (?). Purchased, 1980.

Fra ANGELICO *Christ Glorified in the Court of Heaven* (663) **25**
Wood, 31.8×73 (12 ½ × 28 ¾). Purchased, 1860.

Follower of Fra ANGELICO *The Rape of Helen by Paris* (591) **26**
Wood, 50.8×61 (20×24). Purchased, 1857.

ANTONELLO *Portrait of a Man* (1141) **46**
Wood, 35.6×25.4 (14×10). Purchased, 1883.

ANTONELLO *Christ Crucified* (1166) **47**
Wood, 41.9×25.4 (16 ½ ×10). Purchased, 1884.

AUSTRIAN School *The Trinity with Christ Crucified* (3662) **118**
Wood, 118.1×114.9 (46 ½ ×45 ¼). Purchased, 1922.

AVERCAMP *Winter Scene with Skaters near a Castle* (1346) **142**
Wood, diameter 40.7 (16). Purchased, 1891.

BALDOVINETTI *A Lady in Yellow* (758) **28**
Wood, 62.9×40.6 (24 ¾ ×16). Purchased, 1866.

BALDUNG *Portrait of a Man* (245) **123**
Wood, 59.3×48.9 (23 ⅜ × 35 ⅛). Purchased, 1854.

Jacopo BASSANO *The Good Samaritan* (277) **83**
Canvas, 101.5×79.4 (40× 31 ¼). Purchased, 1856.

BATONI *Time orders Old Age to destroy Beauty* (6316) **102**
Canvas, 135.3×96.5 (53 ¼ ×38). 1746. Purchased, 1961.

BEERSTRAATEN *The Castle of Muiden in Winter* (1311) **156**
Canvas, 96.5×129.5 (38× 51). 1658. Purchased, 1890.

Ascribed to Gentile BELLINI *The Sultan Mehmet II* (3099) **48**
Canvas, transferred from wood (?), 69.9×52.1 (27 ½ × 20 ½).
Layard Bequest, 1916.

Giovanni BELLINI *The Agony in the Garden* (726) **50**
Wood, 81.3×127 (32× 50). Purchased, 1863.

Giovanni BELLINI *The Madonna of the Meadow* (599) **50**
Canvas, transferred from wood, 67.3×86.4 (26 ½ × 34).
Purchased, 1858.

Giovanni BELLINI *Doge Leonardo Loredan* (189) **51**
Wood, 61.6×45.1 (24 ¼ × 17 ¾). Purchased, 1844.

BERCHEM *Peasants with Cattle by an Aqueduct* (820) **148**
Wood, 47.1×38.7 (18 ½ ×15 ¼). Purchased, 1871.

BERCKHEYDE *The Market Place at Haarlem* (1420) **172**
Canvas, 51.8×67 (20 ⅜ × 26 ⅜). 1674. Purchased, 1894.

BOLTRAFFIO *A Man in Profile* (3916) **70**
Wood, 56.5×42.5 (22 ¼ ×16 ¾). Mond Bequest, 1924.

Ter BORCH *A Woman making Music with Two Men* (864) **158**
Canvas, 67.6×57.8 (26 ⅝ × 22 ¾). Purchased, 1871.

Ter BORCH *Portrait of a Young Man* (1399) **158**
Canvas, 67.3×54.3 (26 ½ × 21 ⅜). Purchased, 1894.

BOSCH *Christ Mocked* (4744) **114**
Wood, 73.5×59.1 (29×23 ¼). Purchased, 1934.

BOTH *Peasants with Mules and Oxen* (959) **149**
Copper, 39.6×58.1 (15 ⅝ × 22 ⅞). Wynn Ellis Bequest, 1876.

BOTTICELLI *Portrait of a Young Man* (626) **30**
Wood, 37.5×28.3 (14 ¾ ×11 ⅛). Purchased, 1859.

BOTTICELLI *Venus and Mars* (915) **31**
Wood, 69.2×173.4 (27 ¼ ×68 ¼). Purchased, 1874.

BOTTICELLI *Mystic Nativity* (1034) **32**
Canvas, 108.6×74.9 (42 ¾ × 29 ½). 1500 (?). Purchased, 1878.

BOUCHER *Landscape with a Watermill* (6374) **221**
Canvas, 57.2×73 (22 ¾ × 28 ¾). 1755. Purchased, 1966.

Dieric BOUTS *Portrait of a Man* (943) **109**
Wood, 68.6×51.4 (27×20 ¼). 1462. Purchased, 1867.

Dieric BOUTS *The Virgin and Child* (2595) **109**
Wood, 37.1×27.6 (14 ⅝ ×10 ⅞). Salting Bequest, 1910.

BREENBURGH *The Finding of Moses* (208) **143**
Wood, 41.5×56.7 (16 ⅜ × 22 ⁵/₁₆). 1636. Bequeathed, 1847.

BRONZINO *An Allegory with Venus and Cupid* (651) **65**
Wood, 146.1×116.2 (57 ½ × 45 ¾). Purchased, 1860.

Pieter BRUEGEL the Elder *The Adoration of the Kings* (3556) **130**
Wood, 111.1×83.2 (43 ¾ × 32 ¾). Purchased, 1920.

Ter BRUGGHEN *The Concert* (6483) **157**
Canvas, 99.1×116.8 (39×46). Purchased, 1983.

CAMPIN *The Virgin and Child before a Fire-screen* (2609) **107**
Wood, 63.5×49.5 (25×19 ¼). Salting Bequest, 1910.

CANALETTO *Venice: The Basin of San Marco* **95**
on Ascension Day (4453)
Canvas, 121.9×182.8 (48× 72). Bequeathed, 1929.

CANALETTO *Venice: 'The Stonemason's Yard'* (127). Canvas, **96**
123.8×162.9 (48 ¾ ×64 ⅛). Sir George Beaumont Gift, 1828.

CAPPELLE *A River Scene* (967) **155**
Canvas, 122×154.5 (48×60 ¾). Wynn Ellis Bequest, 1876.

CARAVAGGIO *The Supper at Emmaus* (172) **88**
Canvas, 141×196.2 (55 ½ × 77 ¼). Presented, 1839.

Annibale CARRACCI *The Dead Christ Mourned* (2923) **89**
Canvas, 92.8×103.2 (36 ½ × 40 ⅝). Presented, 1913.

CATENA *A Warrior adoring the Infant Christ* **79**
and the Virgin (234). Canvas, transferred from panel (?),
155.3×263.5 (61 ⅛ ×103 ¾). Purchased, 1853.

CEZANNE *Mountains in Provence* (4136) **248**
Canvas, 63.5×79.4 (25×31 ¼). Purchased, 1926.

CEZANNE *Bathers* (6359) **249**
Canvas, 127.2×196.1 (50 ⅜ × 77 ⅛). Purchased, 1964.

CHAMPAIGNE *Cardinal Richelieu* (1449) **212**
Canvas, 259.7×177.8 (102 ½ × 70). Presented, 1895.

CHARDIN *The House of Cards* (4078) **223**
Canvas, 60.3×71.8 (23 ¾ × 28 ¼). John Webb Bequest, 1925.

CIMA *David and Jonathan* (2505) **52**
Wood, 40.6×39.4 (16×15 ½). Salting Bequest, 1910.

CLAUDE *'The Enchanted Castle'* (6471) **213**
Canvas, 87×151 (34 ¼ × 59 ½). Purchased, 1981.

CLAUDE *Seaport with the Embarkation of the Queen of Sheba* (14) **214**
Canvas, 148.6×193.7 (58 ½ × 76 ¼). 1648. Purchased, 1824.

CONSTABLE *The Haywain* (1207) **204**
Canvas, 130.2×185.4 (51 ¼ ×73). 1821. Presented, 1886.

COQUES *A Family Group* (821) **139**
Canvas, approx. 64×85 (25 ¼ × 33 ⅝). Purchased, 1871.

COROT *A Horseman in a Wood* (3816) **232**
Canvas, 39.1×29.8 (15 ⅜ ×11 ¾). Purchased, 1923.

COROT *Avignon from the West* (3237) **233**
Canvas, 33.7×73 (13 ¼ × 28 ¾). Lane Bequest, 1917.

CORREGGIO *The Madonna of the Basket* (23) **66**
Wood, 33.7×25.1 (13 ¼ ×9 ⅞). Purchased, 1825.

CORREGGIO *Mercury instructing Cupid before Venus* (10) **66**
Canvas, 155.6×91.4 (61 ¼ × 36). Purchased, 1834.

COSTA *A Concert* (2486) **44**
Wood, 95.3×75.6 (37 ½ × 29 ¾). Salting Bequest, 1910.

CRANACH *Cupid complaining to Venus* (6344) **124**
Wood, 81.3×54.6 (32×21 ½). Purchased, 1963.

CRIVELLI *The Annunciation* (739) **54**
Wood, transferred to canvas, 207×146.7 (81 ½ × 57 ¾).
1486. Presented, 1864.

CUYP *Ubbergen Castle* (824) **149**
Wood, 32.1×54.5 (12 ⅝ × 21 ⅜). Purchased, 1871.

DAUBIGNY *St Paul's from the Surrey Side* (2876) **235**
Canvas, 44×81.3 (17 ½ ×32). 1873. Presented, 1912.

Gerard DAVID *The Adoration of the Kings* (1079) **112**
Wood, 59.7×58.4 (23 ½ × 23). Bequeathed, 1880.

Jacques-Louis DAVID *Jacobus Blauw* (6495) **228**
Canvas, 92×73 (36 ¼ × 28 ¾). 4 (1795). Purchased, 1984.

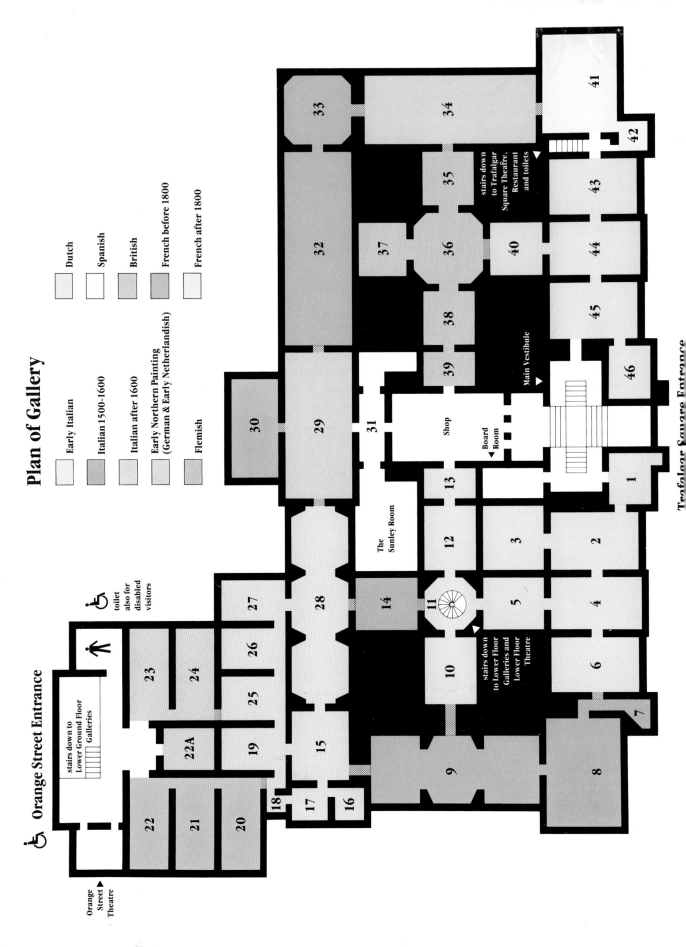

Plan of Gallery

Dutch

Spanish

British

French before 1800

French after 1800

Early Italian

Italian 1500-1600

Italian after 1600

Early Northern Painting
(German & Early Netherlandish)

Flemish

Orange Street Entrance

Trafalgar Square Entrance

Orange
Street
Theatre

stairs down to
Lower Ground Floor
Galleries

toilet
also for
disabled
visitors

The
Sunley Room

Shop

Board
Room

Main Vestibule

stairs down to Lower Floor
Galleries and
Lower Floor
Theatre

stairs down
to Trafalgar
Square Theatre,
Restaurant
and toilets